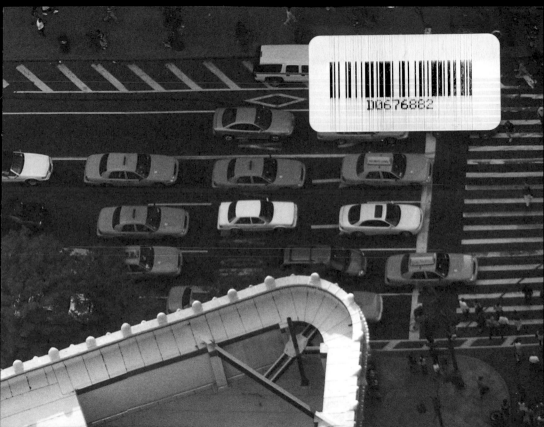

New York
A Photographic Album

New York
A Photographic Album

Edited by Gabriela Kogan

Universe

New York transcends its physical territory. New York is whoever loves it, and this book was created by people who love New York. Sixty New York lovers made portraits of details of the city as a way of making it their own: the subway turnstile, a favorite sandwich in a restaurant or a stand on the sidewalk, the footprint in the snow that someone left in Central Park on the day of a blizzard, the bag from that store that is kept as a treasure.

A lot of us hold the illusion that we belong to New York and that New York belongs to us. It is as if from the moment that classic slogan "I Love NY" was born, our own arms spread wide to embrace the city and to stay with her, our head resting on her chest. What is so special about this city that it can create such a personal bond with all of us? Many of us weren't even born there and don't live there, and yet it is as much ours as our own home town is. It is as close to us as the best friends we choose again and again until they feel like family.

New York: A Photographic Album shows the relationship between a city and the people who love it. It is a relationship that each person feels is unique, but this book allows us to discover its universal aspect, too: when we look at these photographs, we find very similar images taken by different photographers, portraying places that seem to hold some secrets just waiting to be captured in time.

This book is a travel log of our journey, and another's, and of our own again because when we recognize ourselves in the photographs someone else has taken, we are building the same horizon. My experience and the experience of others are brought together here in a single book, diverse points of view in a single album, as the declaration of love for the city we cherish.

This book was possible because something new is happening with photography and communications. The digital camera democratized the possibility of taking many good photographs. And the tools that Internet provides for sharing those photographs with others, throughout the entire world, were indispensable in order to find the people who love New York the way I do, to revisit the perfumes of my own visits there with an image someone else was able to capture, and to open the doorway to my own memories through the memories of other individuals. There are also photographs

that have historical value; they allow us to see what is left and what has gone, to intuit those old images in the contemporary ones.

The order of the photographs is capricious, obeying each image's own proposition. One after another, it ends up being the route that anyone could have taken upon arriving in New York for the first time or after living in the city and knowing exactly what is worth seeing.

There are hundreds of photographs that have been left out, but could and should be here. *New York: A Photographic Album* is an unfinished work, without an end and without a beginning. It is comprised only of 511 moments in New York. We invite all who might one day have this book in their hands to add to it, enrich it, and make it as much their own as they feel this city to be.

Dedicated to all the people who feel like New Yorkers all around the world

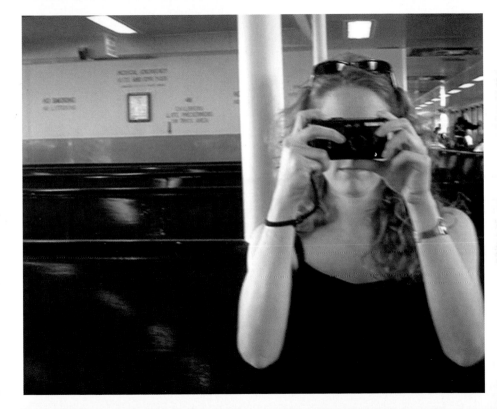

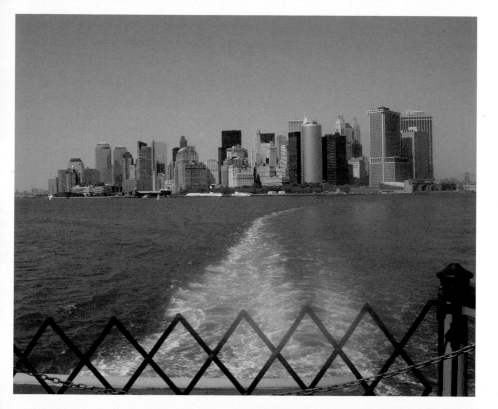

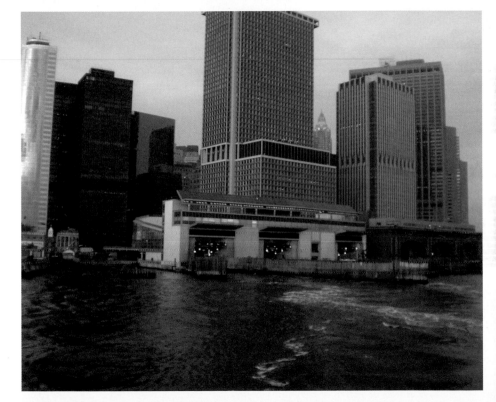

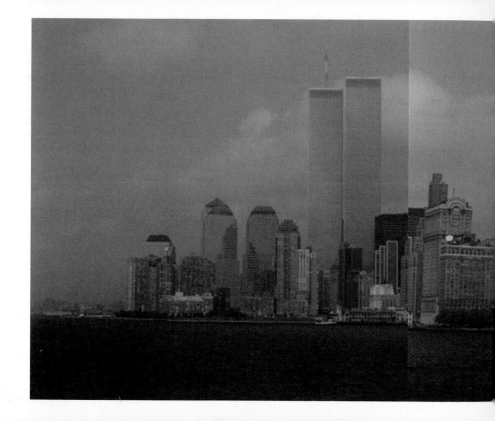

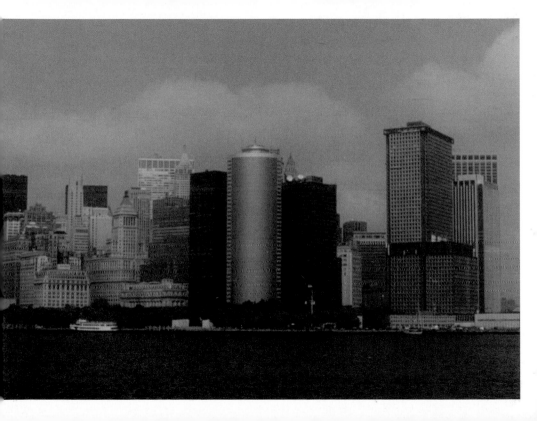

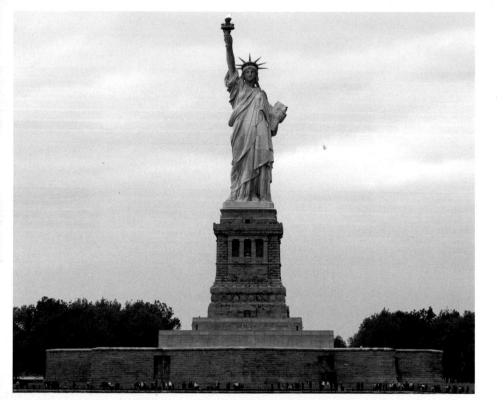

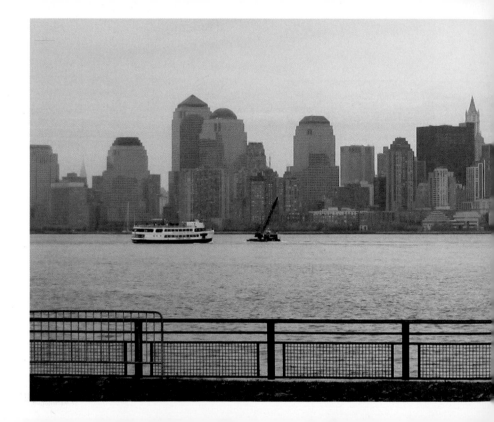

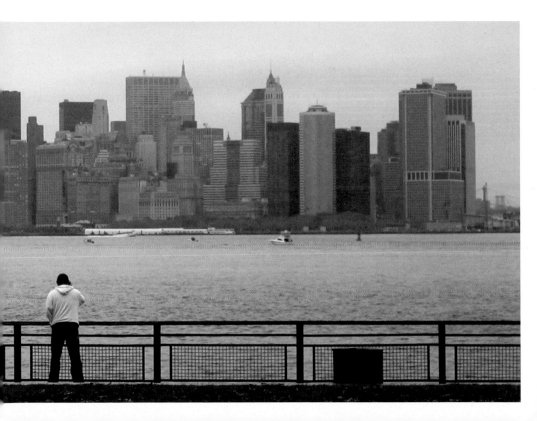

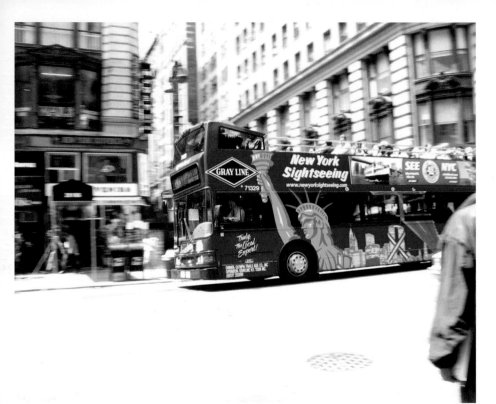

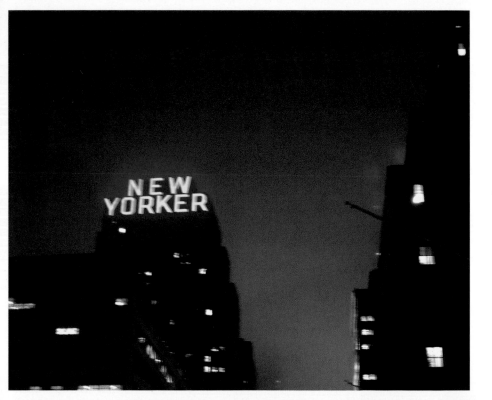

FUMIKA NAGANO ✳ NEW YORKER / 2007

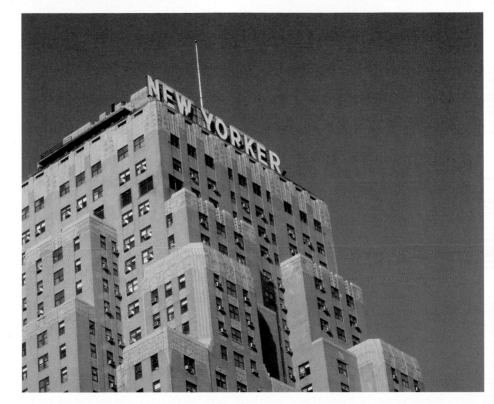

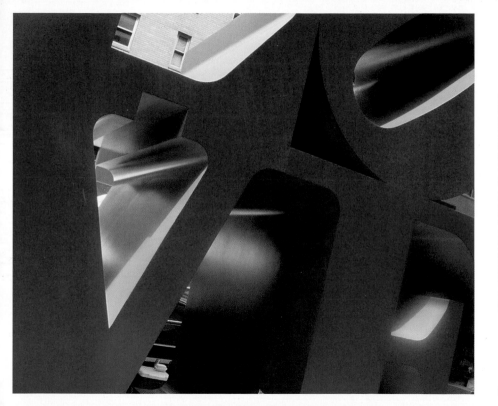

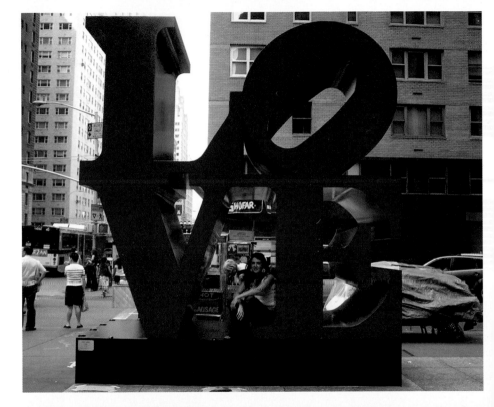

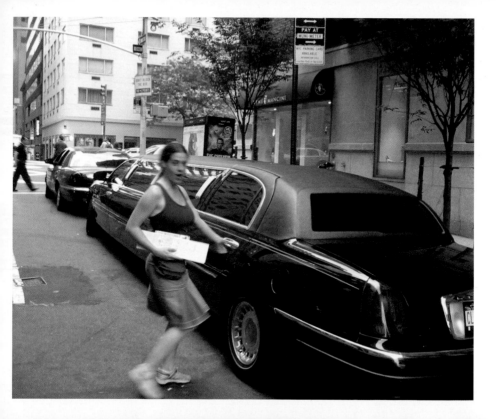

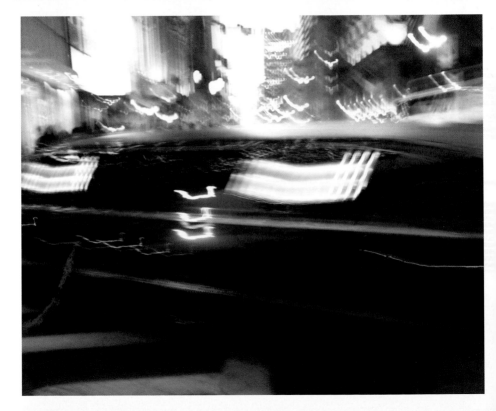

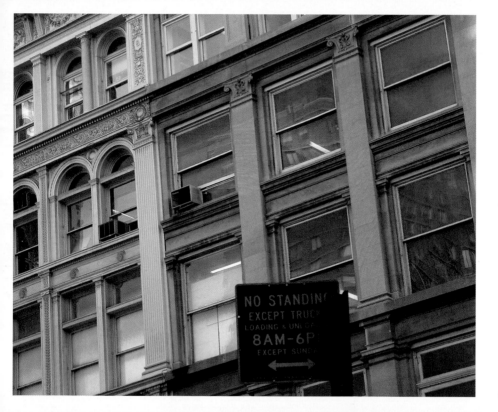

NO STANDING
EXCEPT TRUCK
LOADING & UNLOA
8AM-6P
EXCEPT SUND

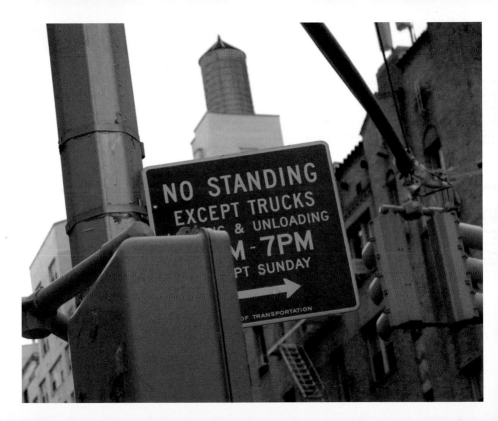

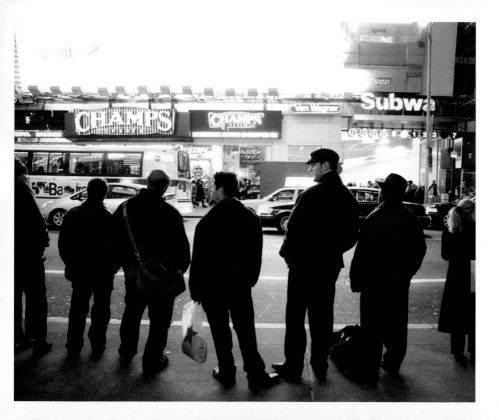

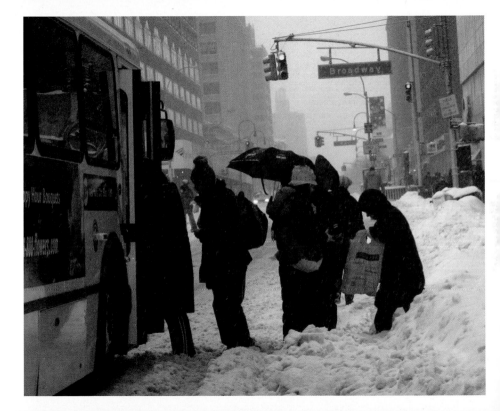

GERALD SAN JOSÉ ✳ BUS / 2007

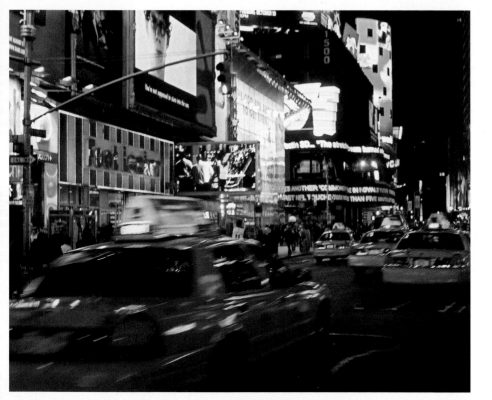

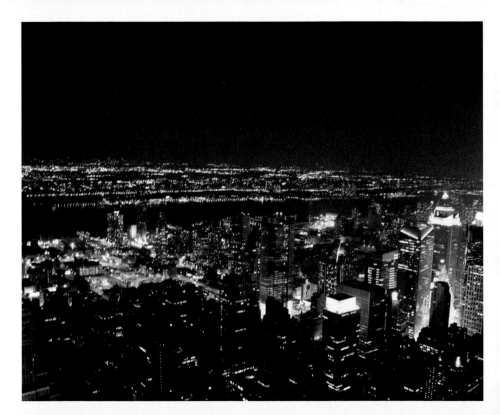

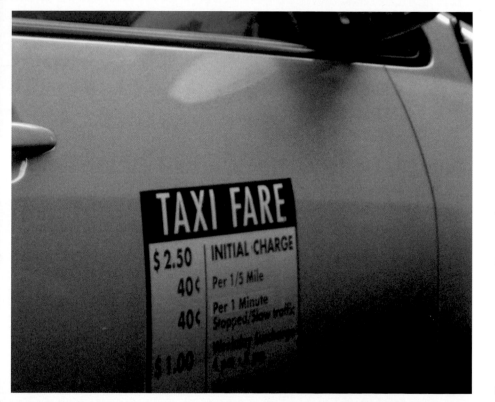

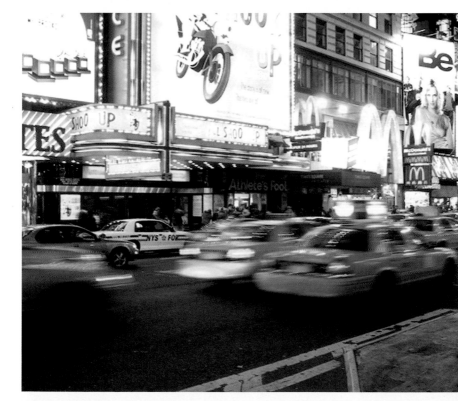

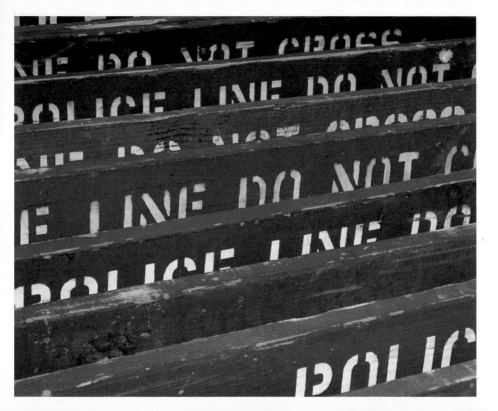

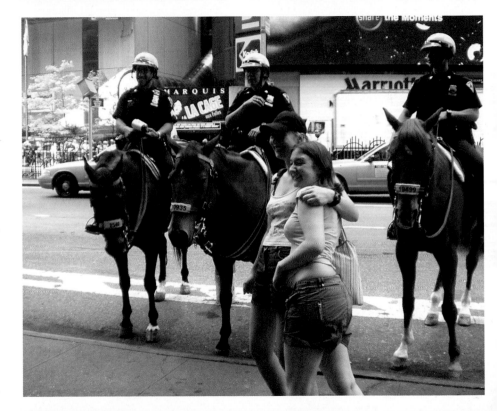

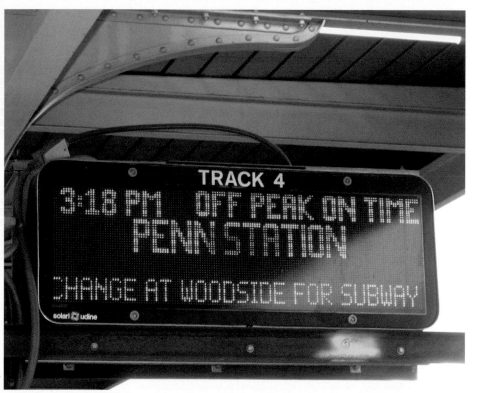

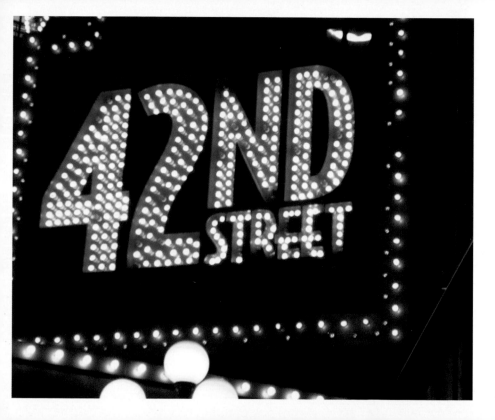

CRISTINA ROUCO·ALEJANDRO GIUSTI ✳ 42 / 2004

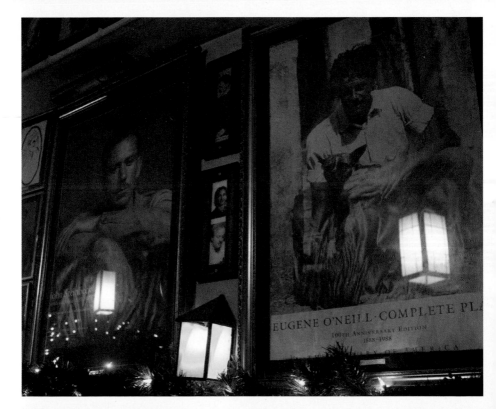

EUGENE O'NEILL · COMPLETE PLA

100TH ANNIVERSARY EDITION
1888-1988

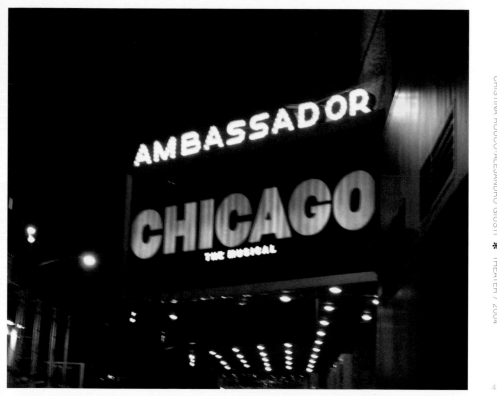

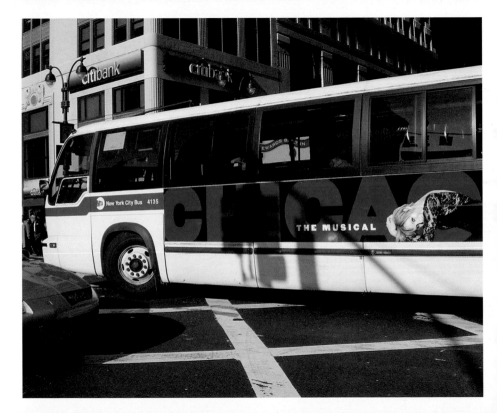

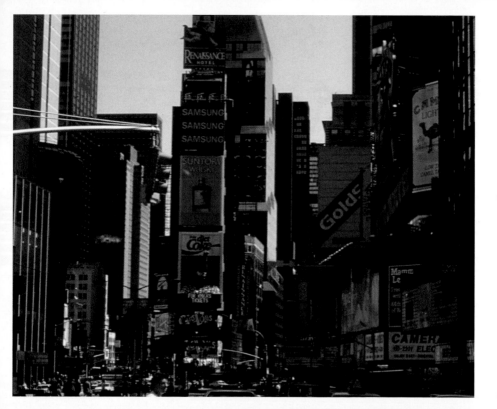

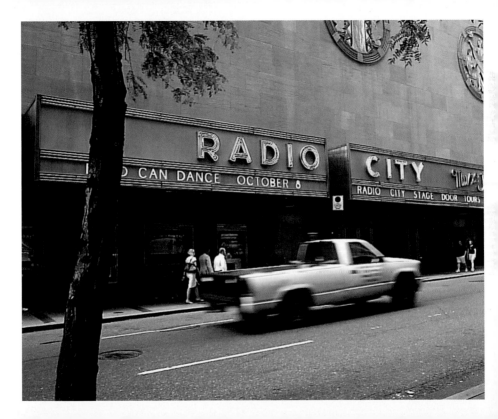

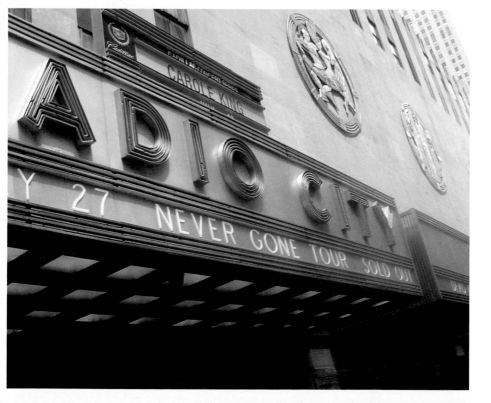

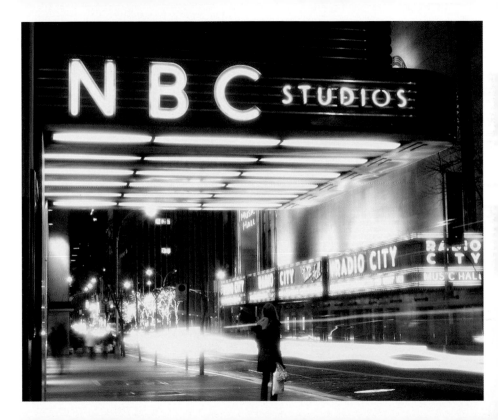

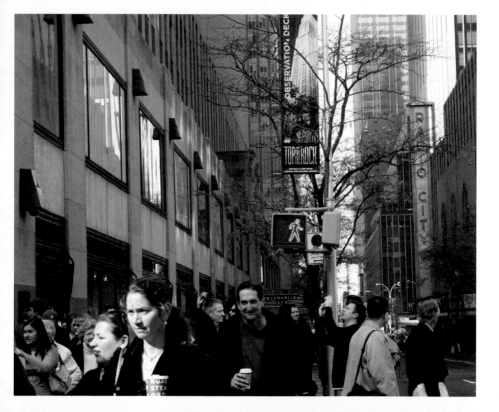

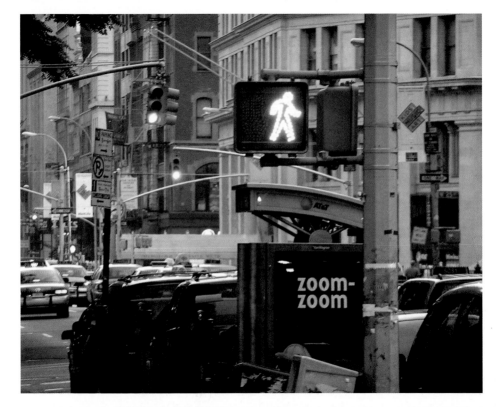

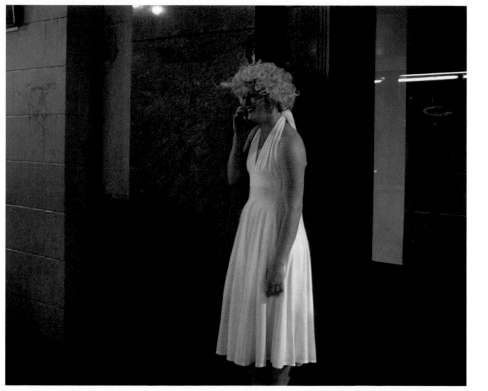

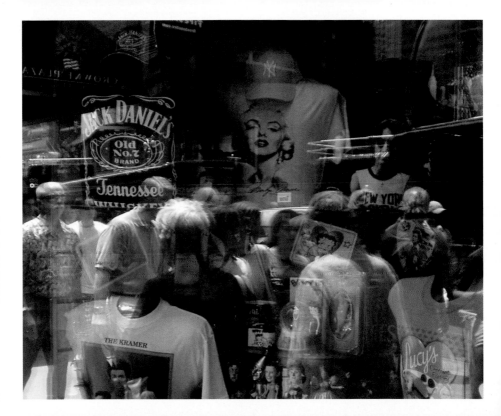

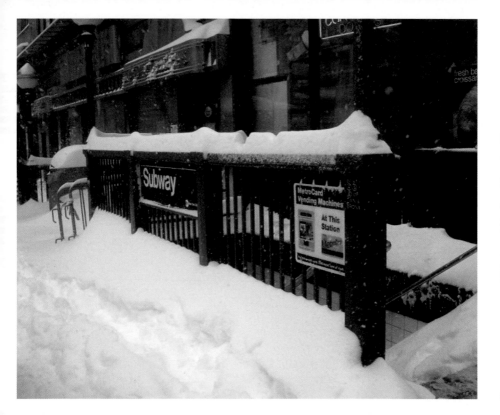

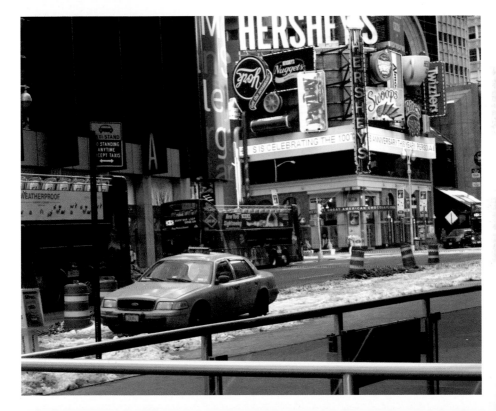

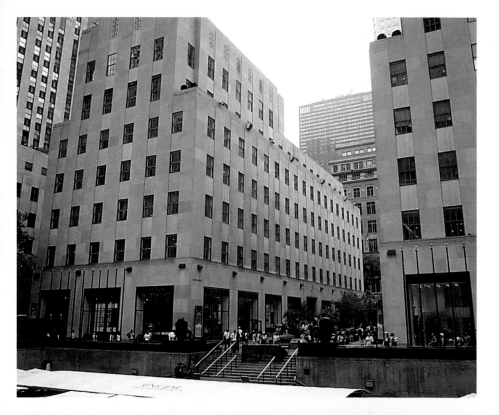

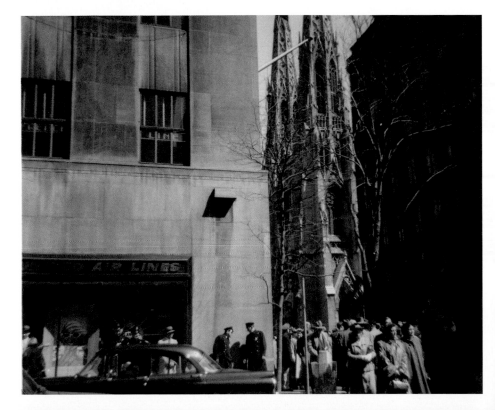

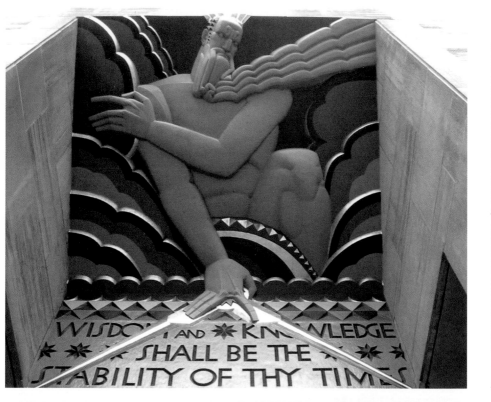

WISDOM AND ✳ KNOWLEDGE ✳
✳ ✳ SHALL BE THE ✳ ✳
STABILITY OF THY TIMES

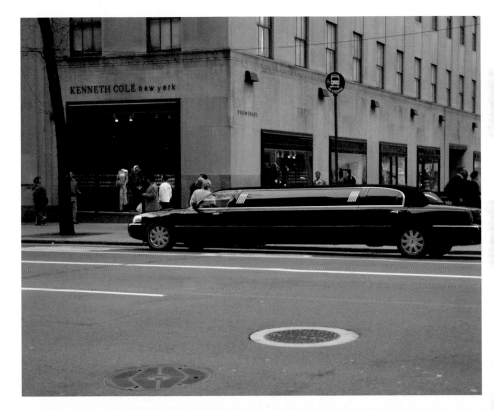

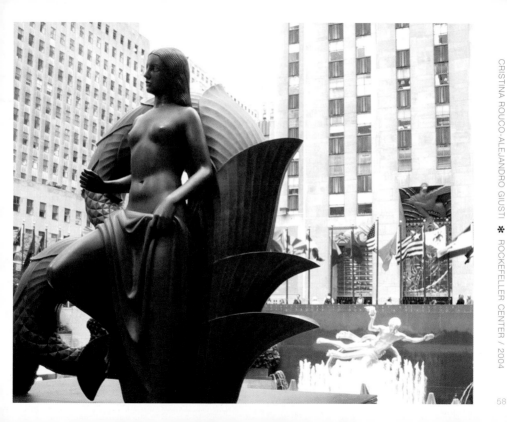

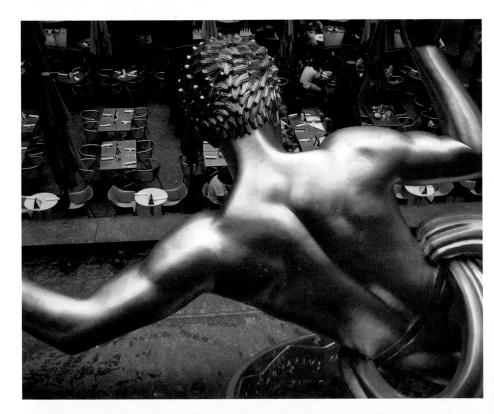

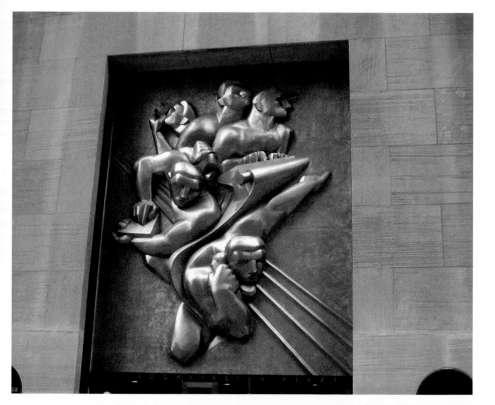

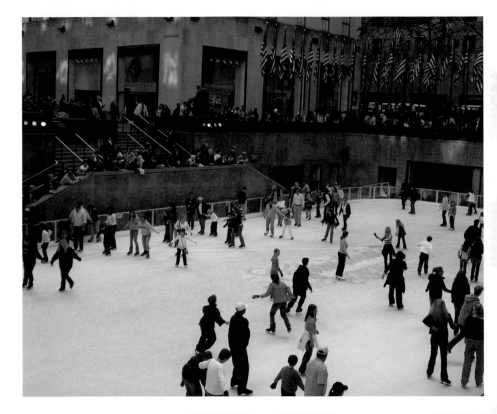

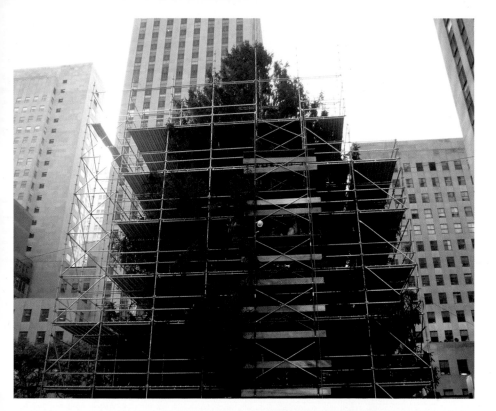

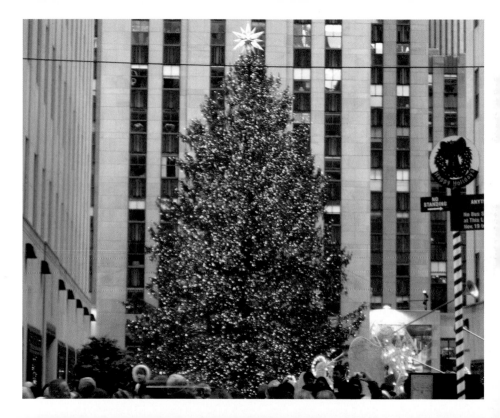

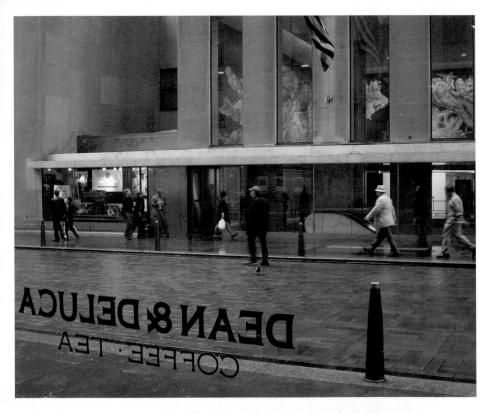

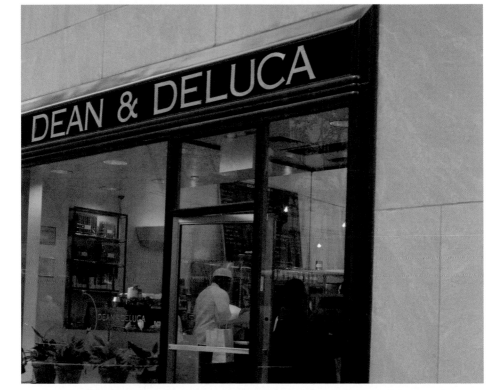

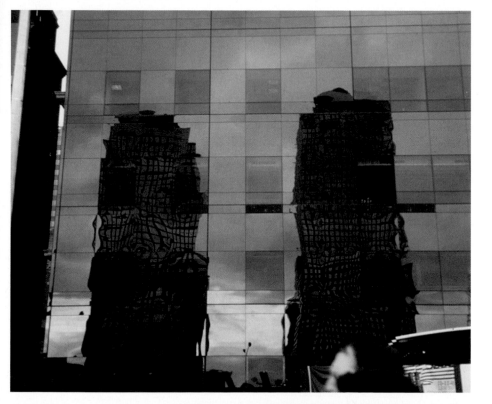

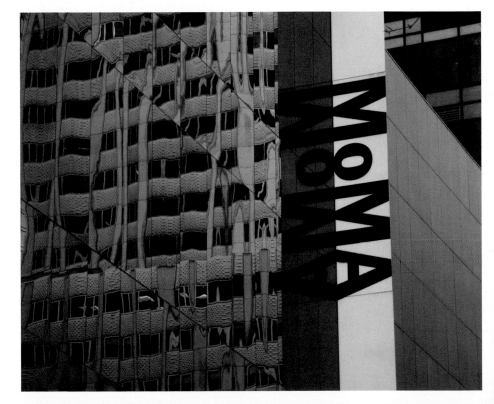

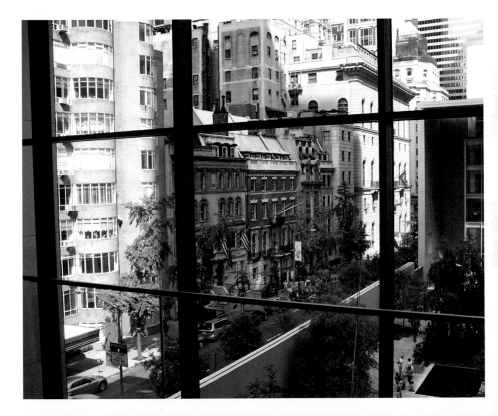

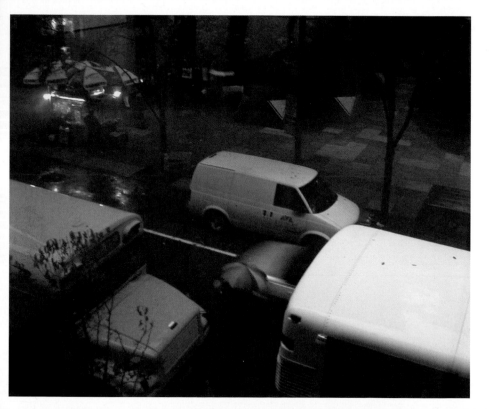

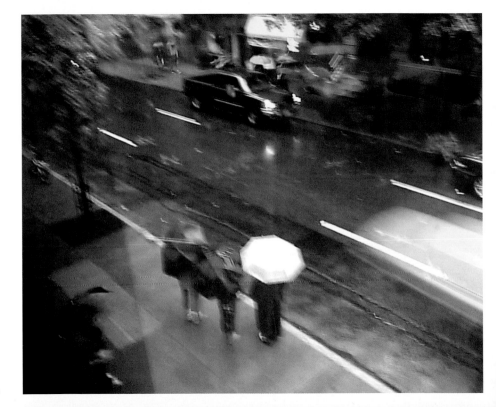

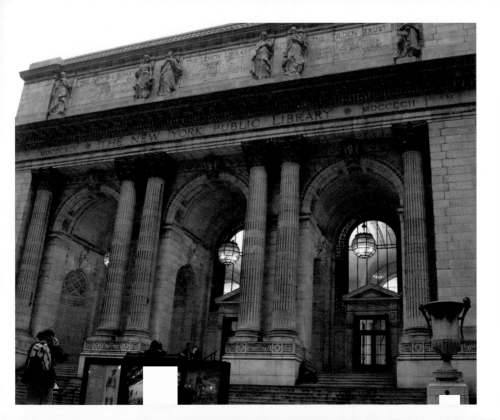

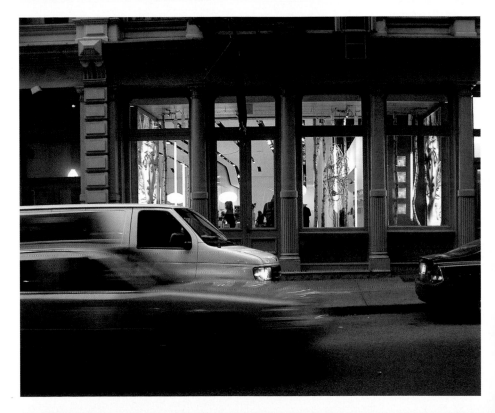

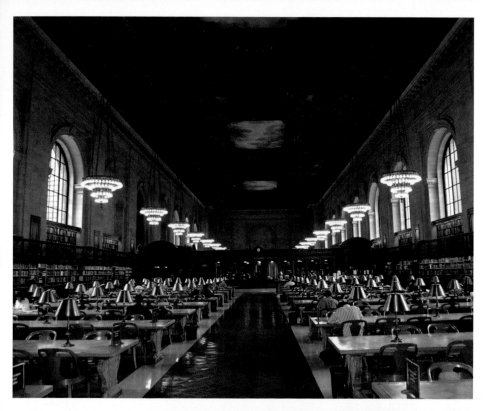

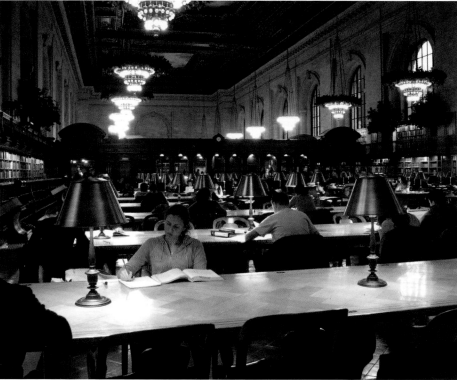

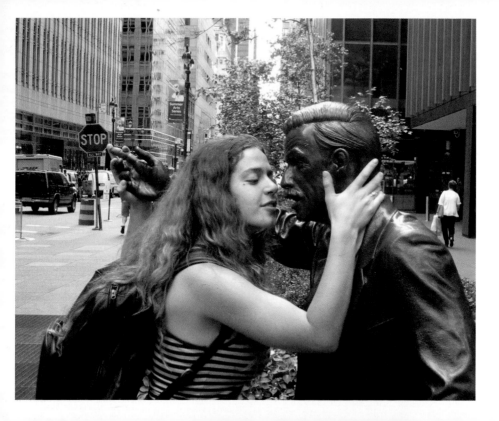

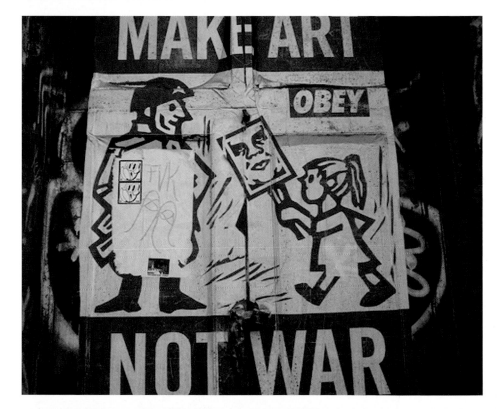

CLAY WILLIAMS ✷ OBEY / 2006

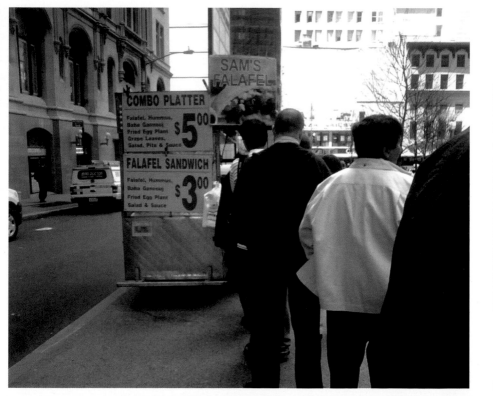

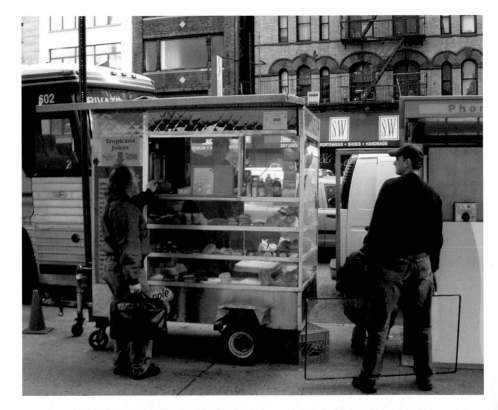

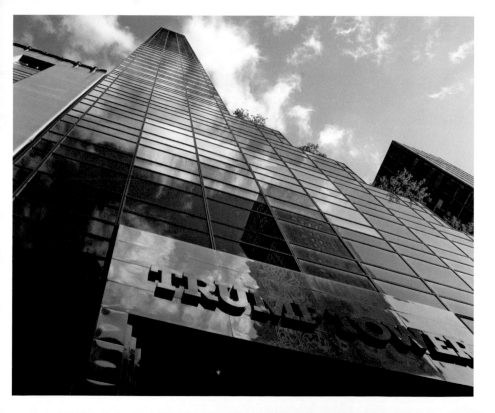

Some dealers have more talent than the artists they represent

Patrick Mimran

GABRIELA KOGAN * CHELSEA / 2002

86

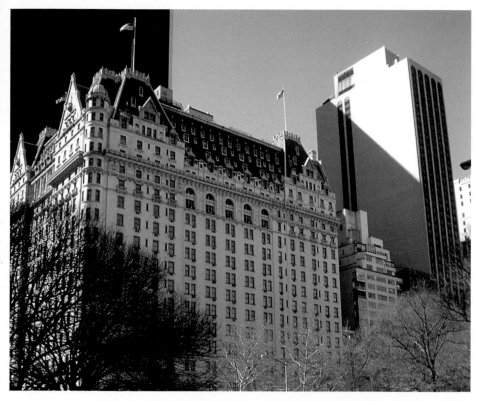

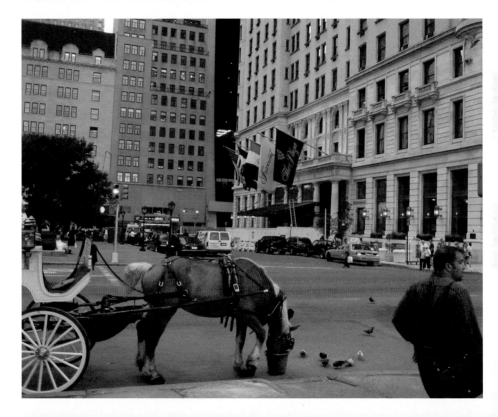

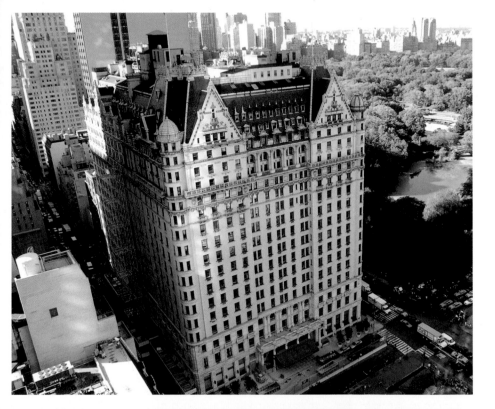

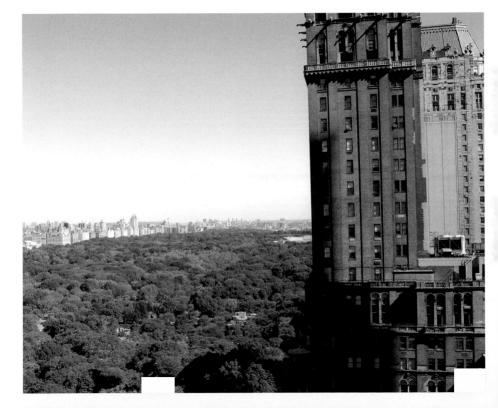

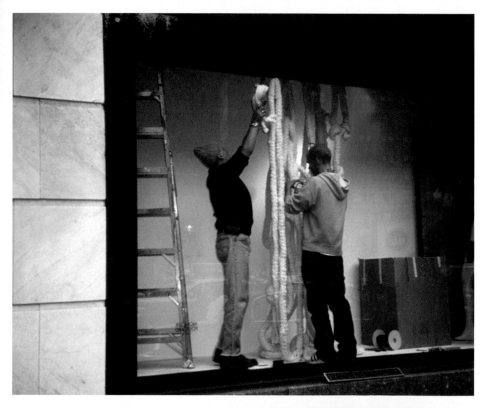

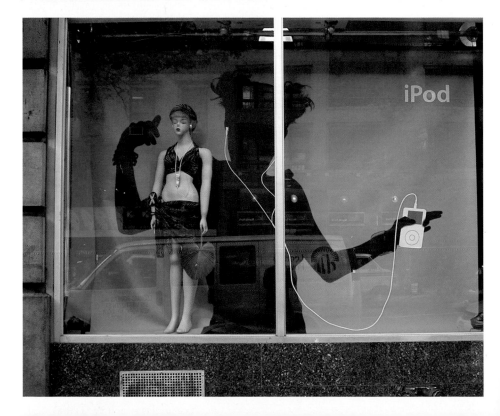

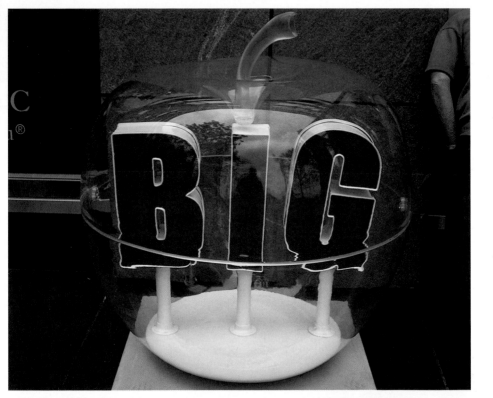

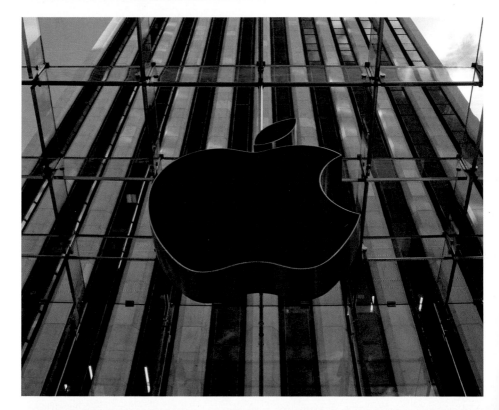

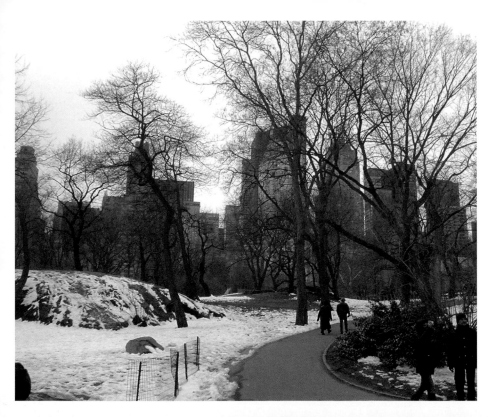

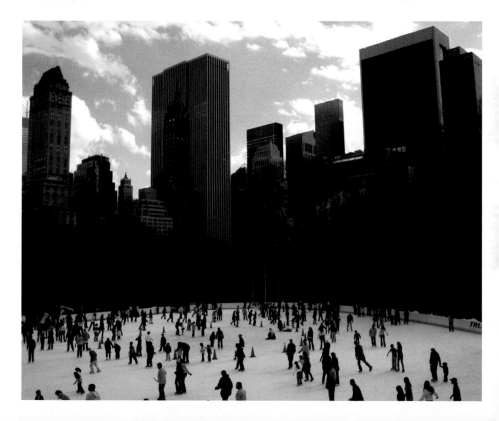

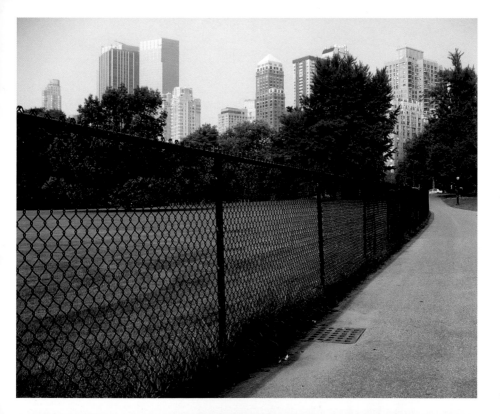

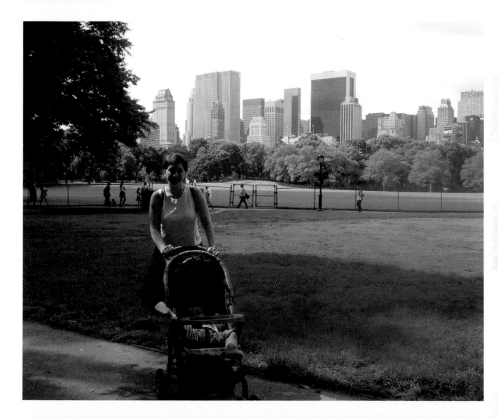

GABRIELA KOGAN ✳ CENTRAL PARK / 2005

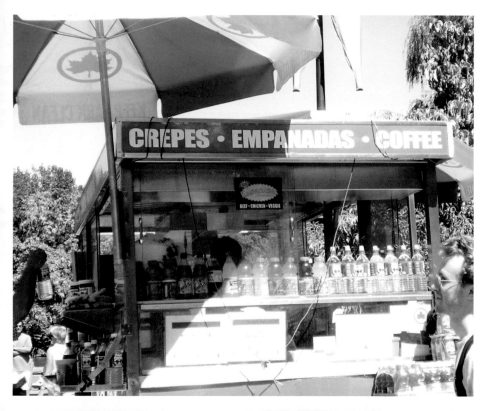

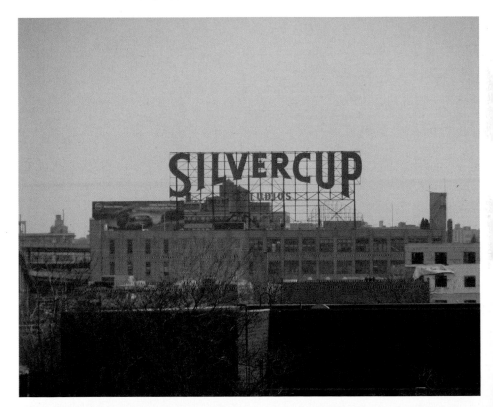

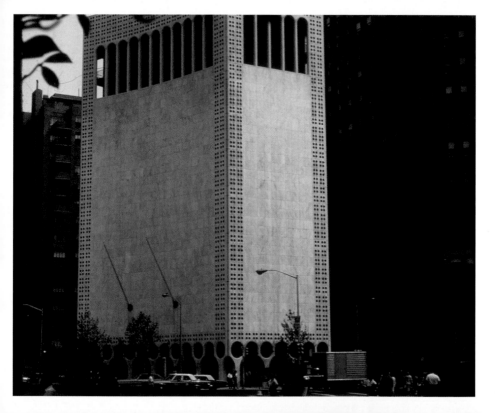

MARLEN DE VRIES ✱ VISITOR BUREAU / 1974

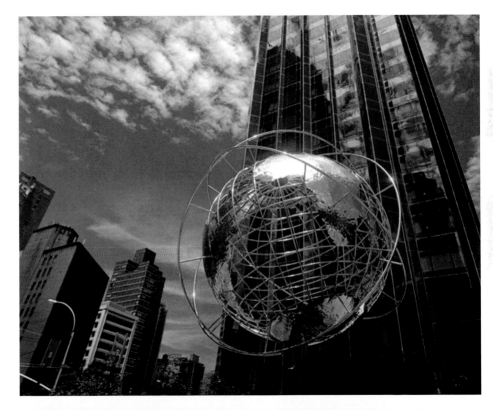

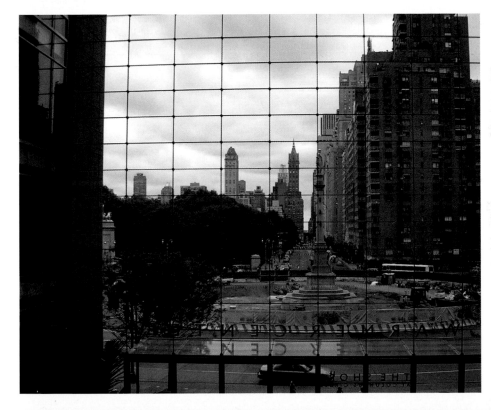

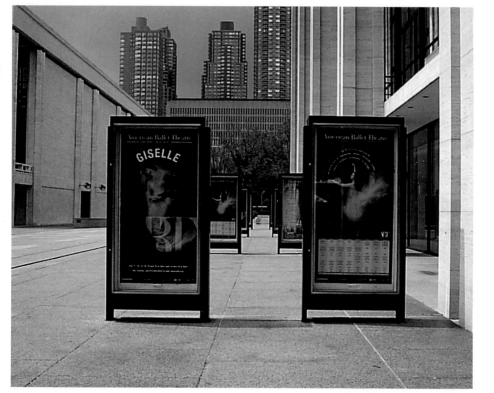

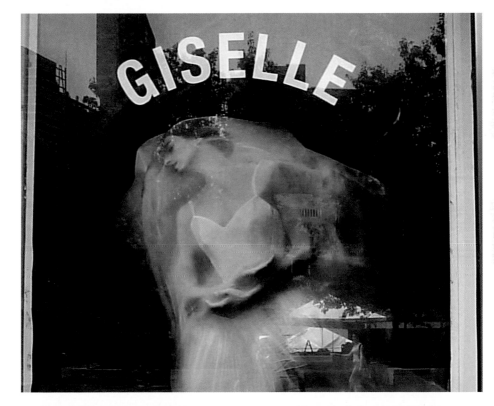

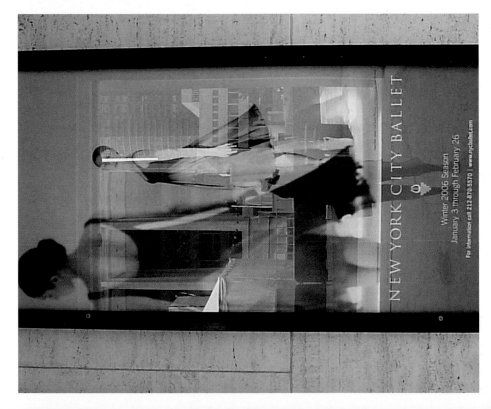

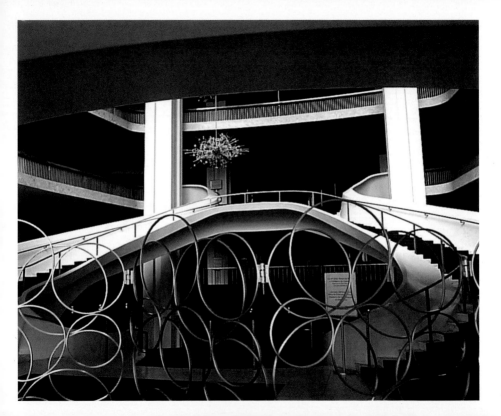

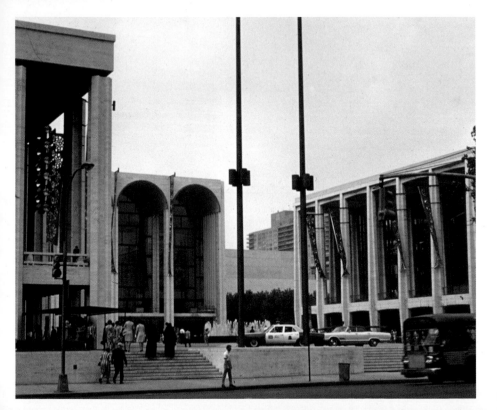

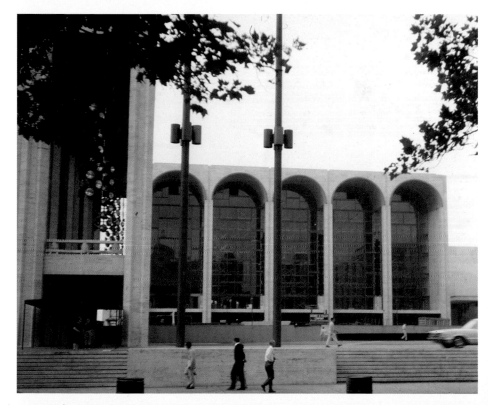

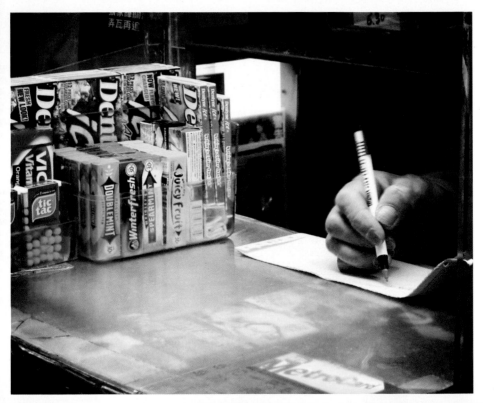

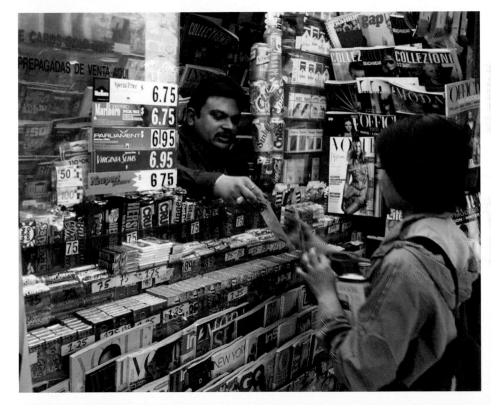

JOHN LIU ✳ I WOULD LOVE TO SELL YOU A PHONE CARD / 2007

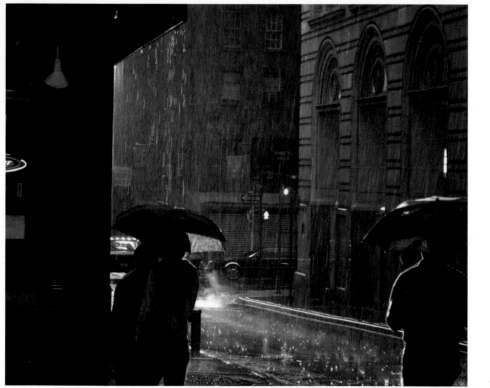

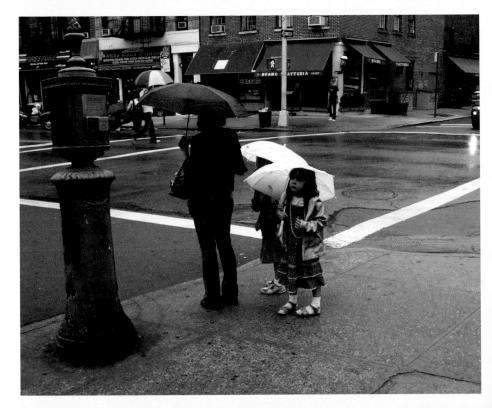

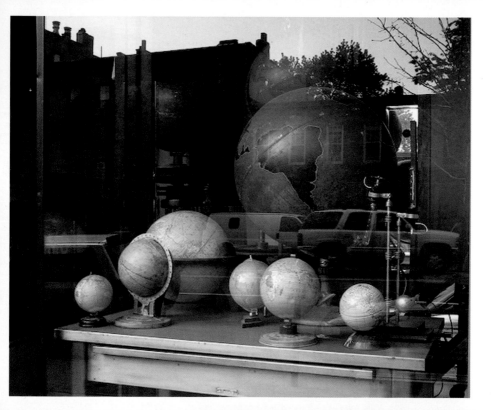

123

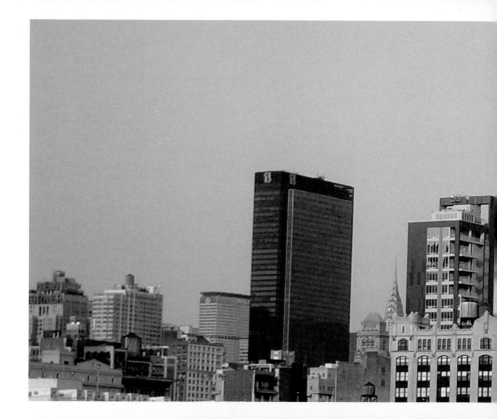

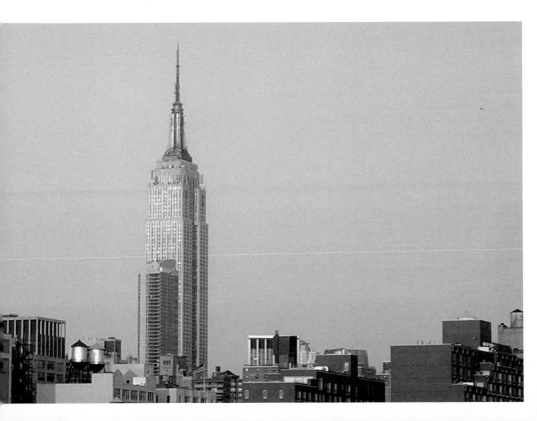

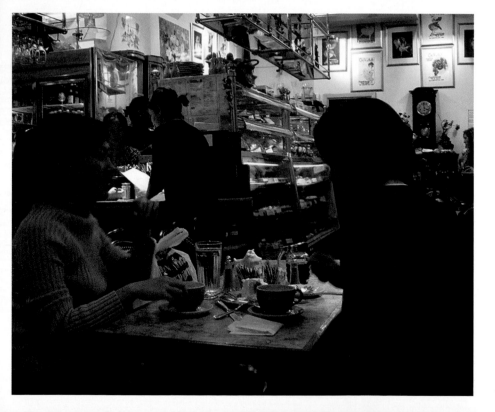

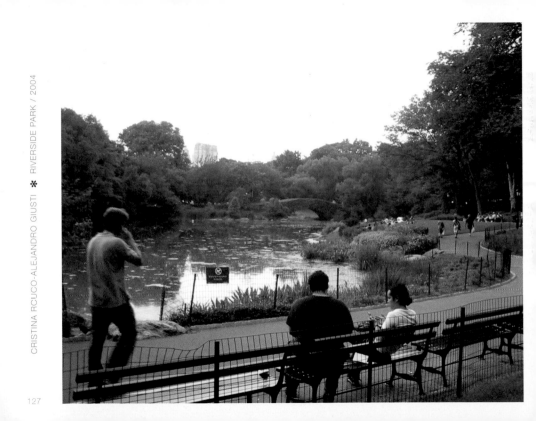

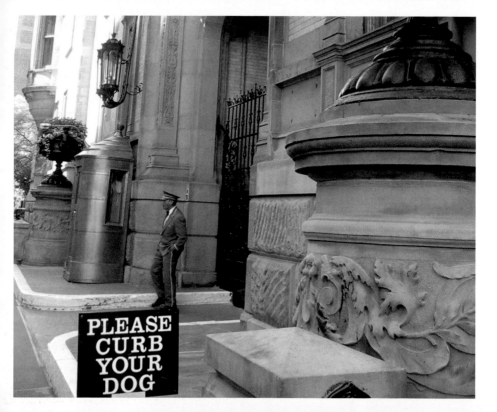

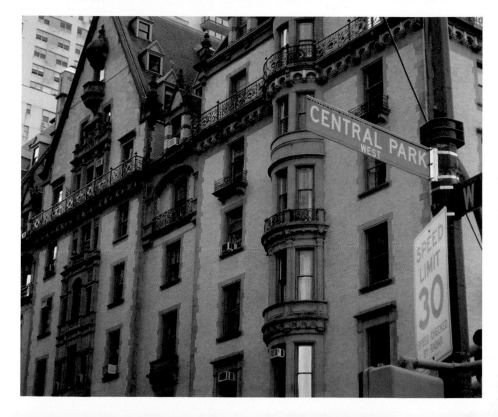

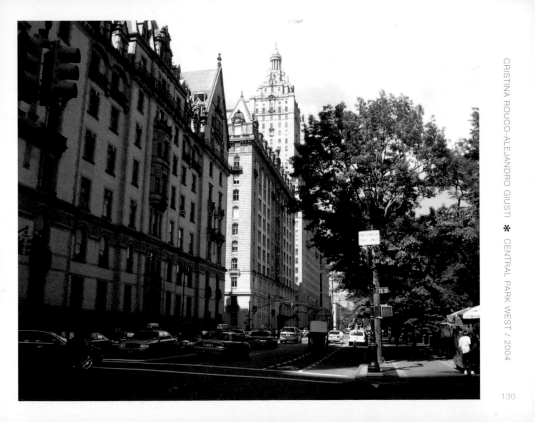

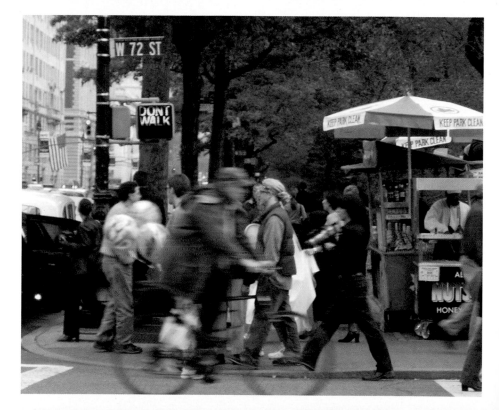

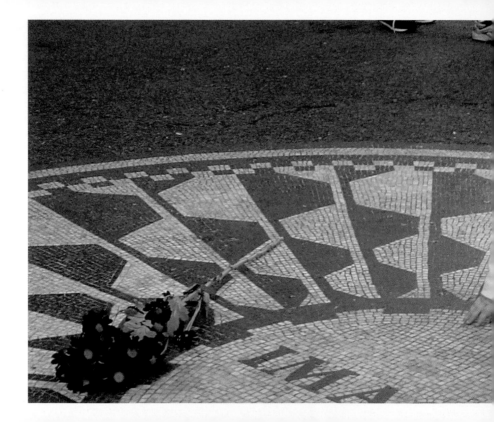

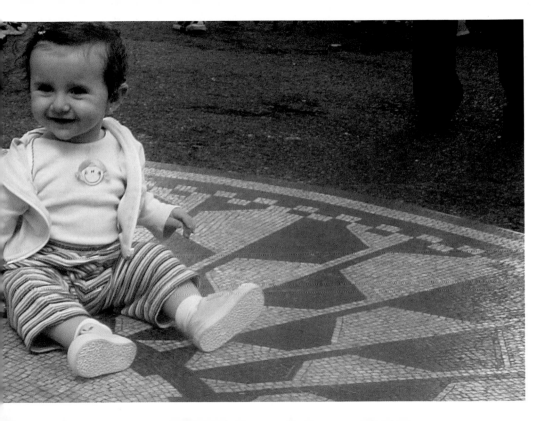

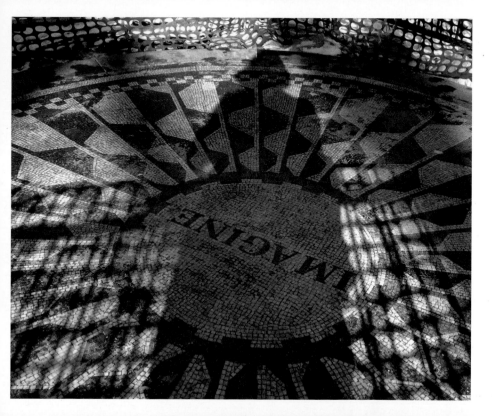

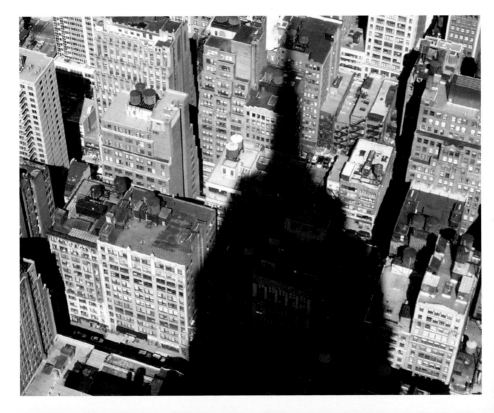

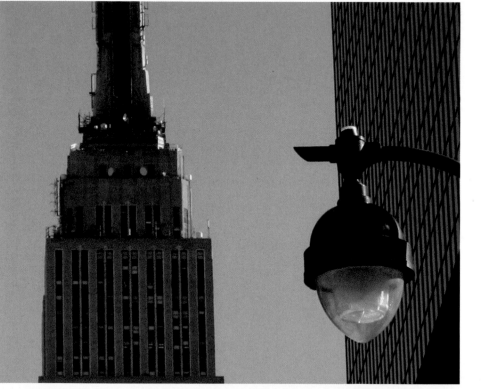

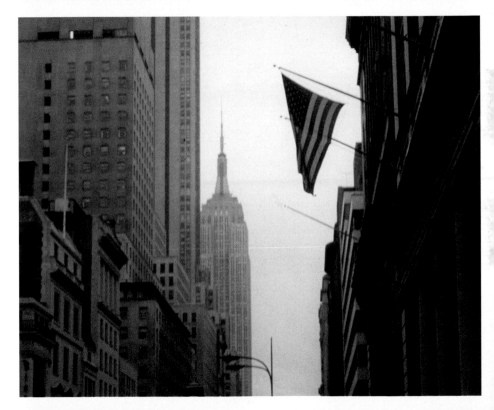

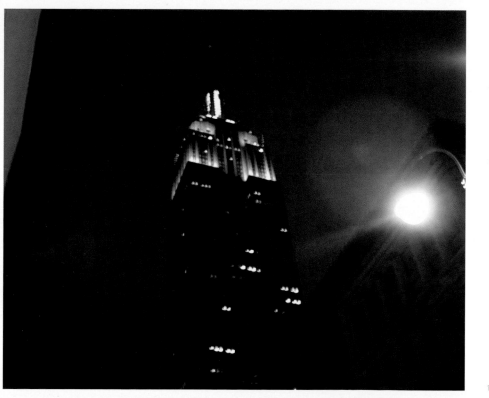

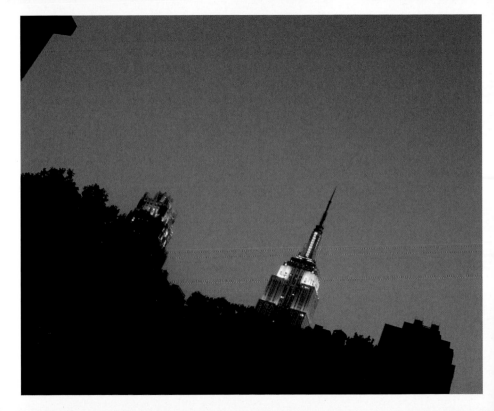

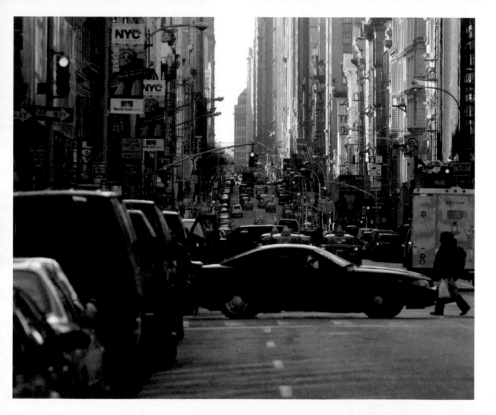

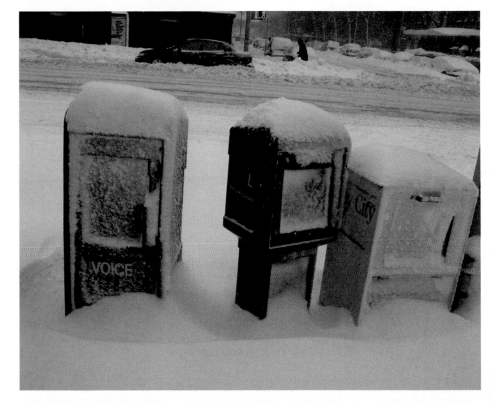

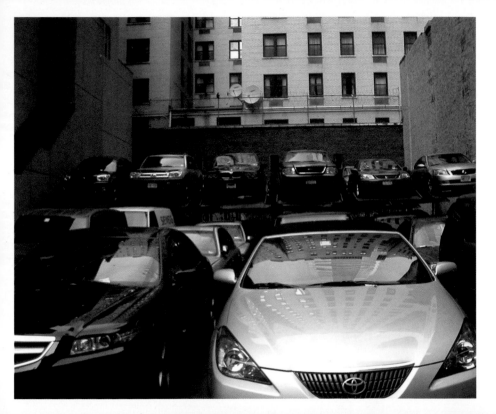

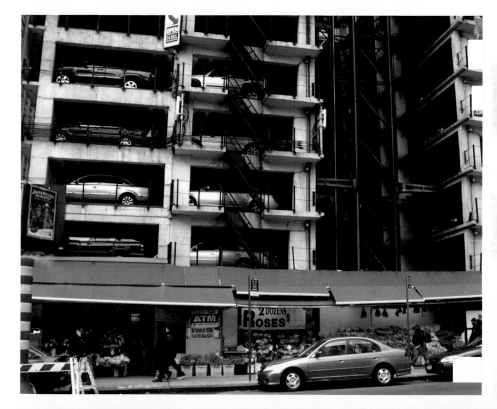

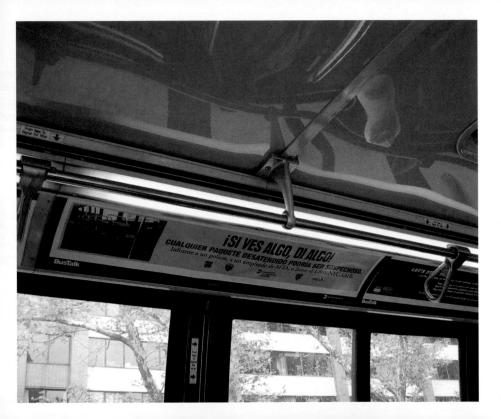

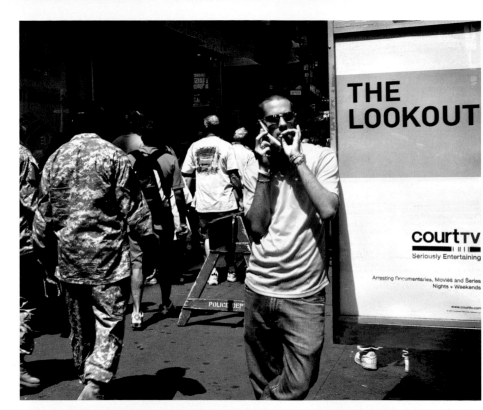

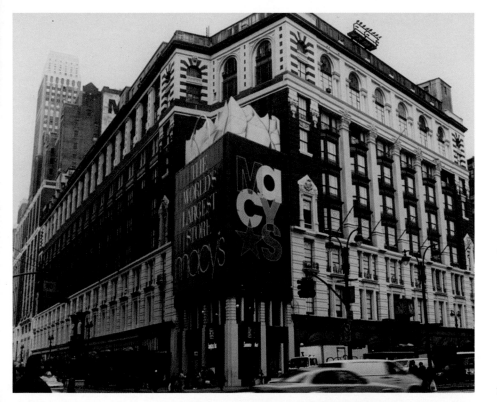

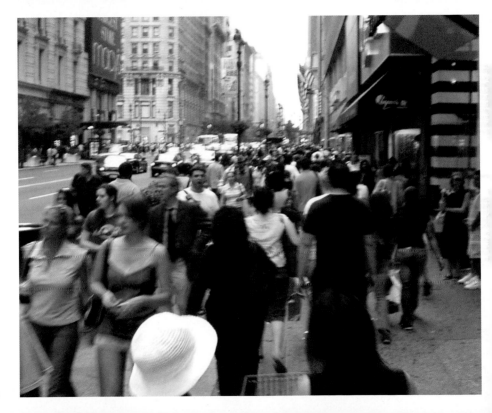

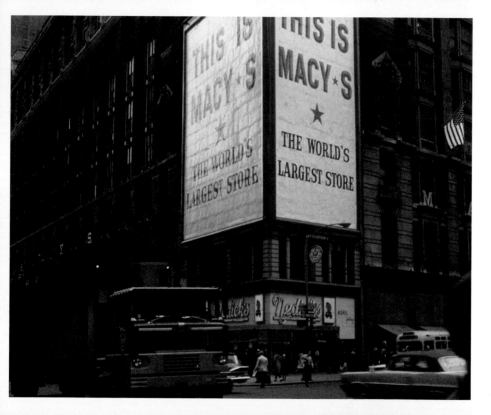

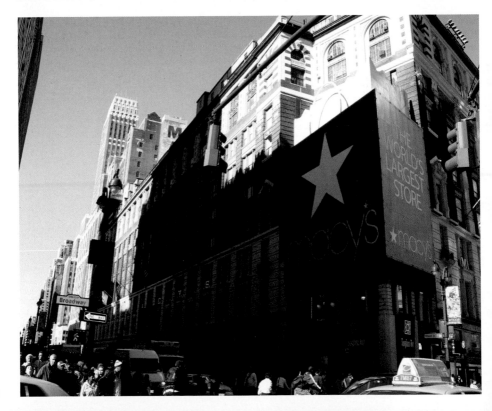

JONATHAN GORANSKY ✳ MACY'S / 2006

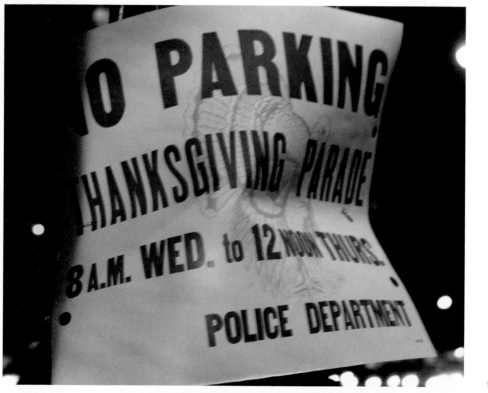

NO PARKING
THANKSGIVING PARADE
8 A.M. WED. to 12 NOON THURS.
POLICE DEPARTMENT

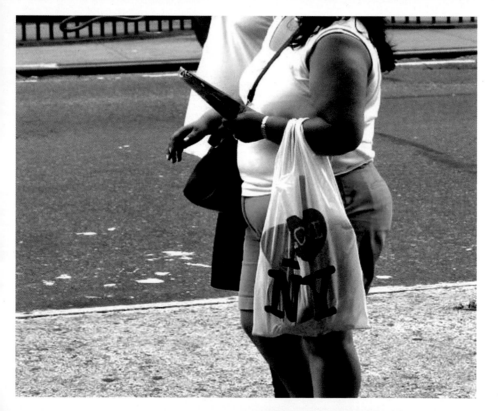

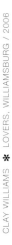
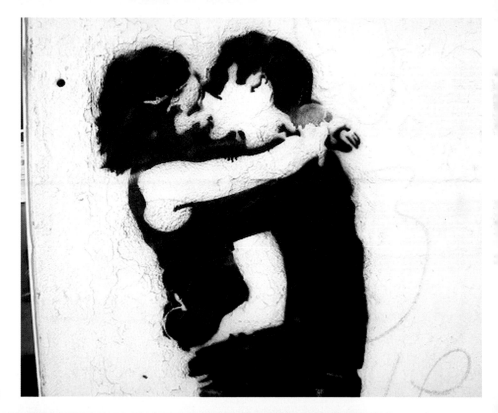

CLAY WILLIAMS ✳ LOVERS, WILLIAMSBURG / 2006

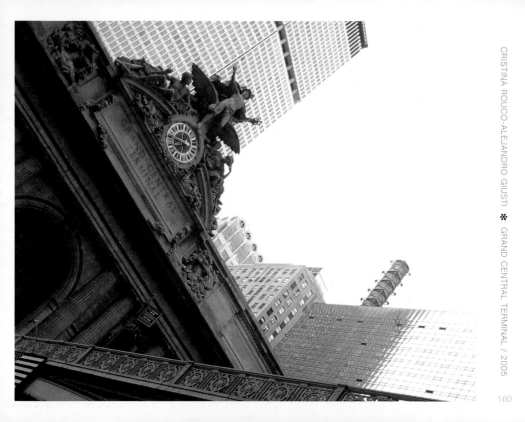

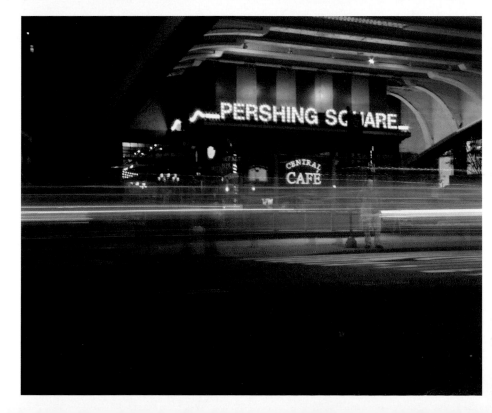

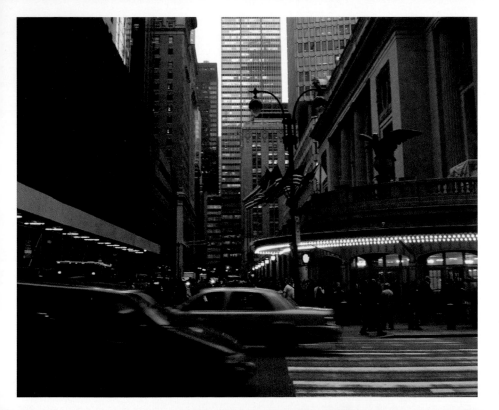

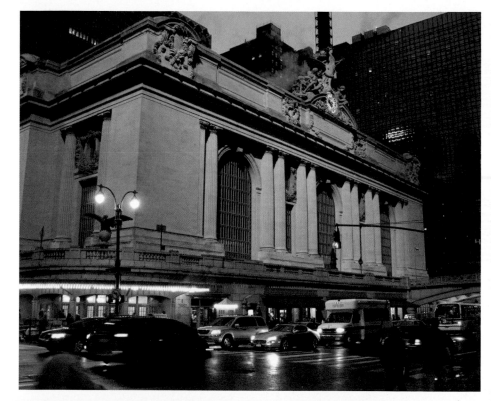

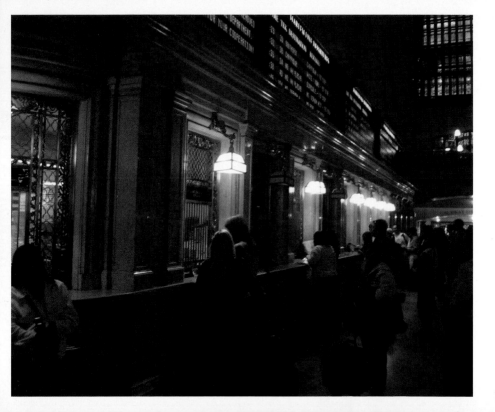

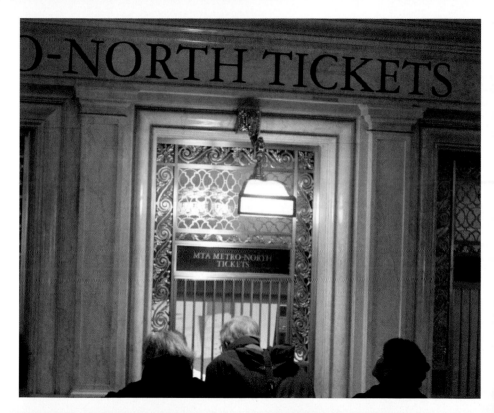

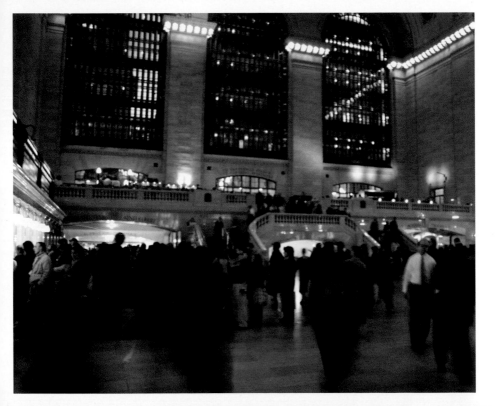

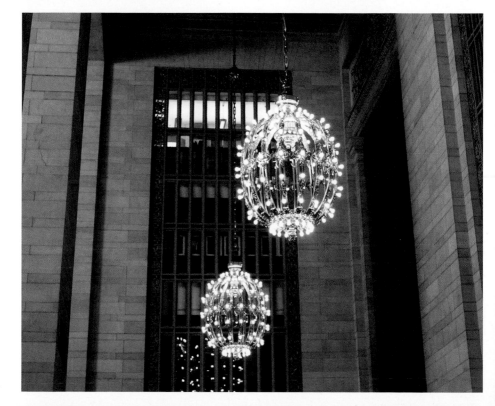

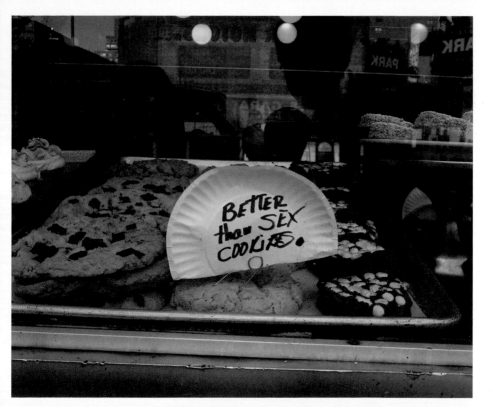

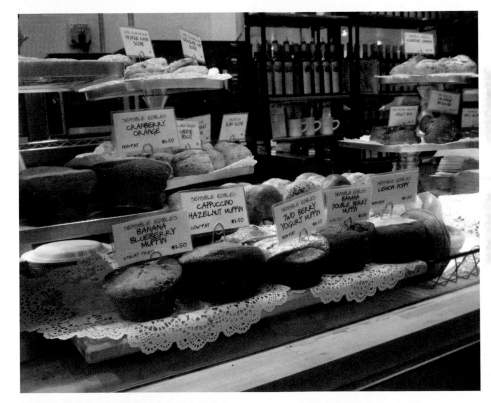

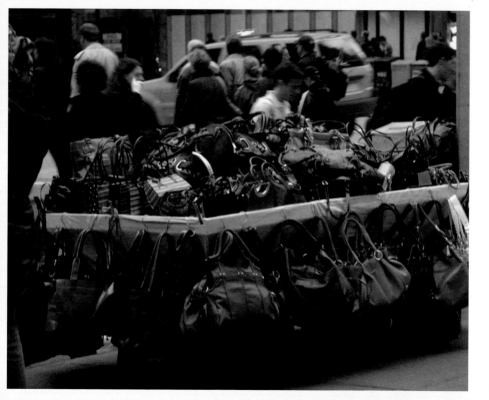

CAMILA MIYAZONO LÓPEZ ✳ BAGS / 2006

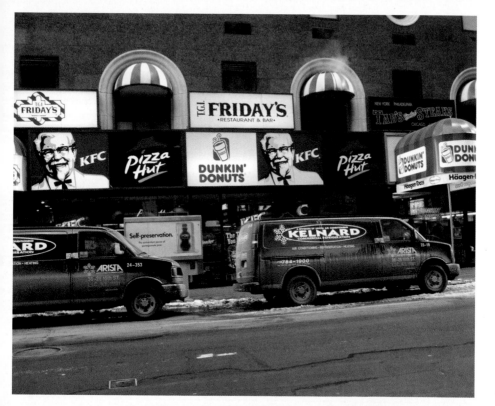

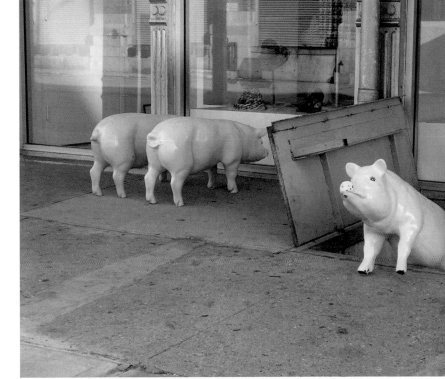

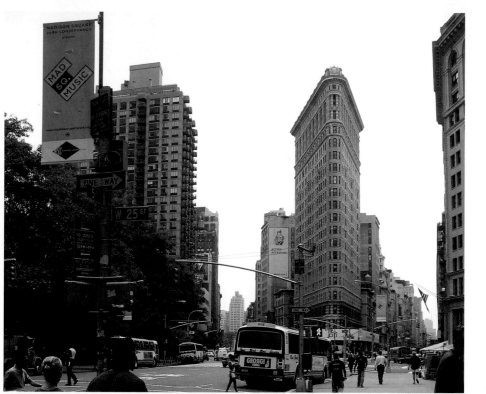

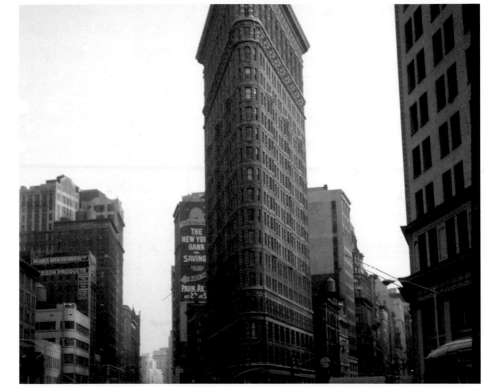

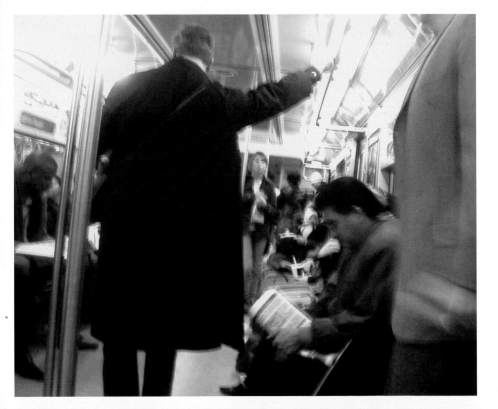

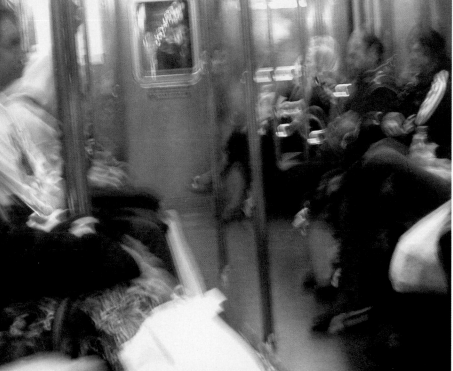

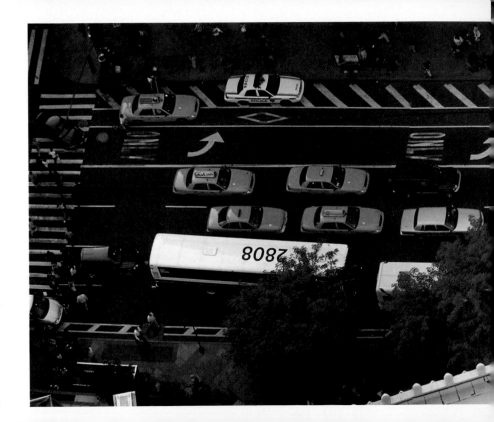

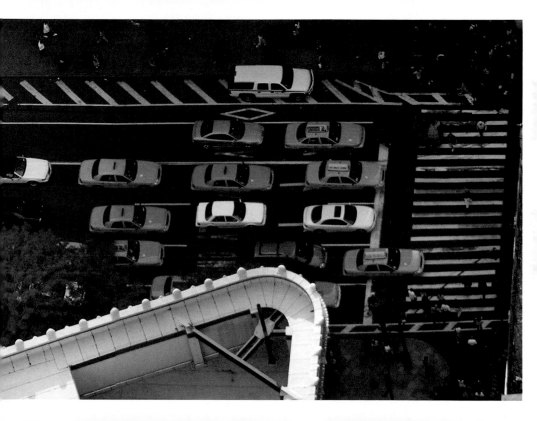

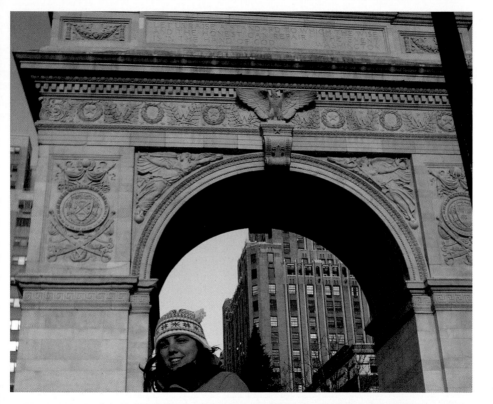

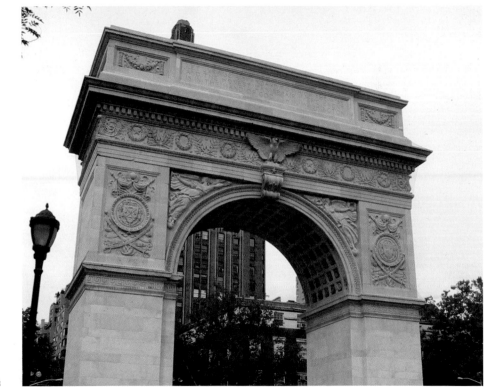

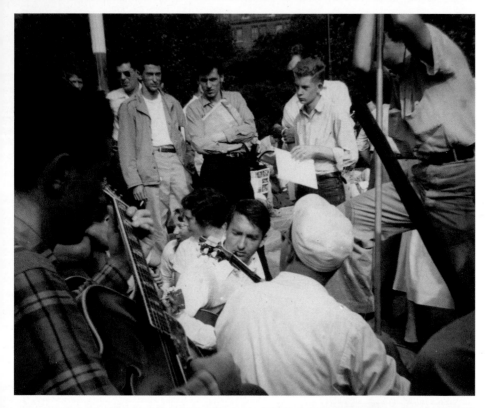

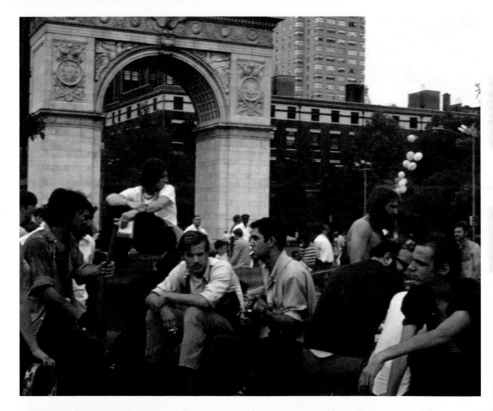

MAURICIO SZUSTER ✱ WASHINGTON SQUARE PARK / 1968

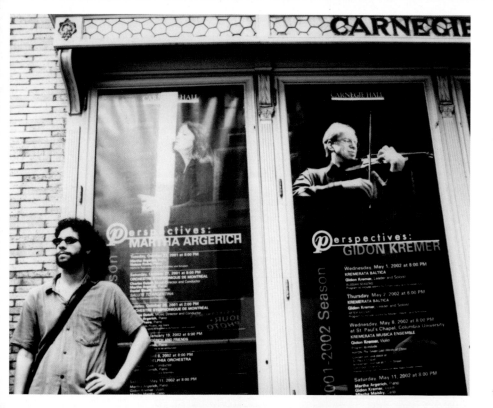

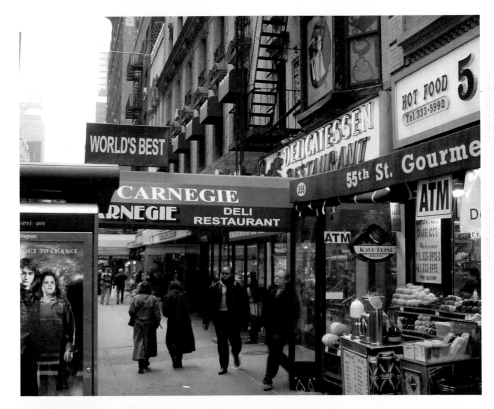

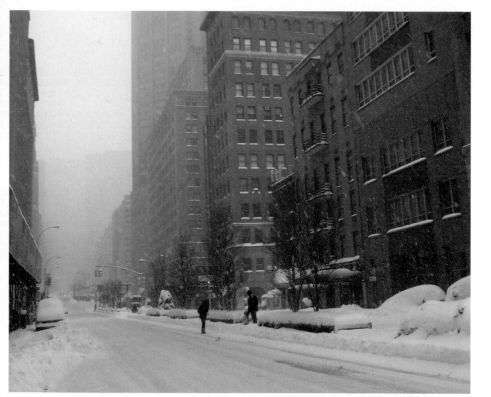

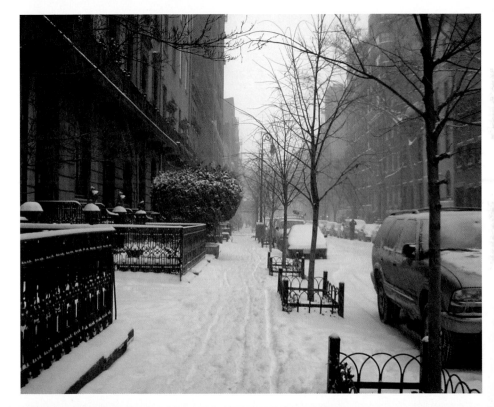

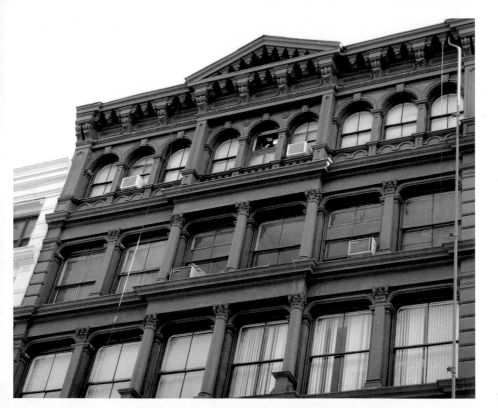

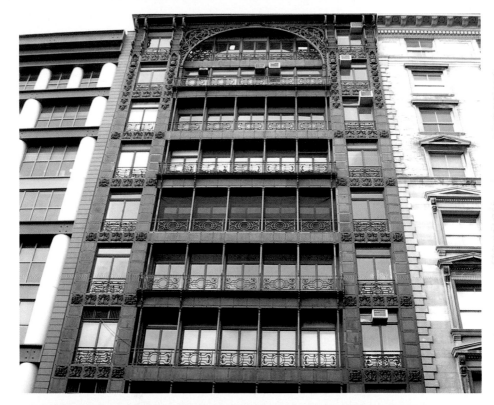

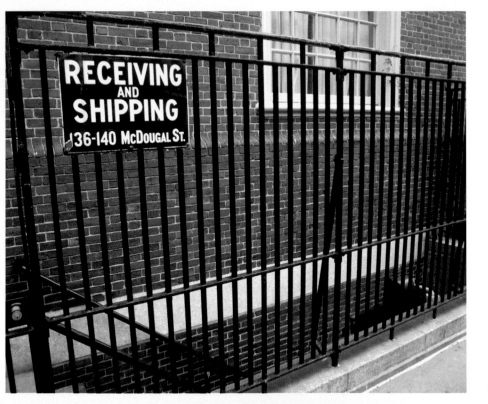

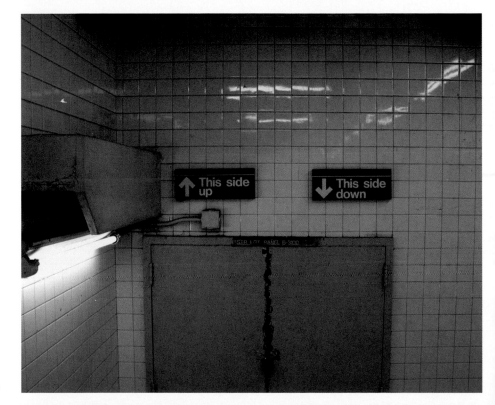

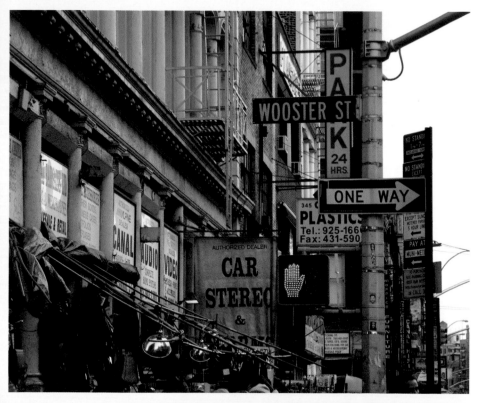

ÉRIC DUPUIS ✳ ONE WAY WOOSTER STREET / 2006

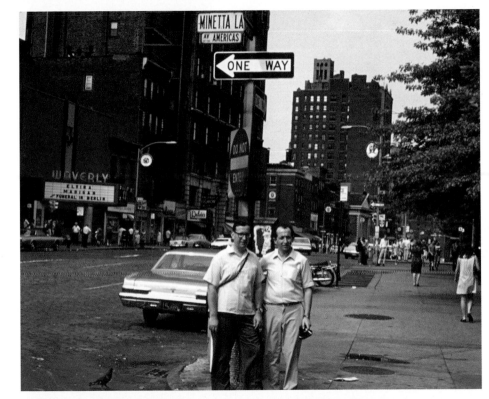

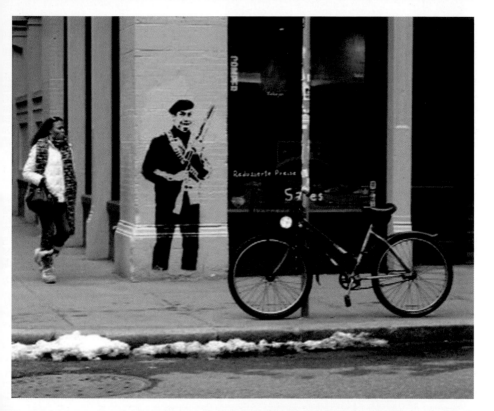

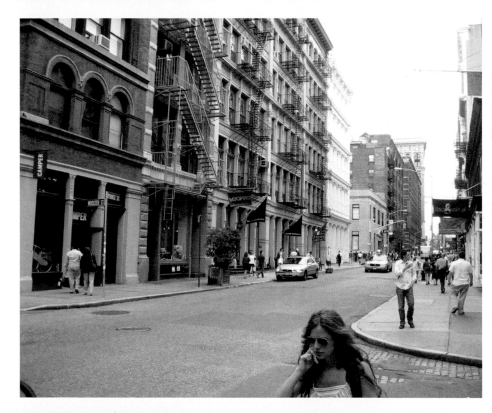

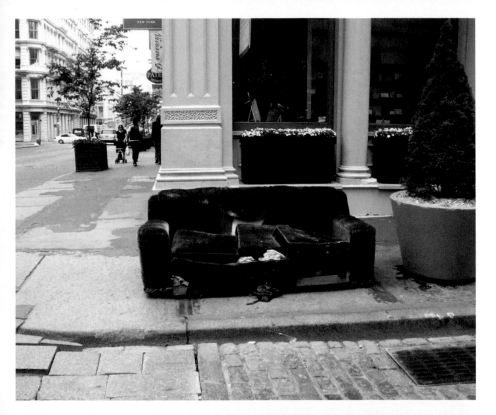

NICOLAS MIRGUET ✱ TAKE A SEAT / 2006

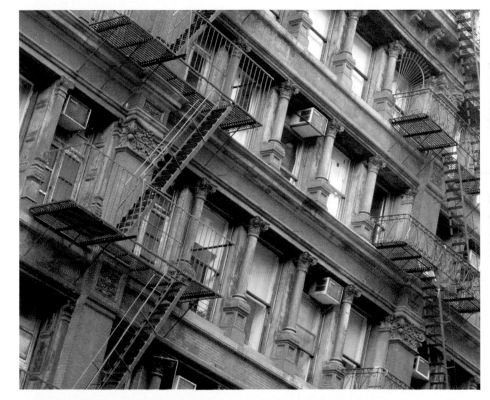

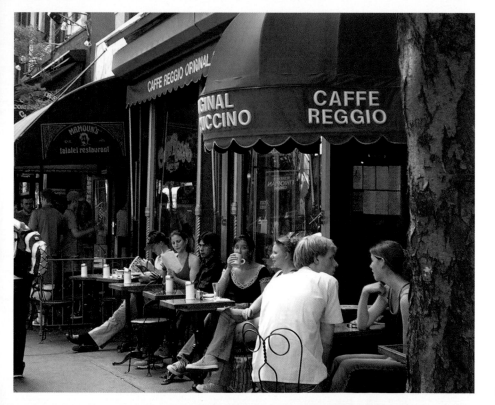

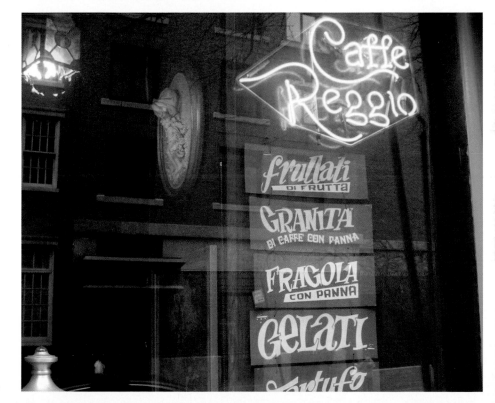

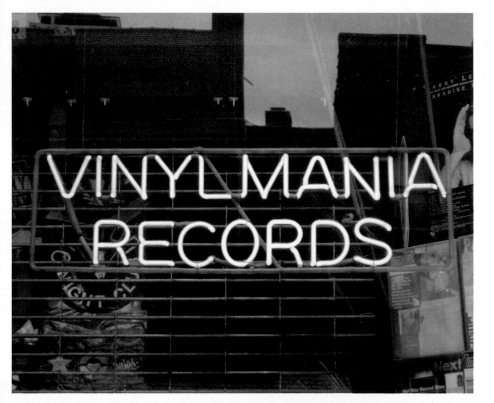

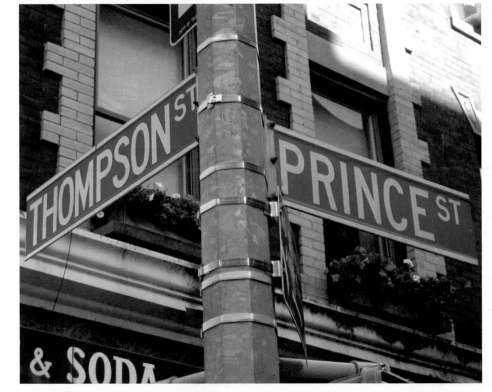

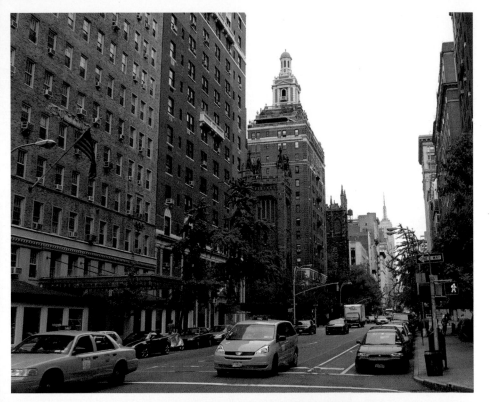

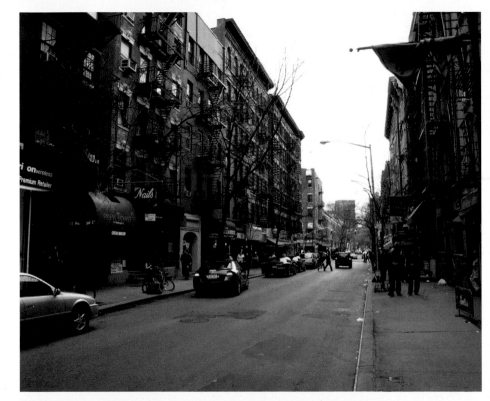

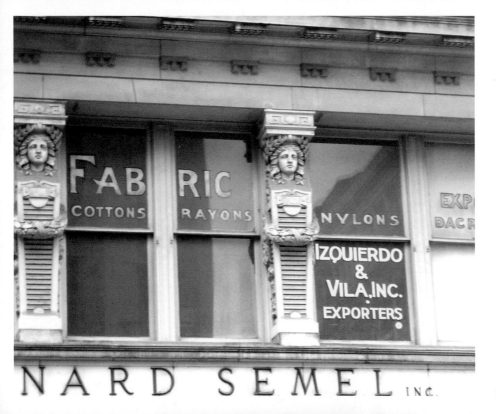

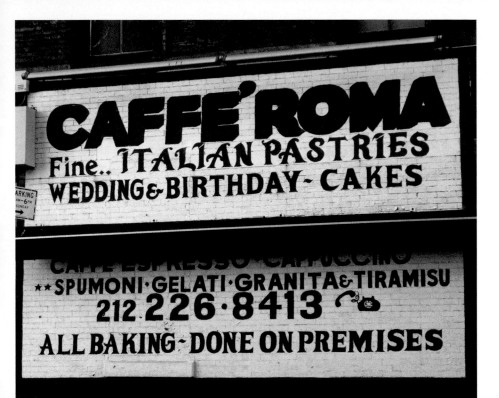

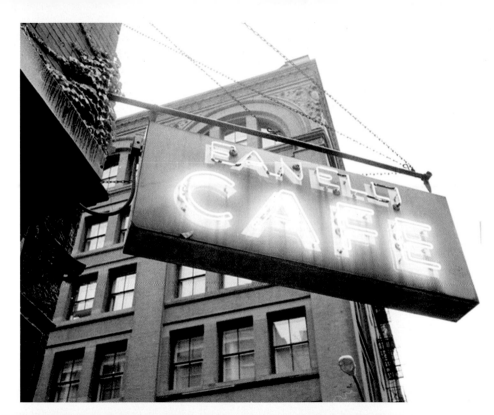

PABLO KOLODNY ✱ FANELLI'S CAFE / 2004

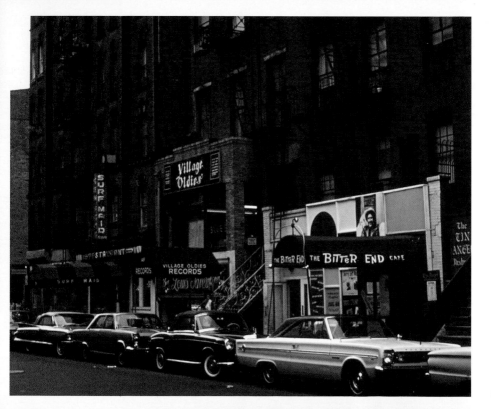

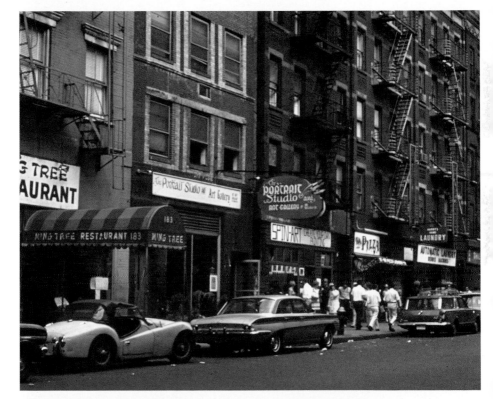

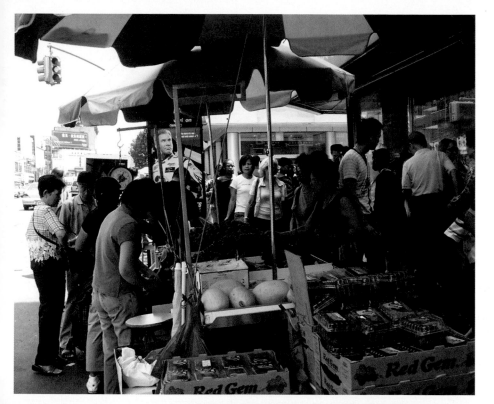

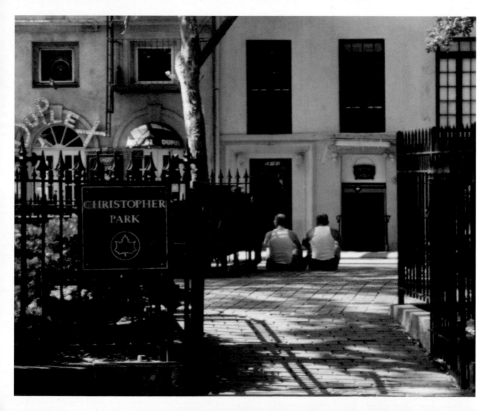

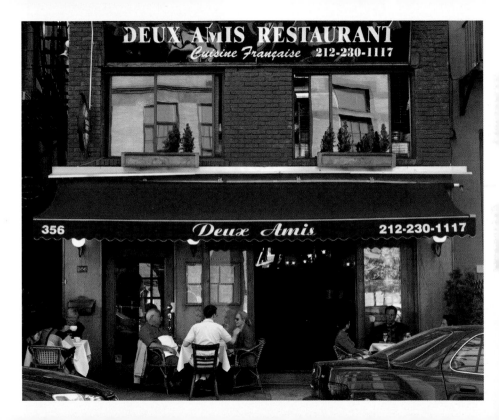

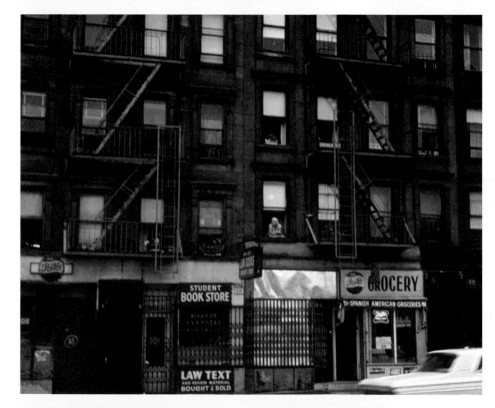

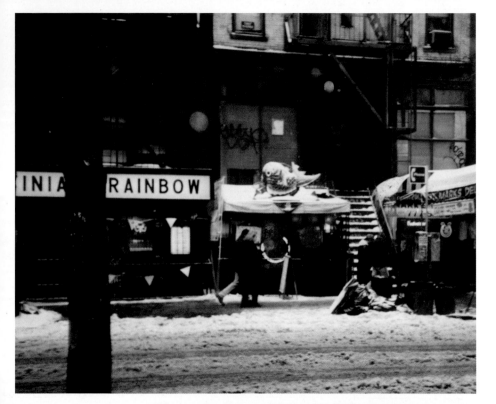

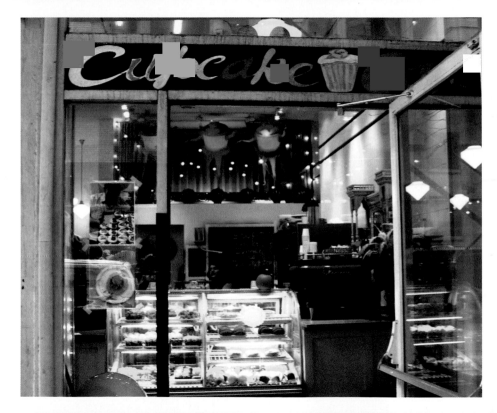

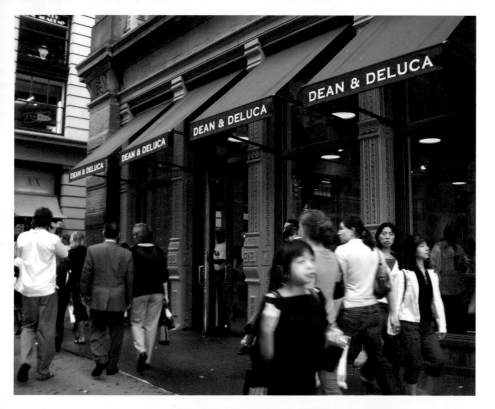

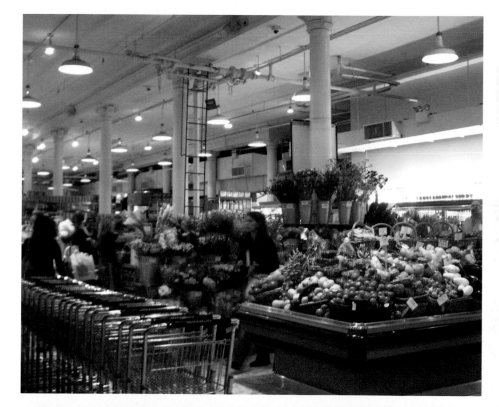

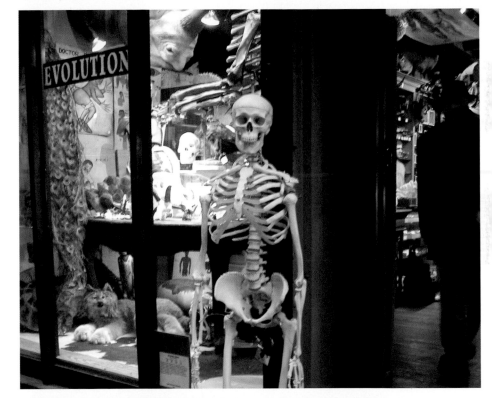

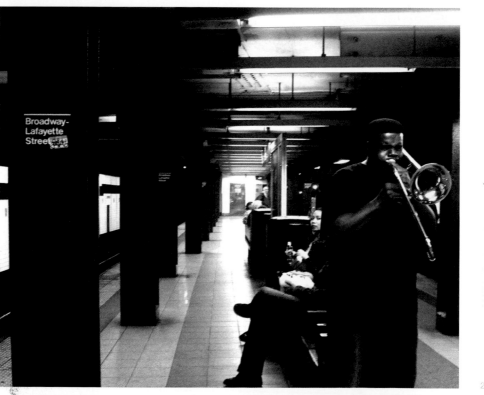

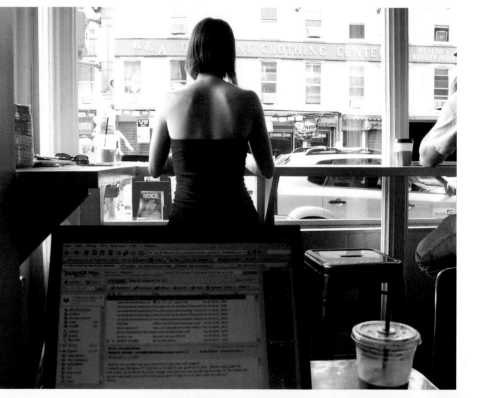

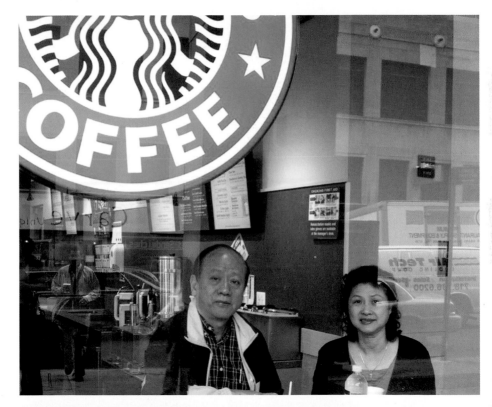

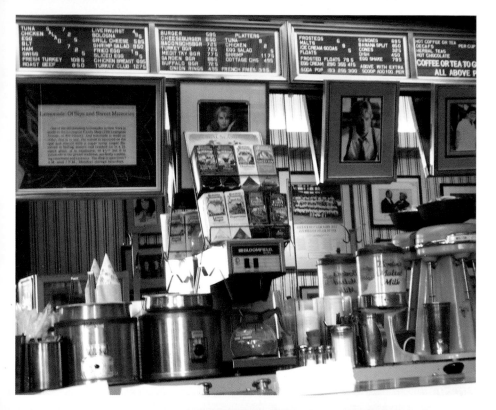

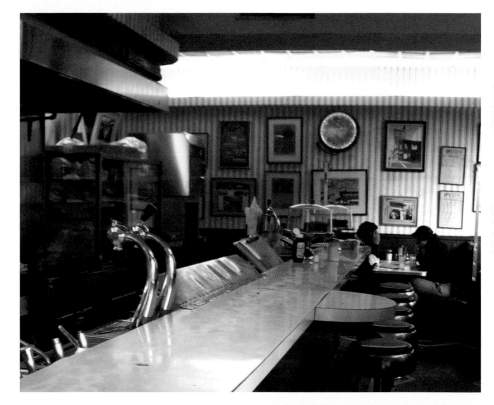

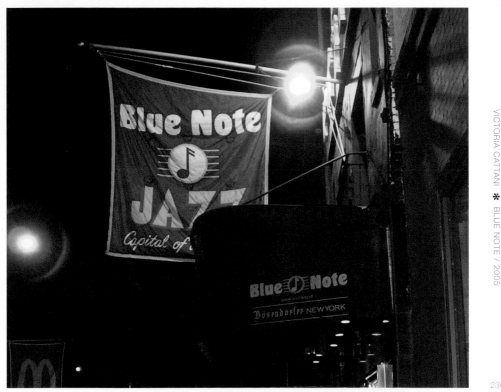

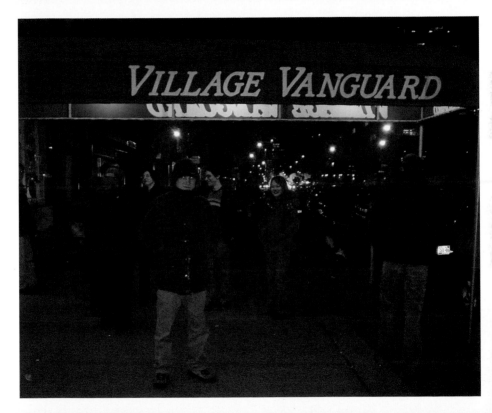

VICTORIA CATTANI ✱ JAZZ IN THE VILLAGE / 2005

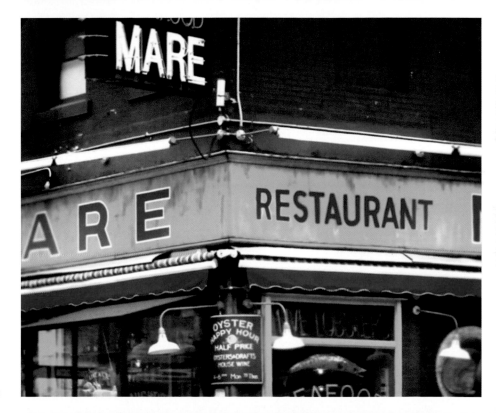

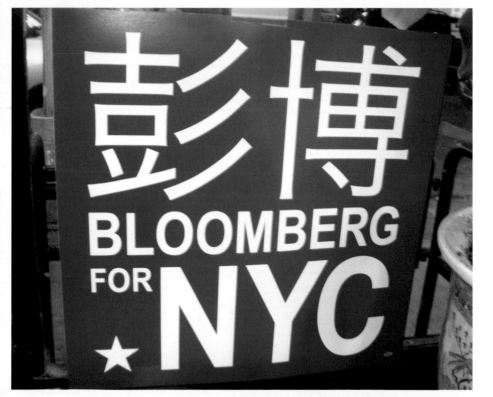

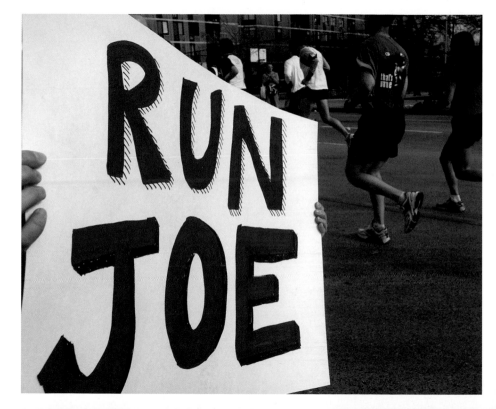

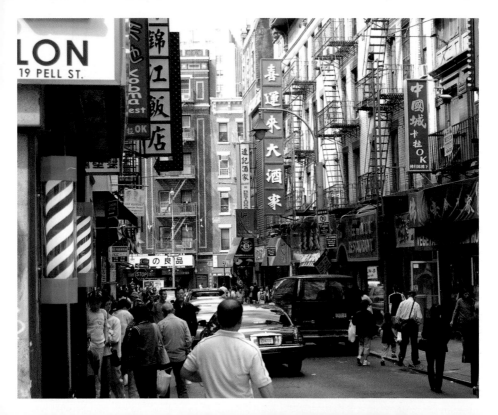

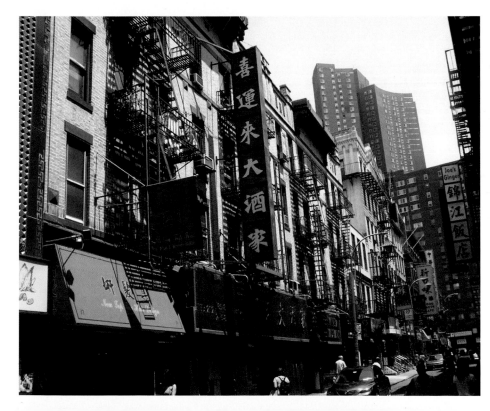

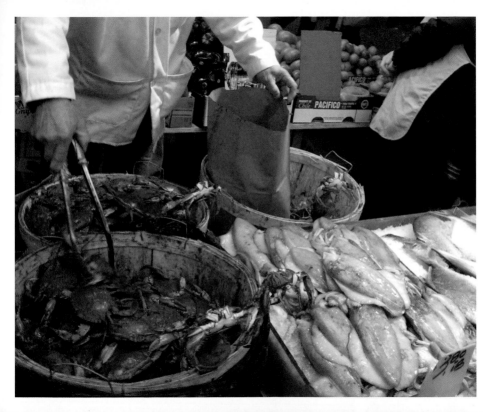

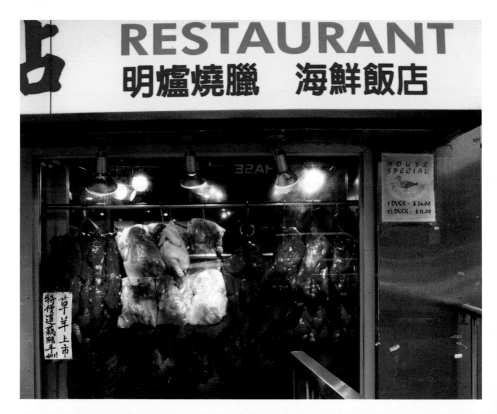

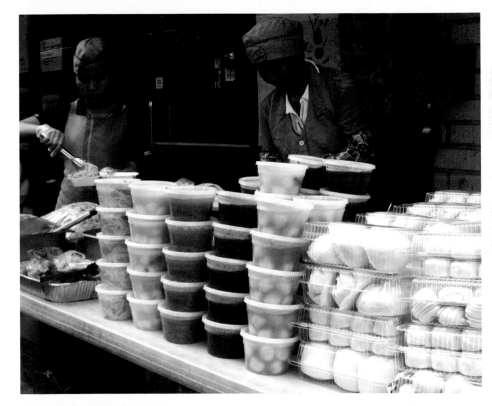

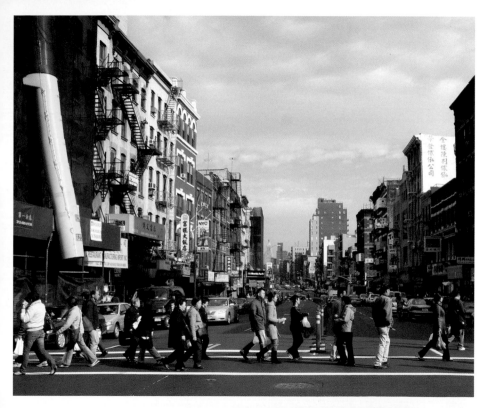

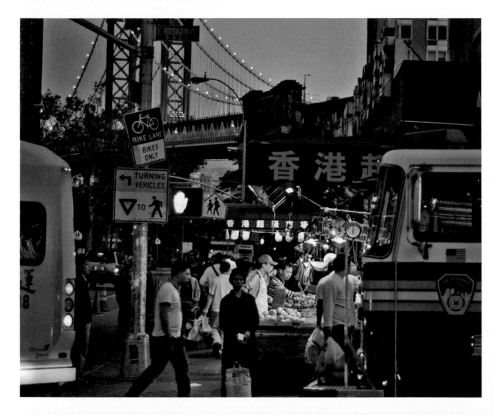

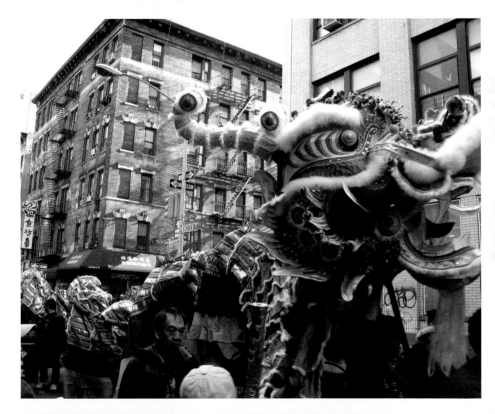

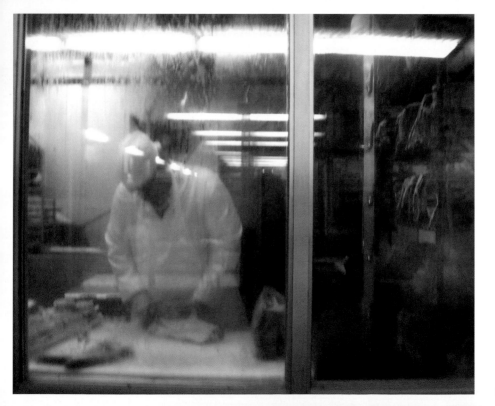

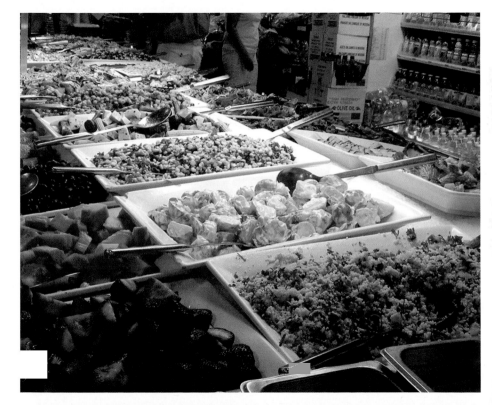

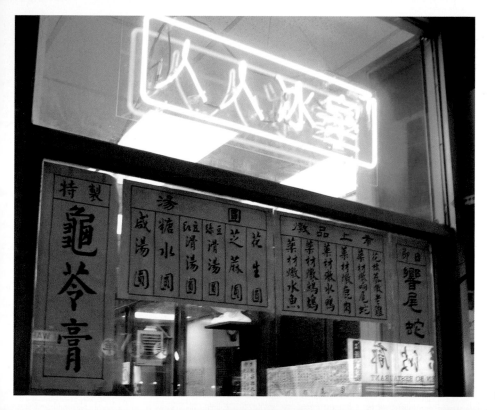

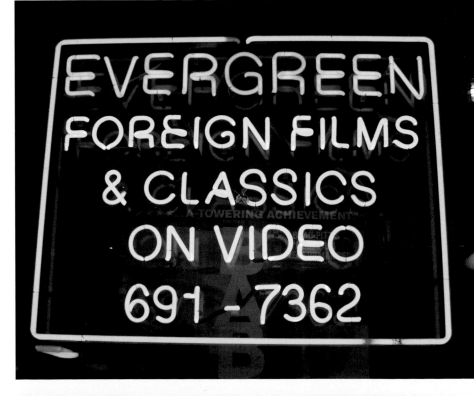

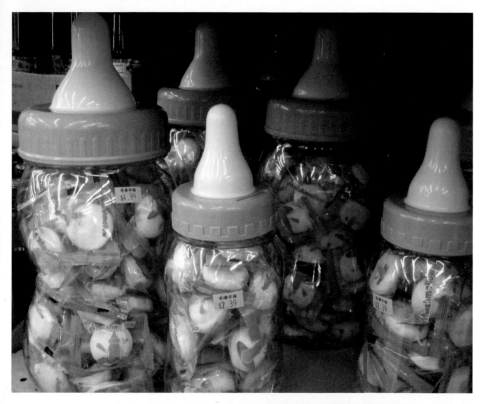

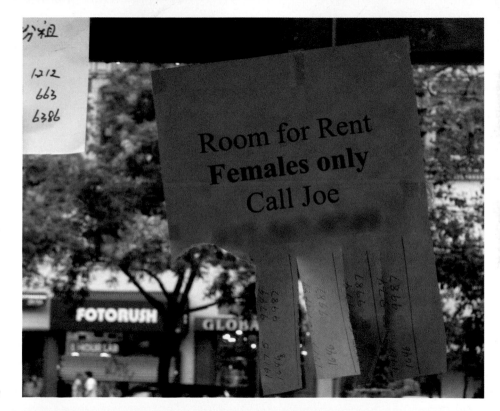

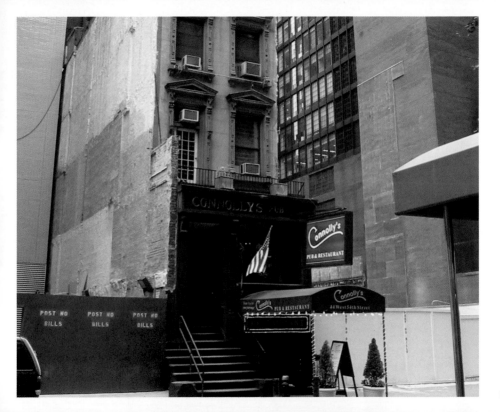

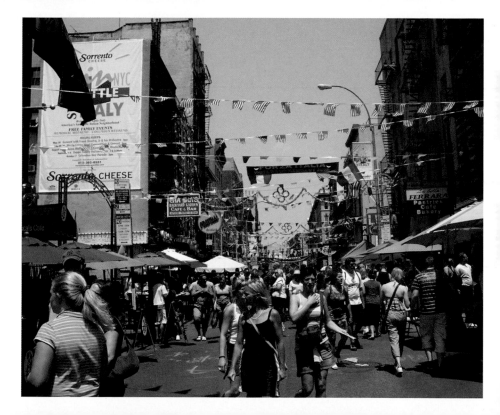

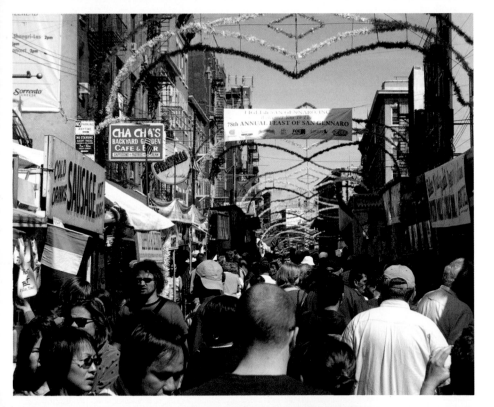

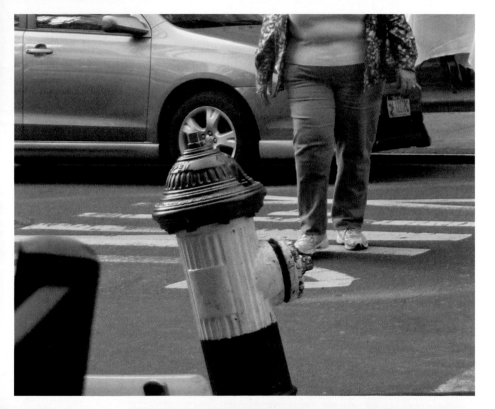

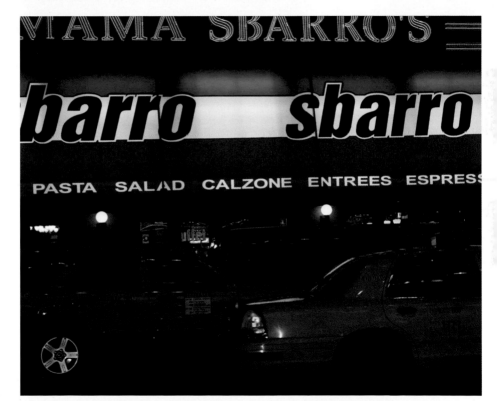

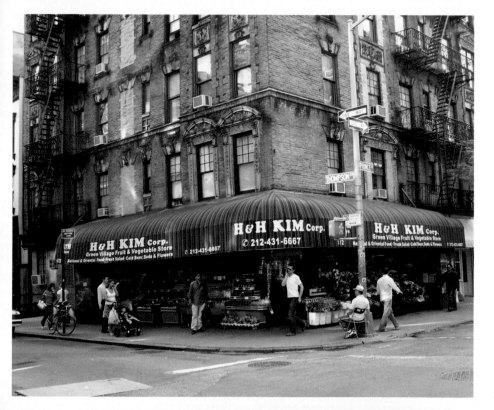

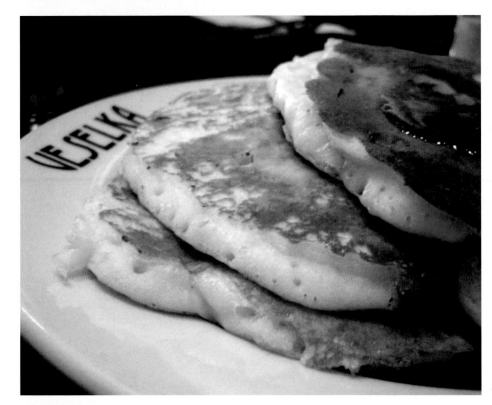

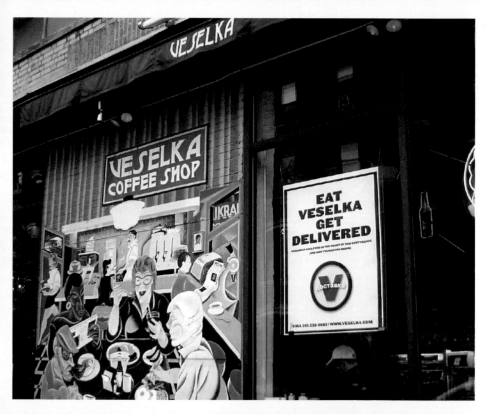

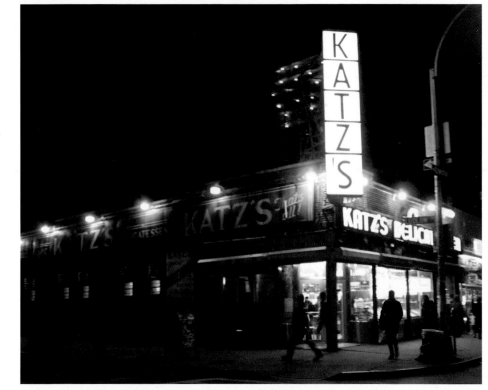

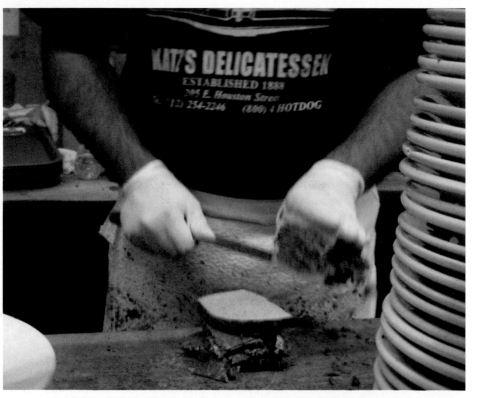

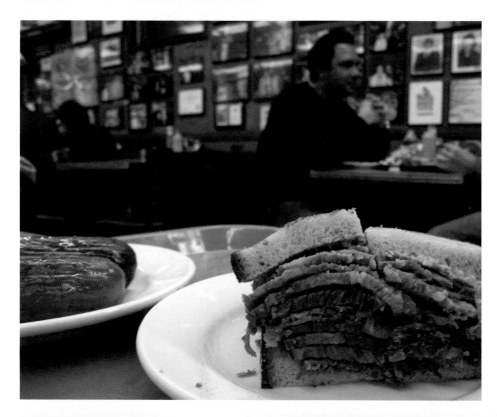

CHIE SHIMODA RA ✳ KATZ'S DELICATESSEN / 2006

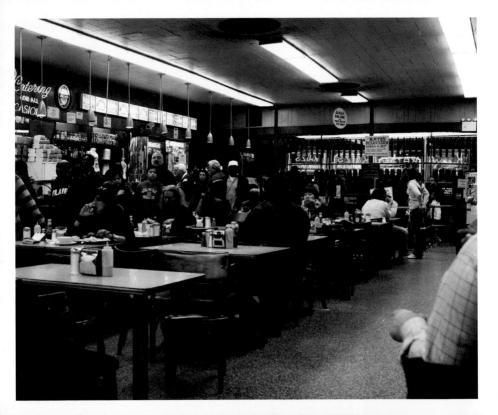

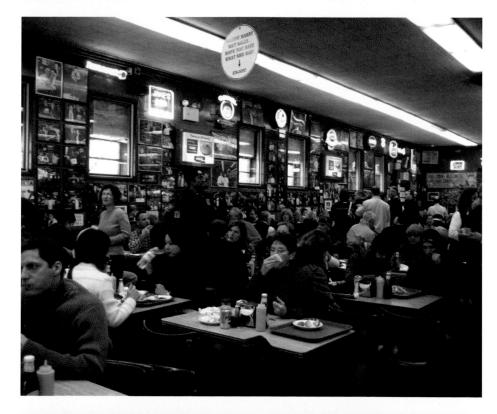

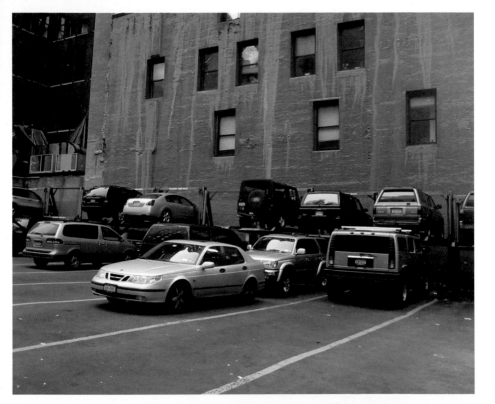

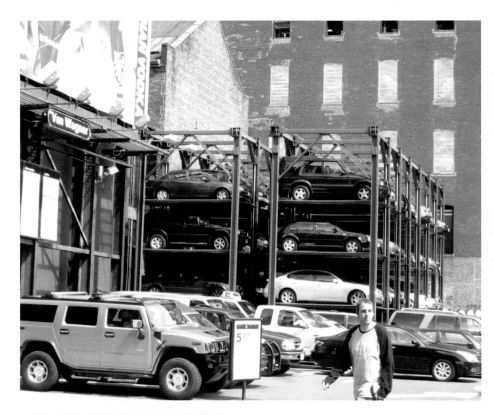

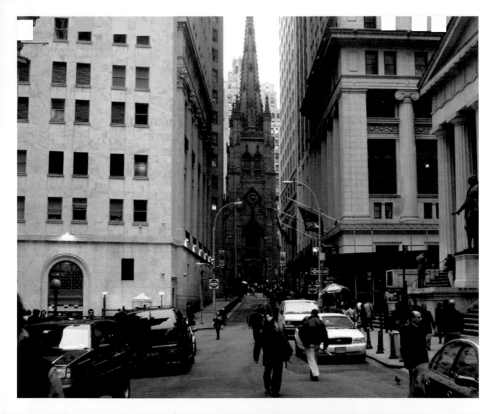

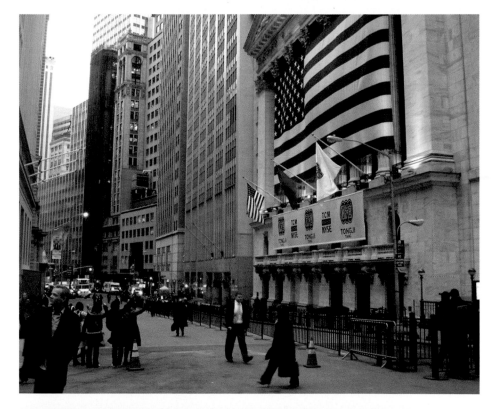

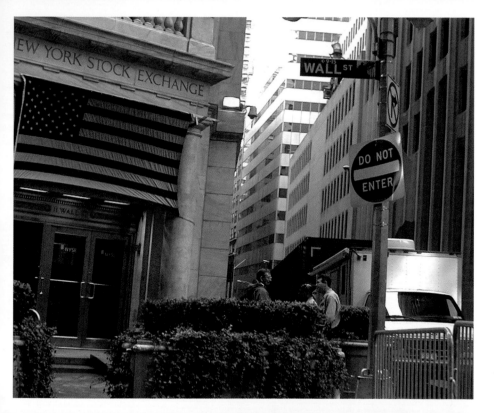

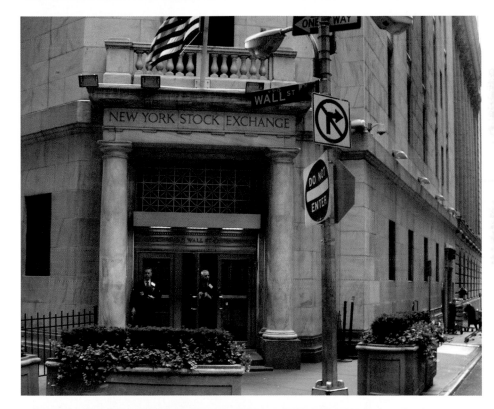

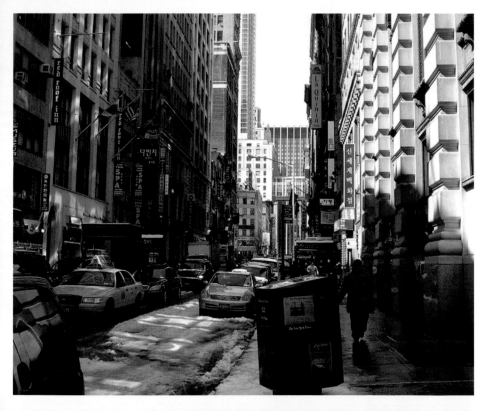

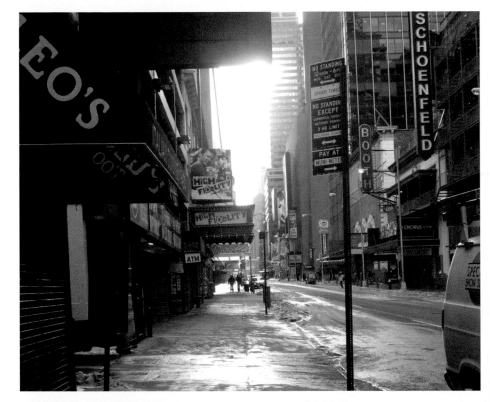

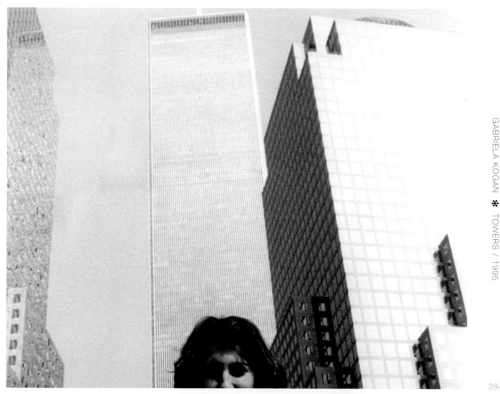

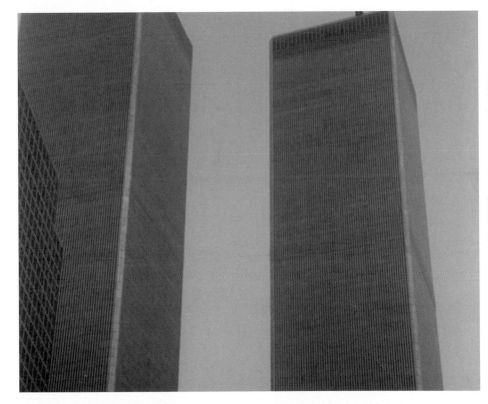

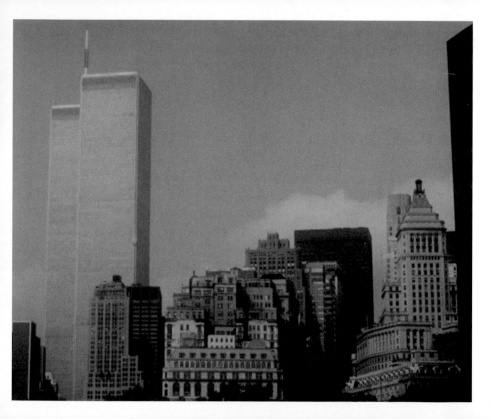

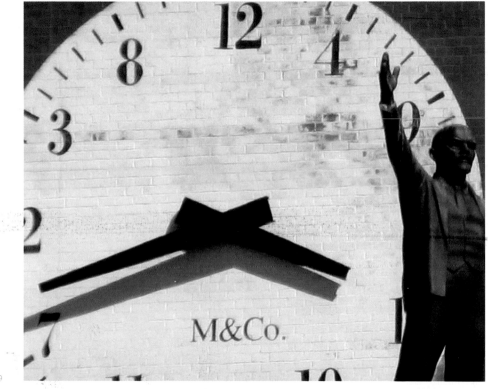

RANDY LEVINE ✱ LENIN & CLOCK / 2006

M&Co.

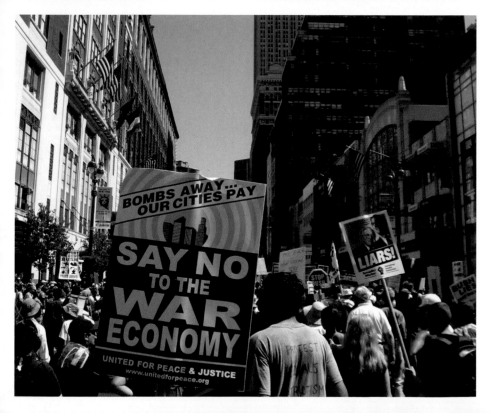

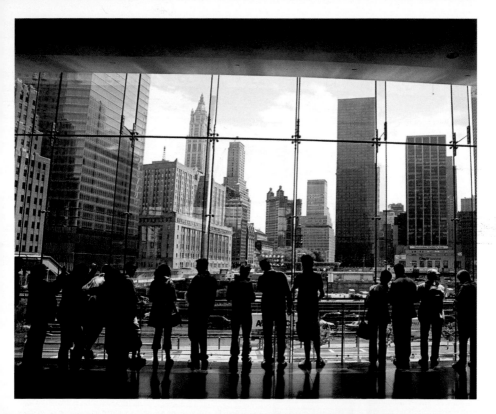

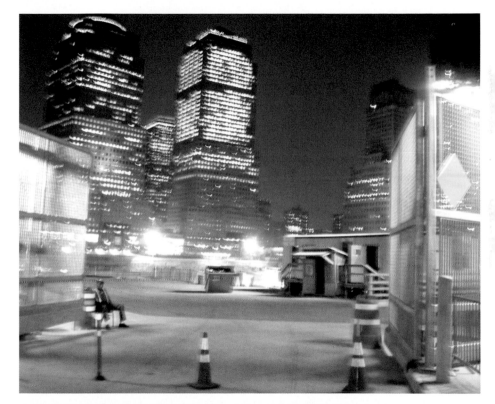

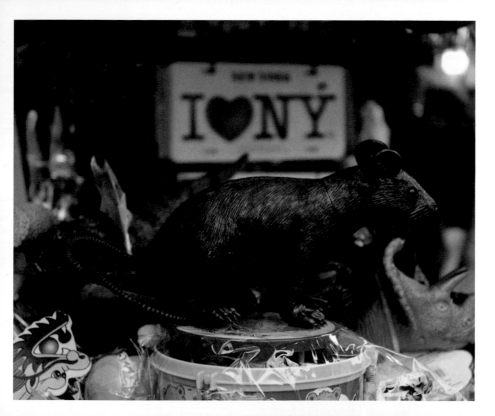

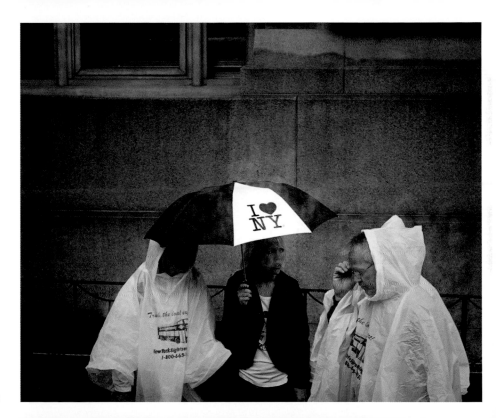

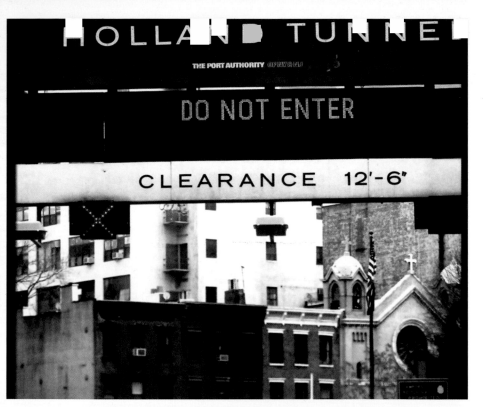

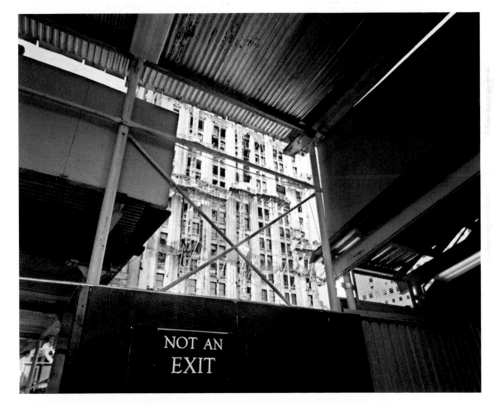

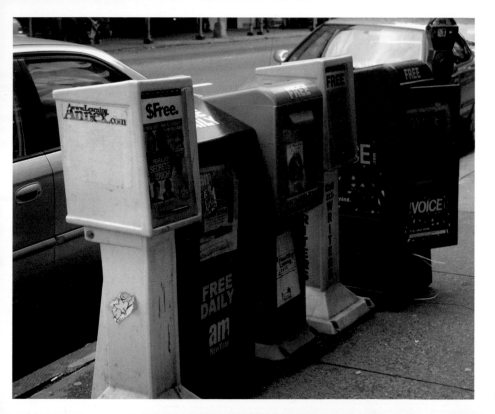

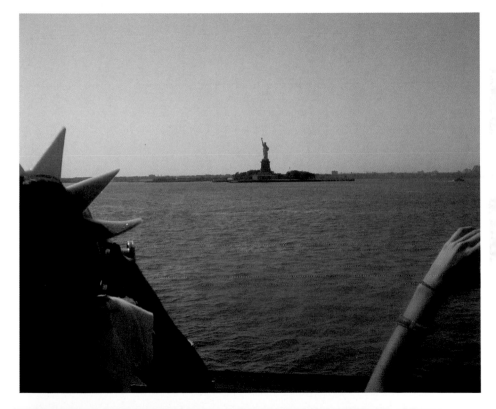

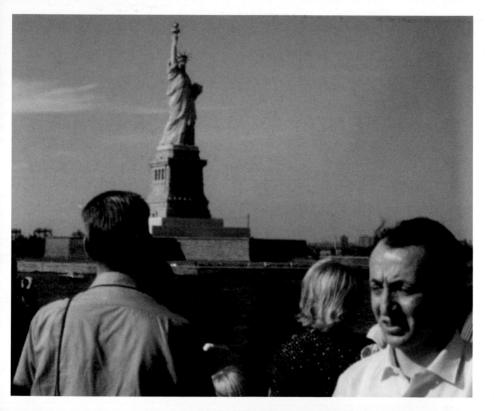

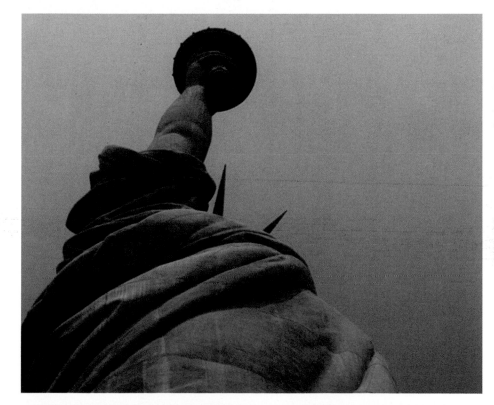

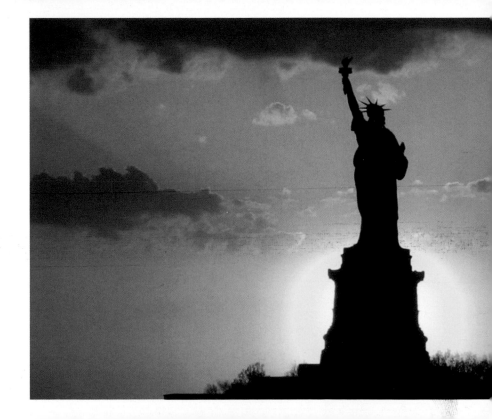

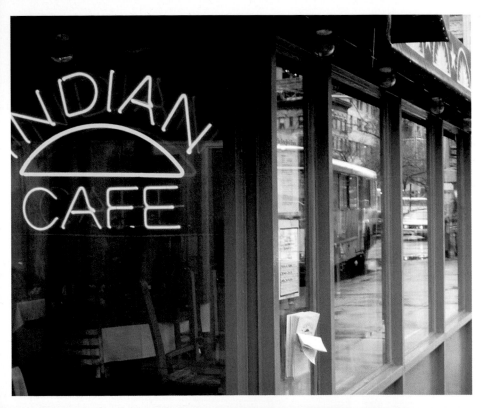

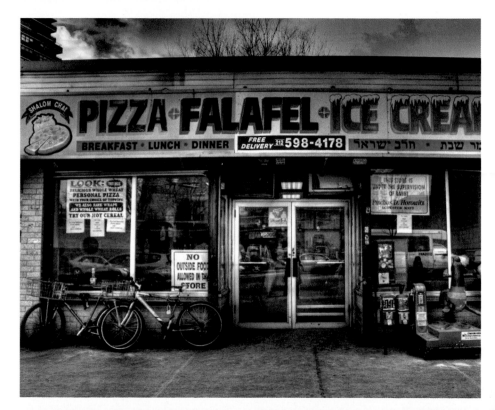

ANDREW LACHANCE ✳ PIZZA FALAFEL ICE CREAM / 20C7

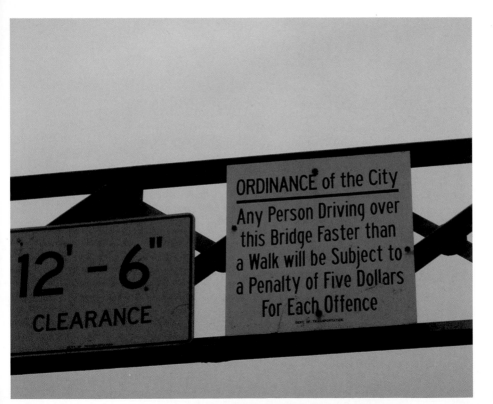

12' - 6"
CLEARANCE

ORDINANCE of the City
Any Person Driving over
this Bridge Faster than
a Walk will be Subject to
a Penalty of Five Dollars
For Each Offence

DEPT. OF TRANSPORTATION

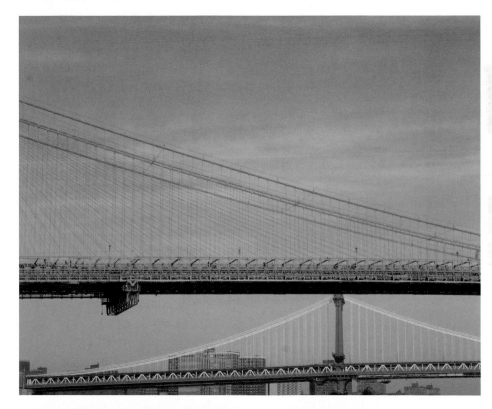

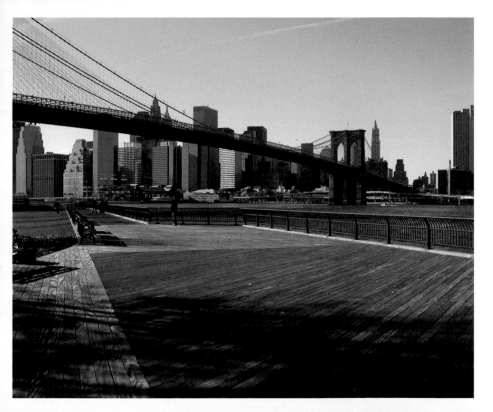

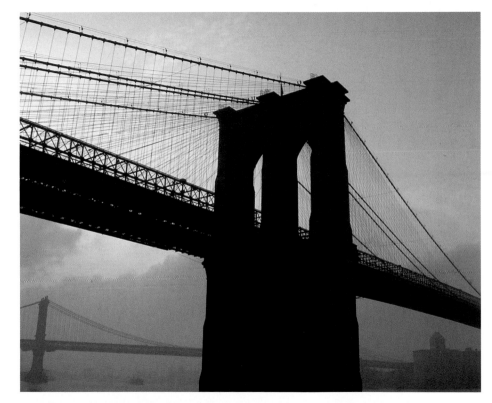

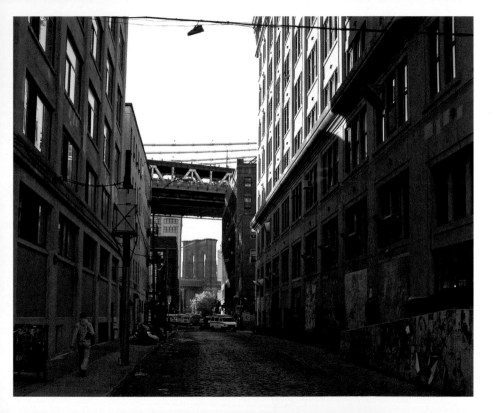

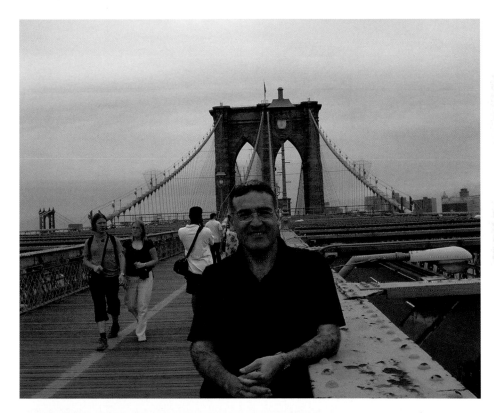

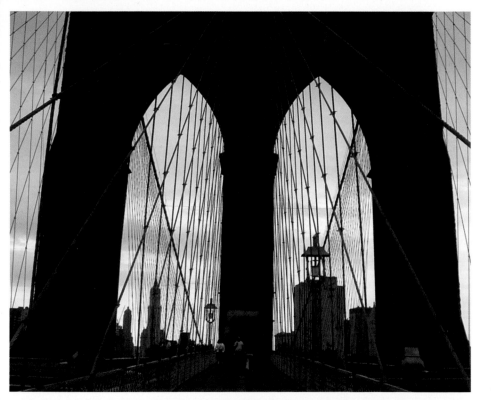

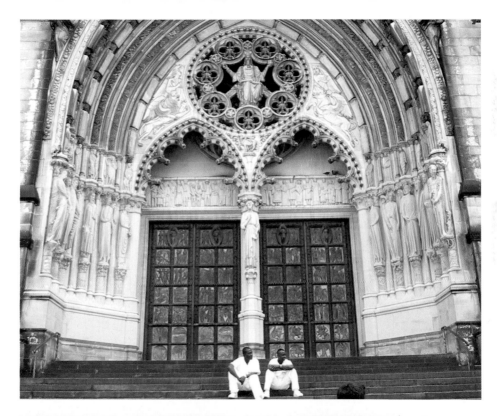

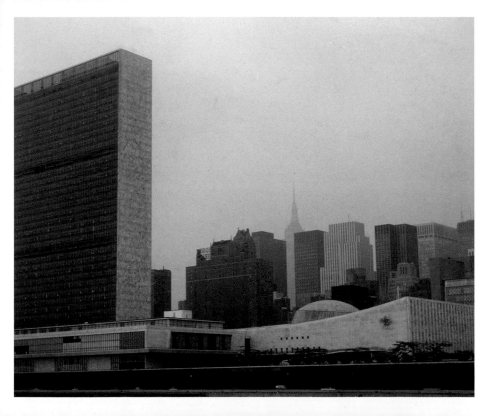

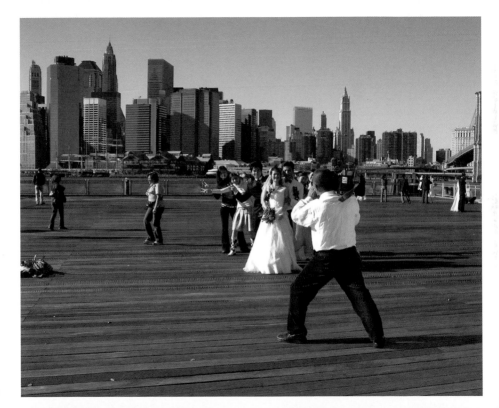

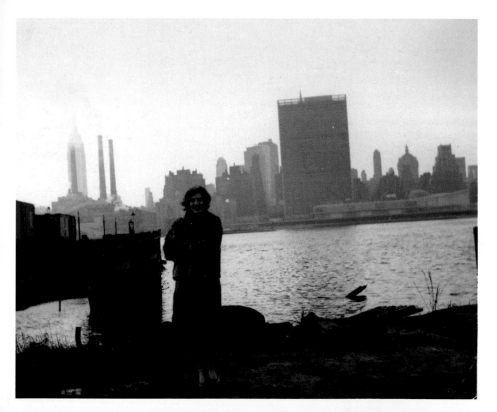

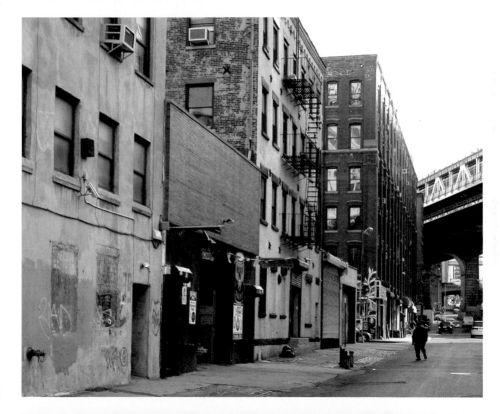

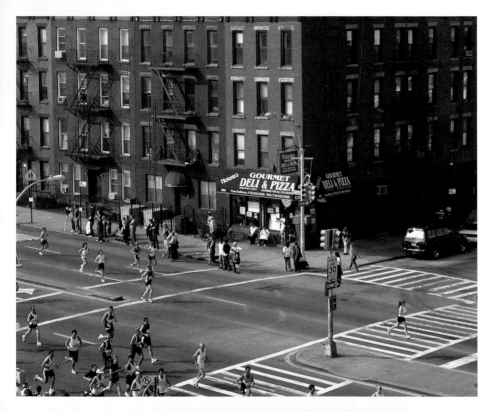

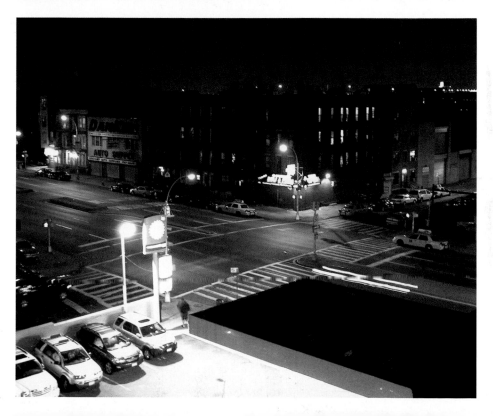

PABLO KOLODNY ✱ BROOKLYN / 2004

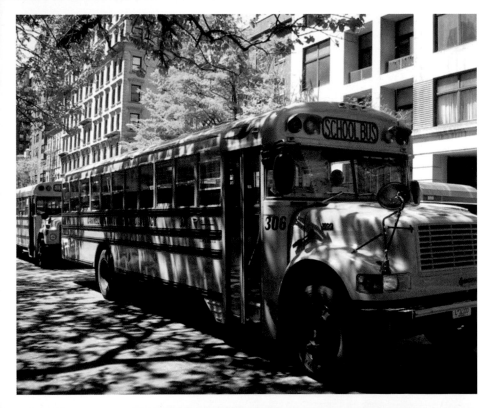

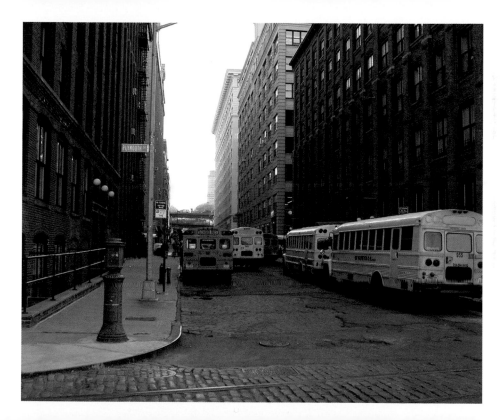

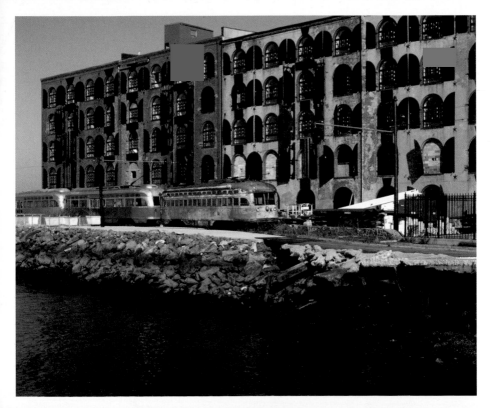

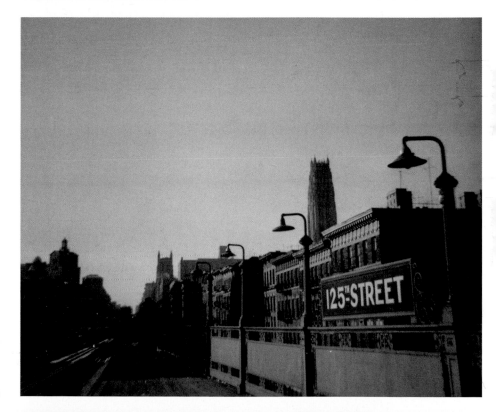

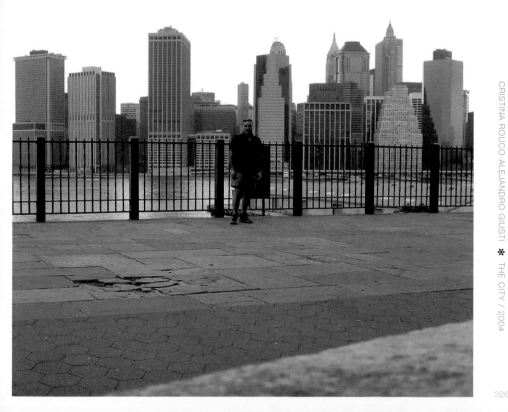

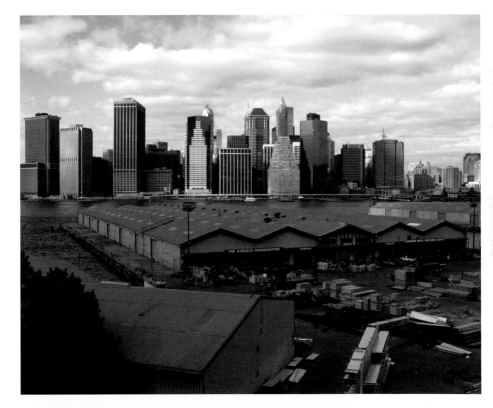

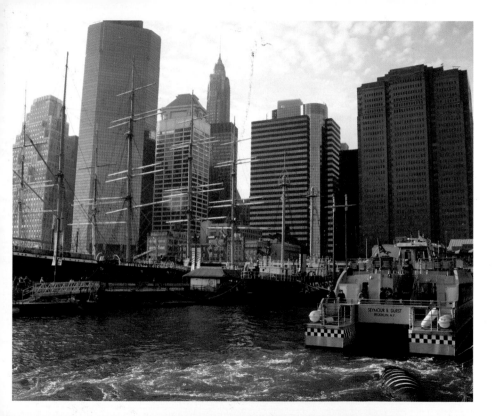

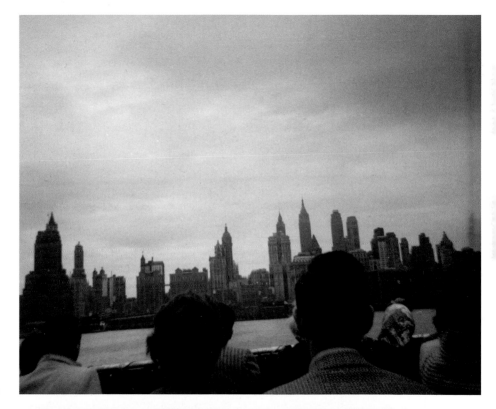

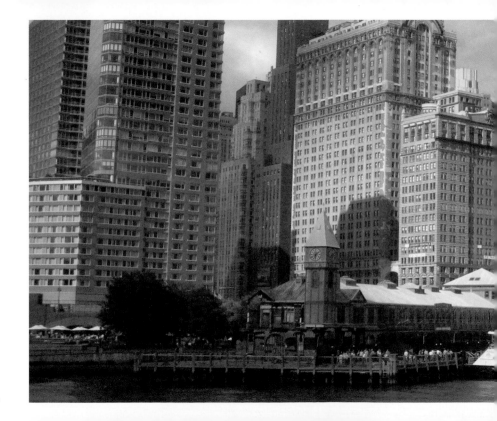

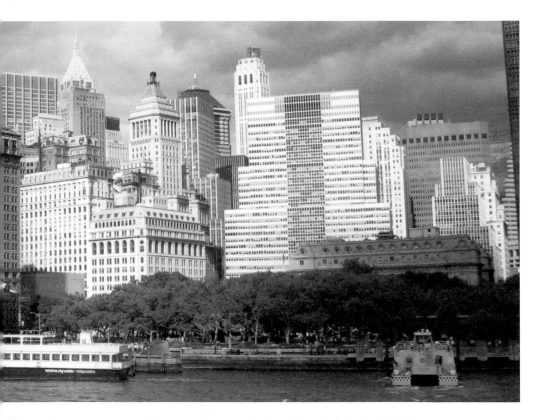

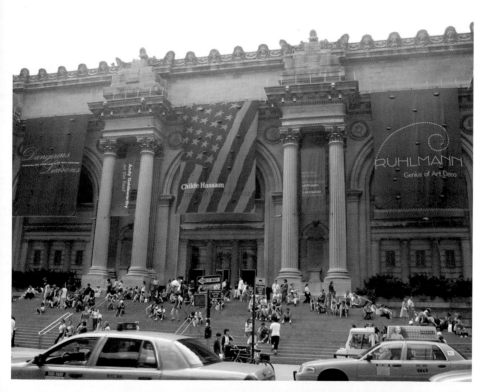

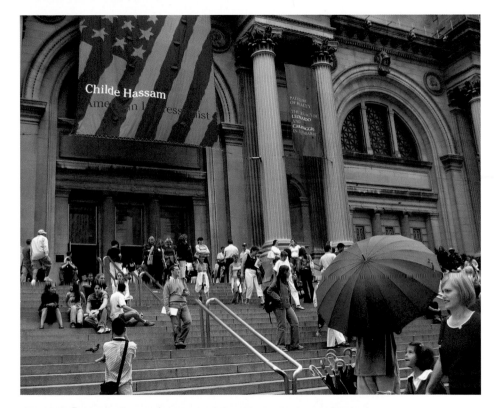

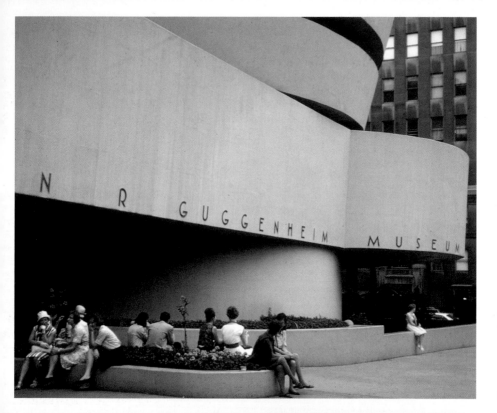

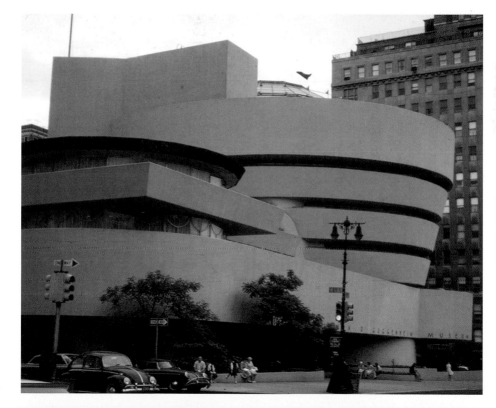

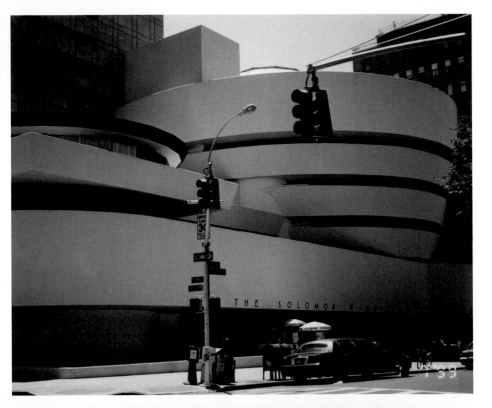

THE SOLOMON R

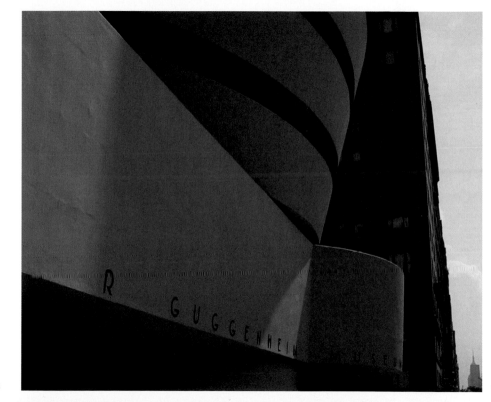

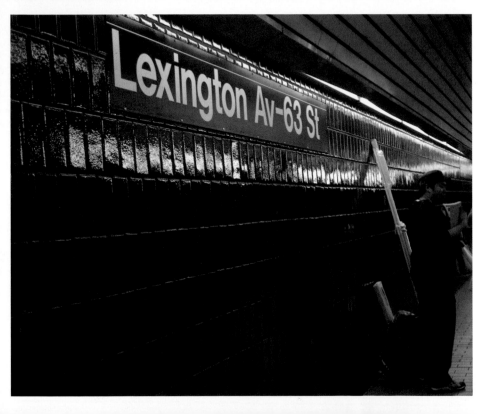

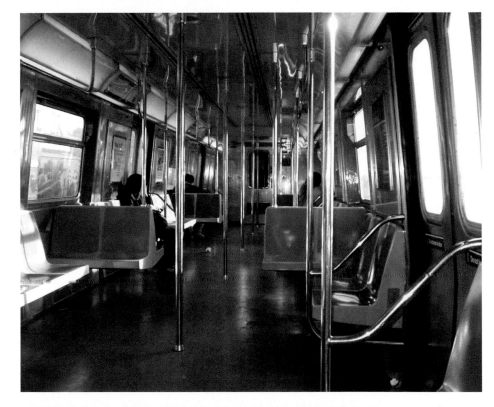

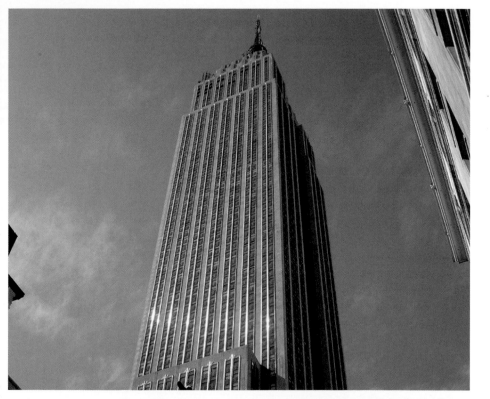

344

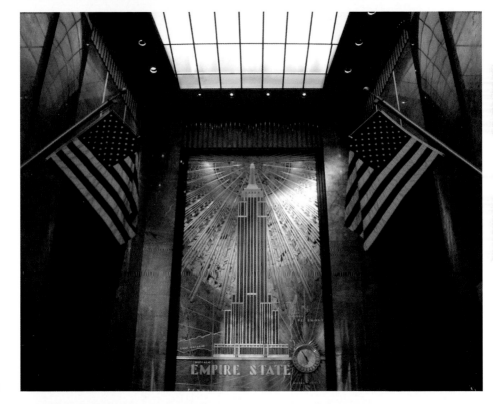

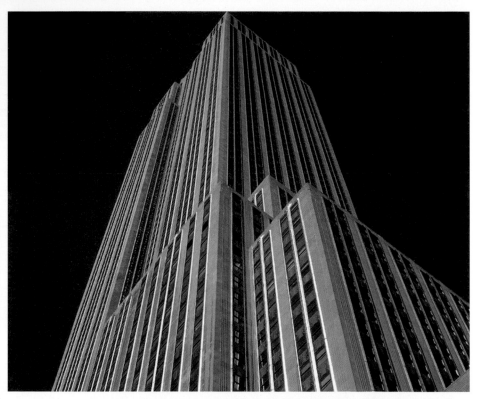

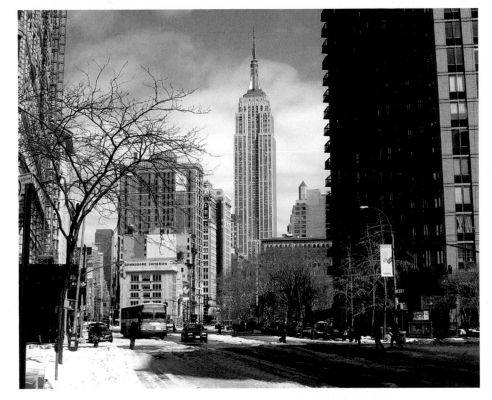

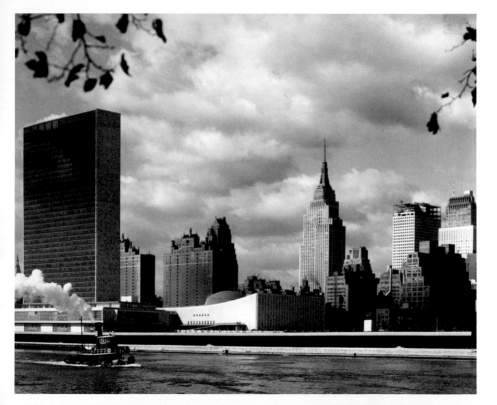

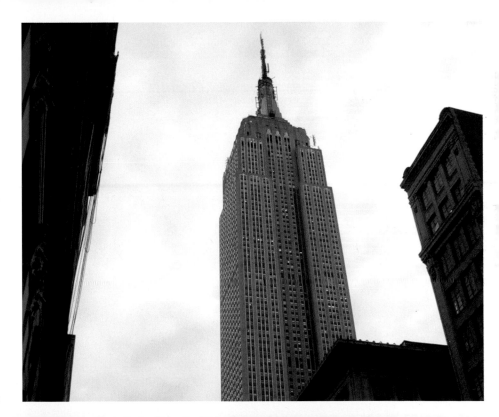

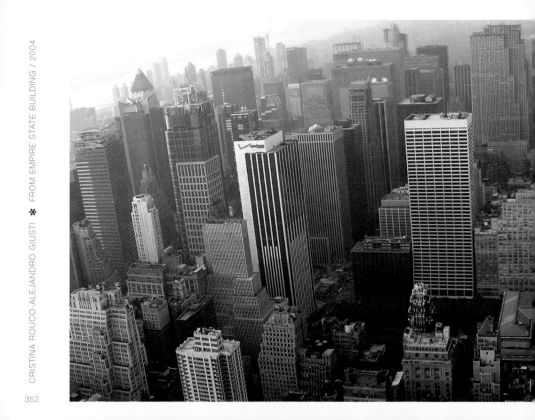

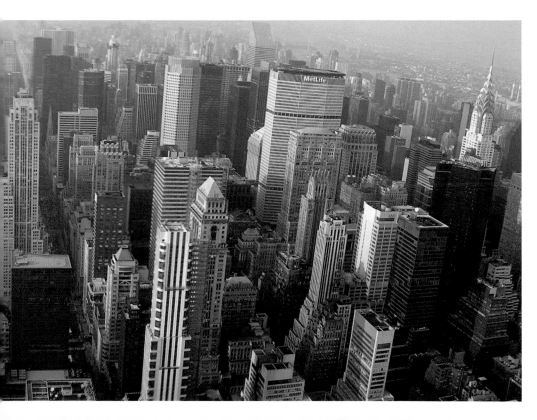

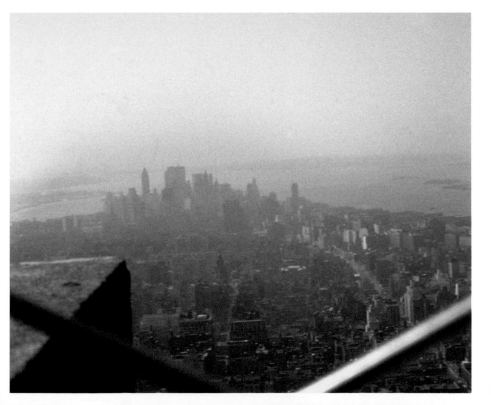

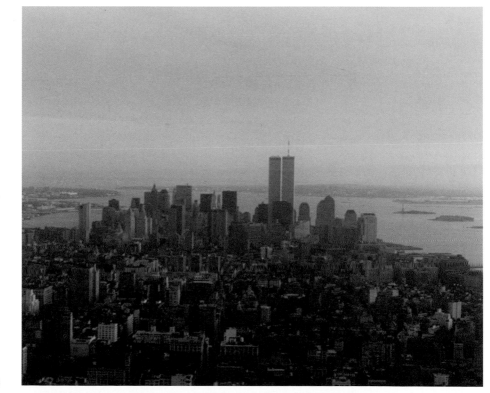

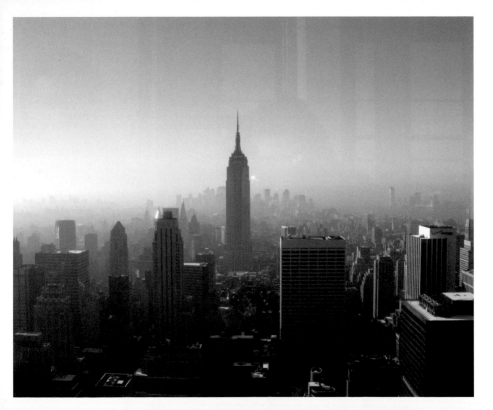

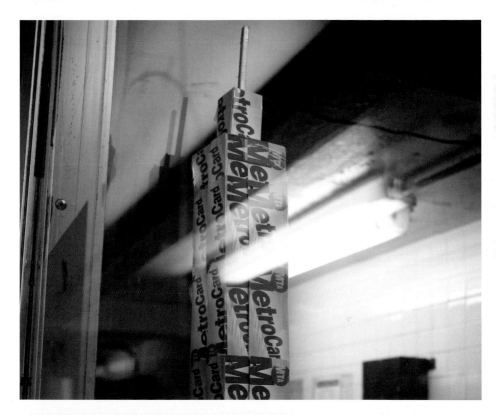

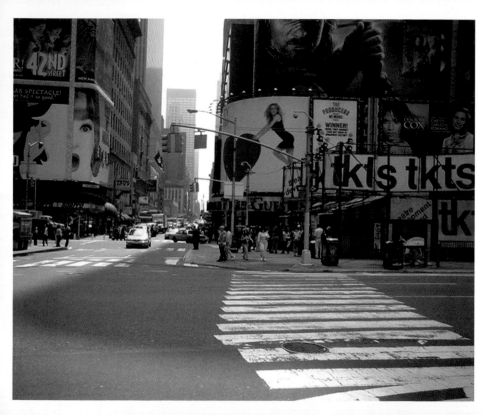

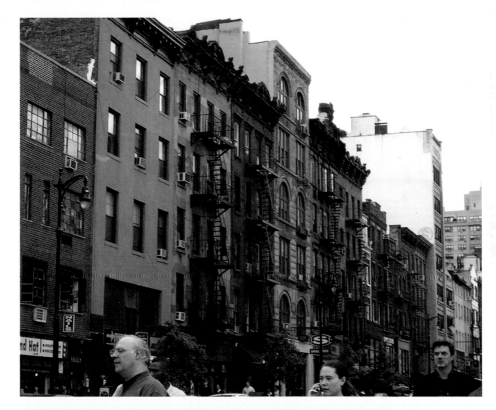

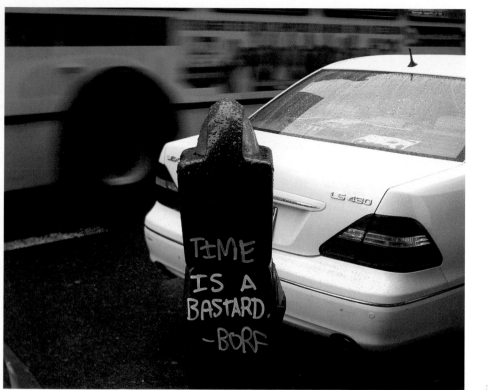

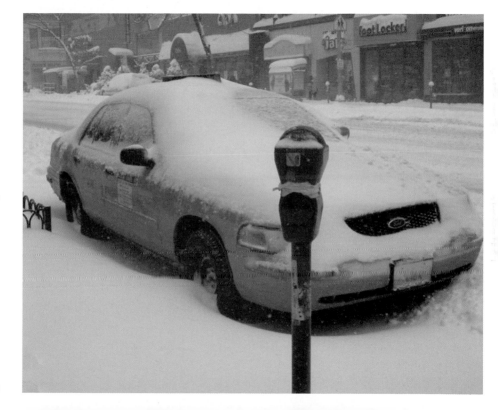

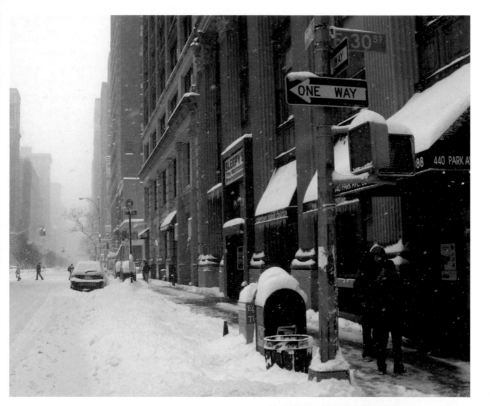

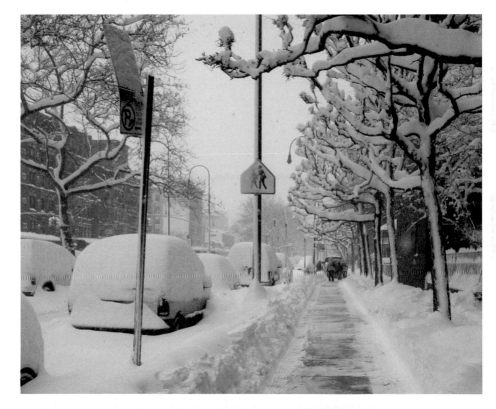

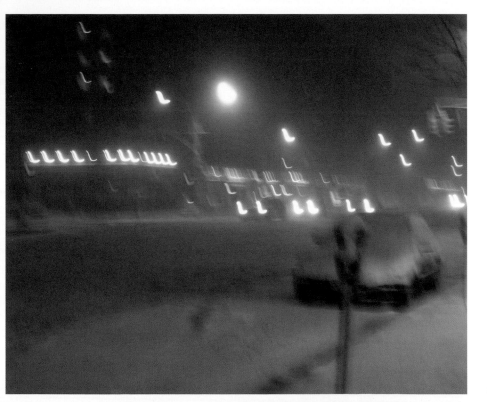

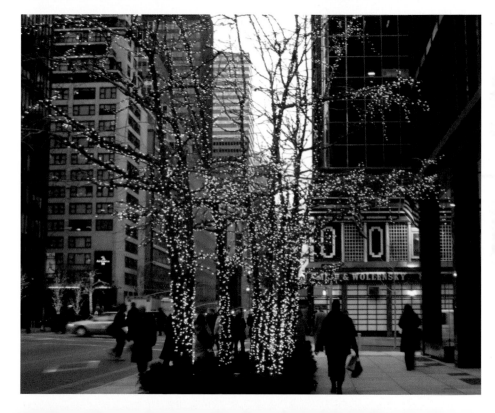

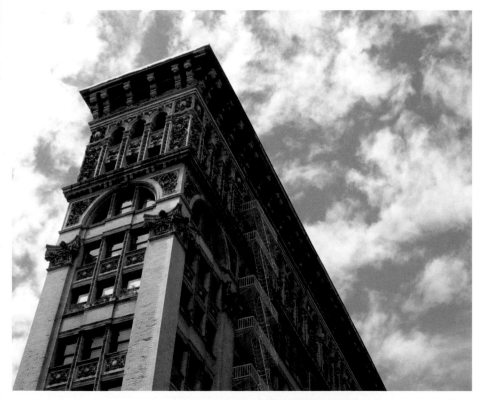

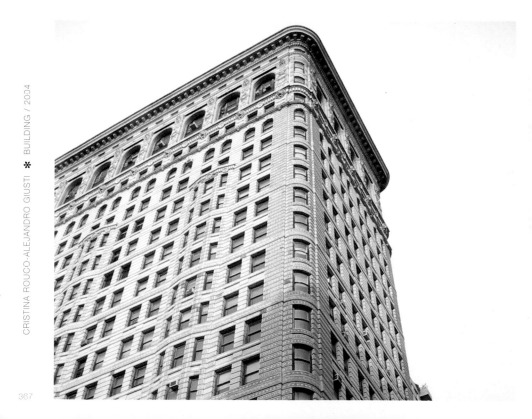

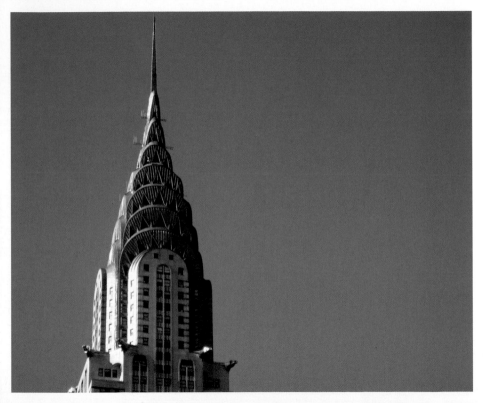

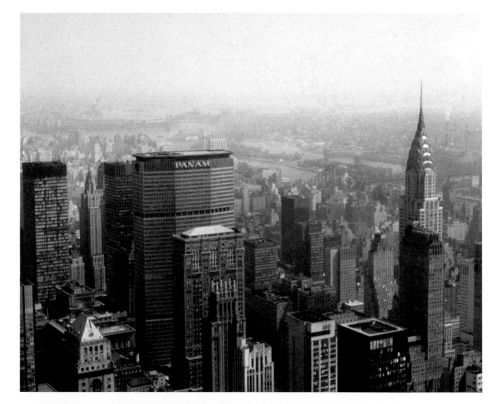

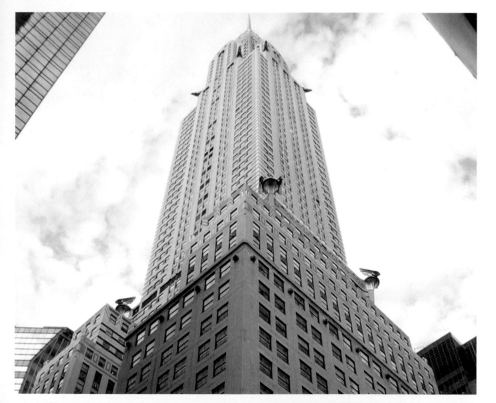

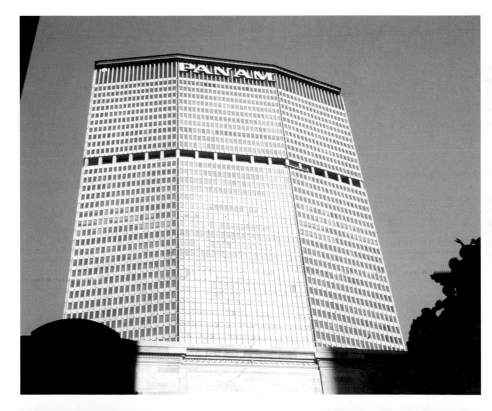

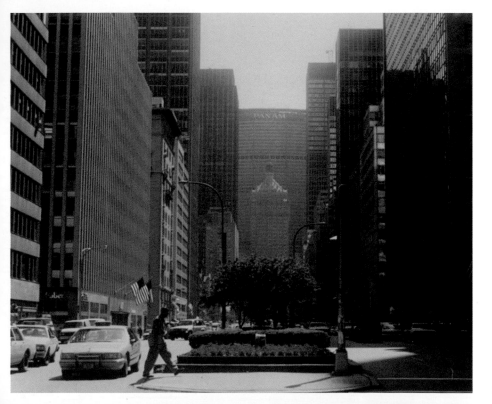

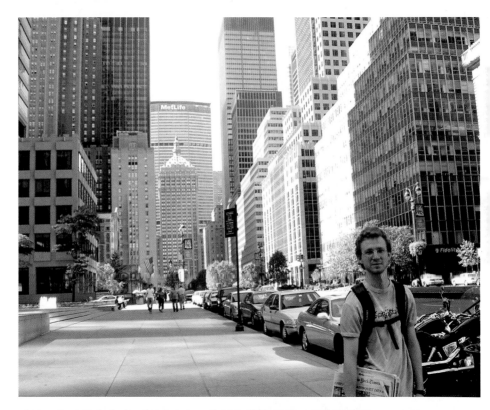

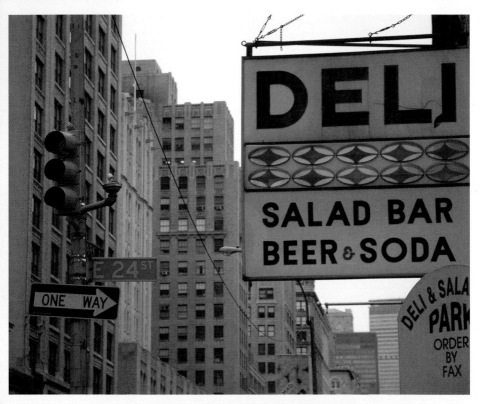

SHANE STROUD ✳ PARK AVENUE DELI / 2005

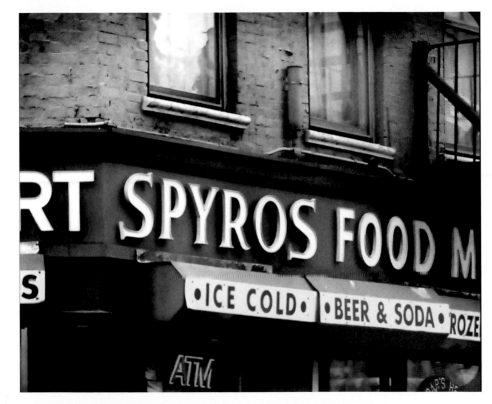

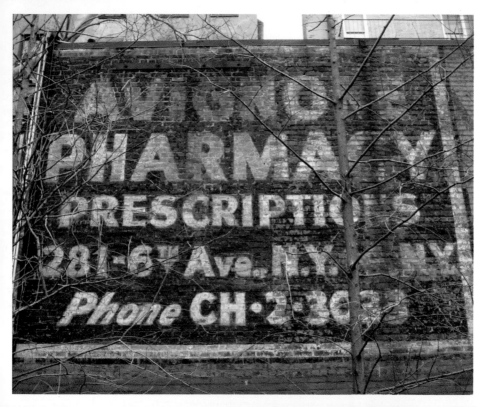

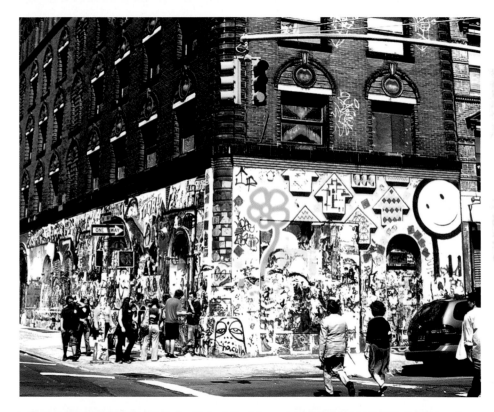

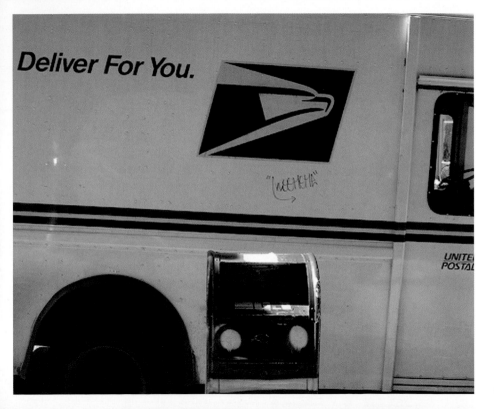

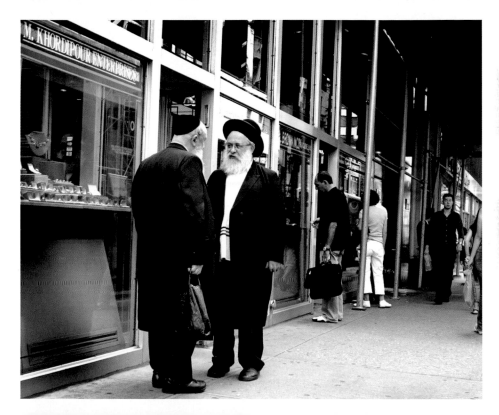

TIFFANY JONES ✳ STREET BIZ CHAT / 2005

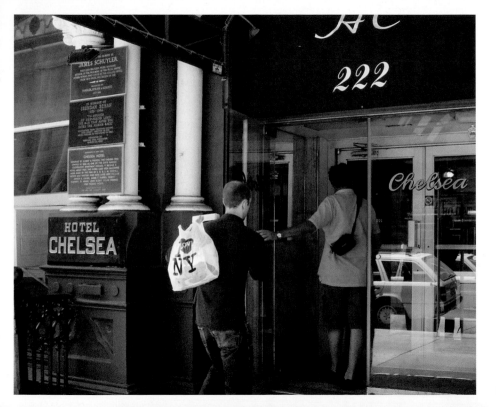

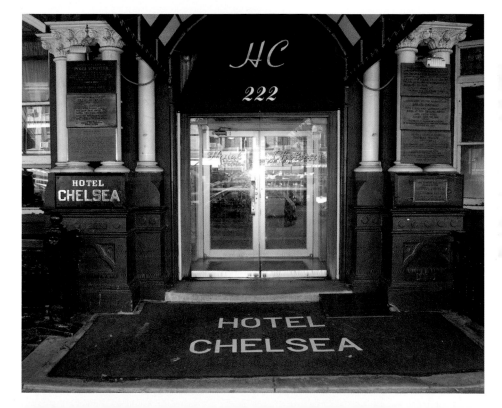

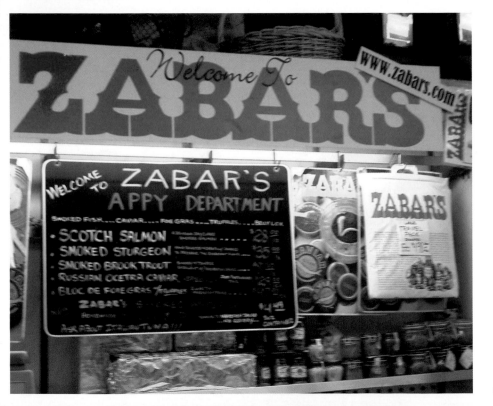

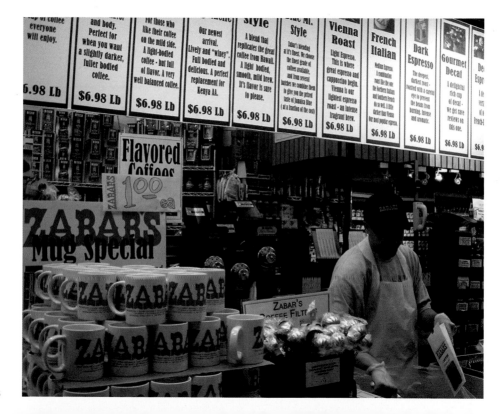

FUJIMIKA NAGANO ✳ ZABAR'S / 2006

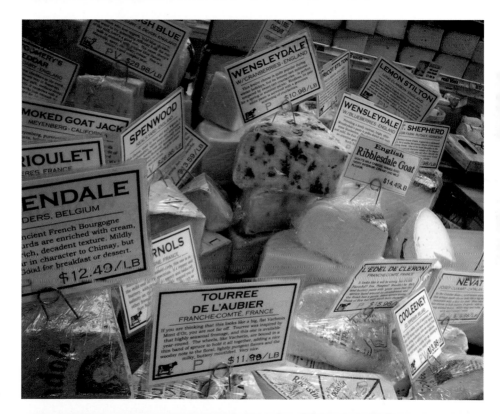

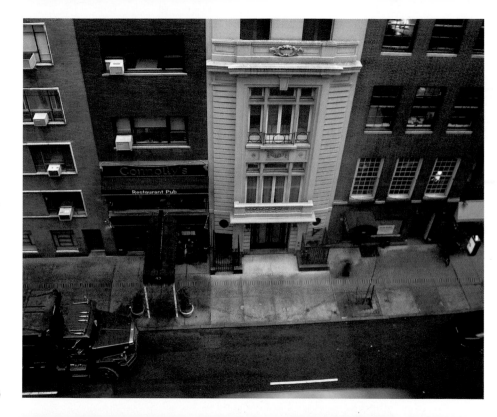

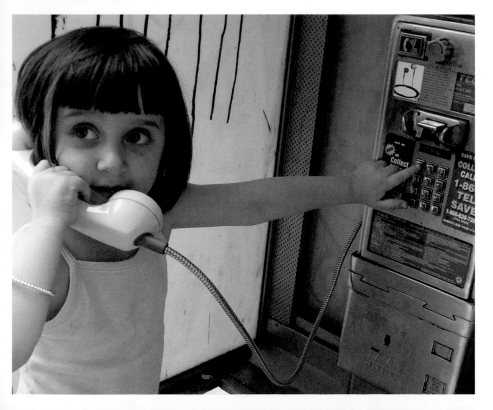

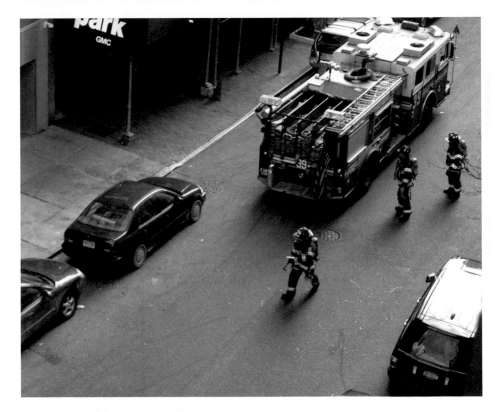

EDA STRAUCH ✳ THE EARLY BIRD GETS THE WORM / 2005

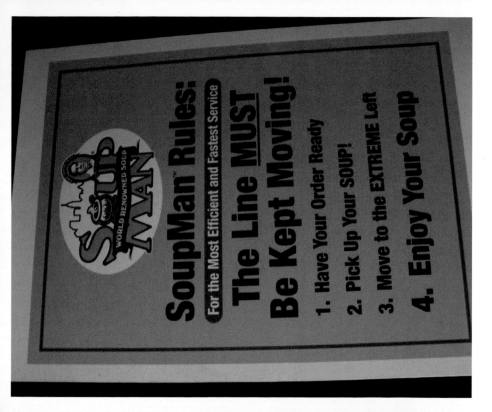

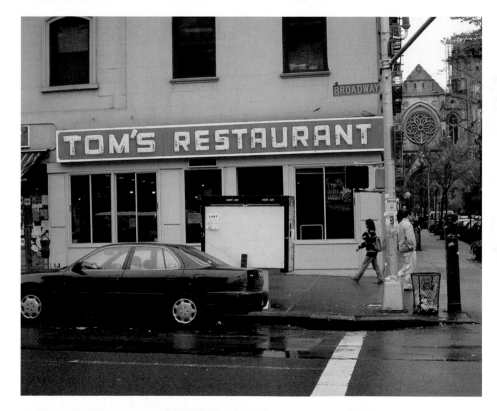

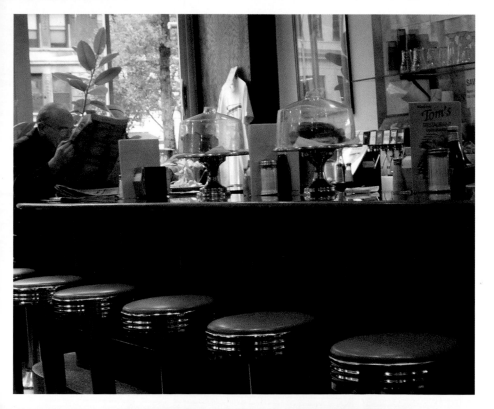

GABRIELA KOGAN ✳ TOM'S RESTAURANT / 2002

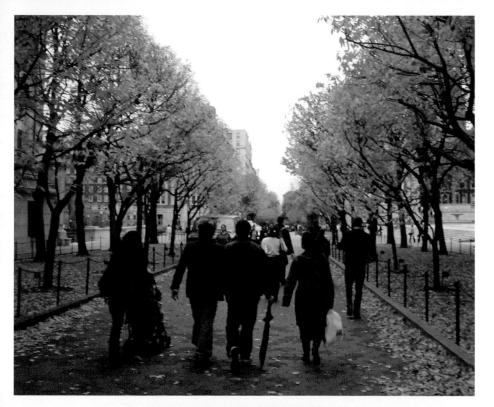

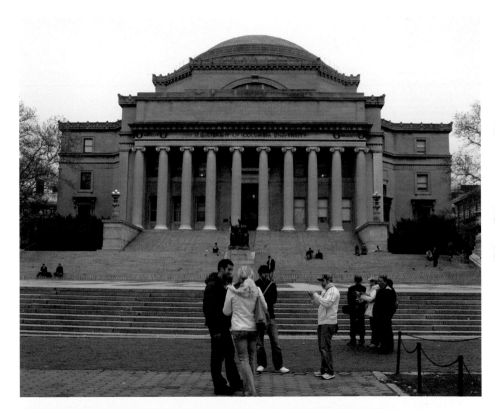

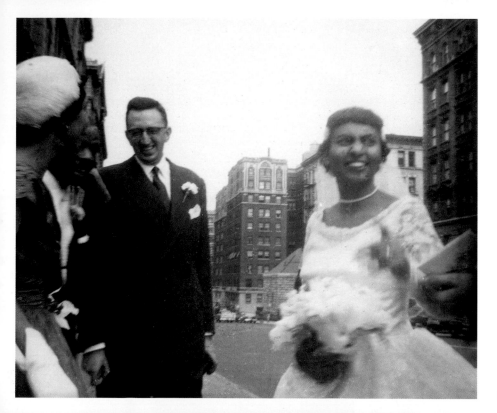

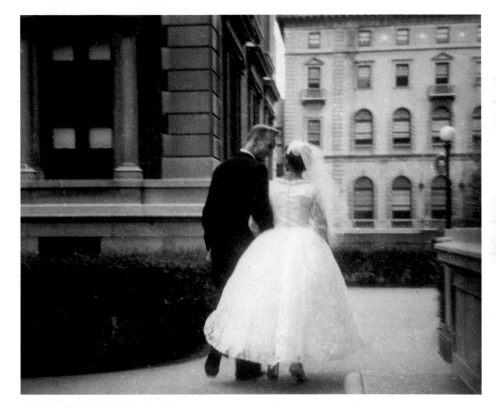

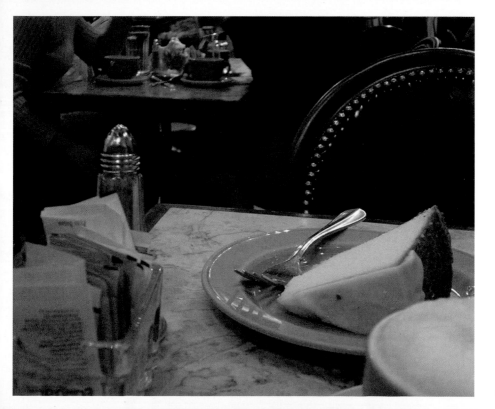

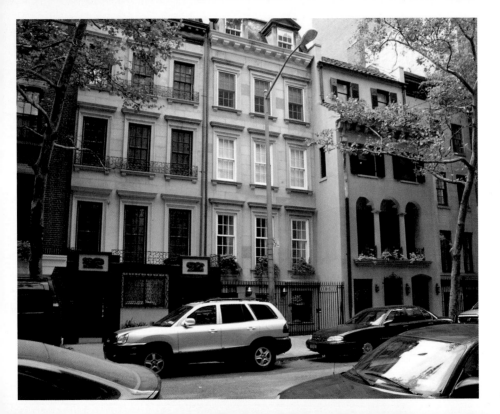

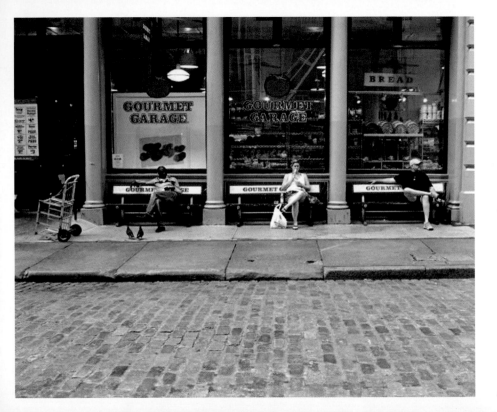

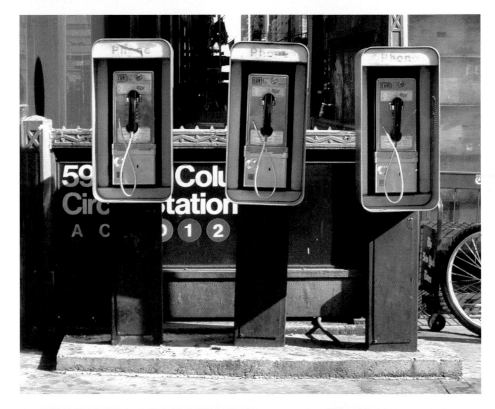

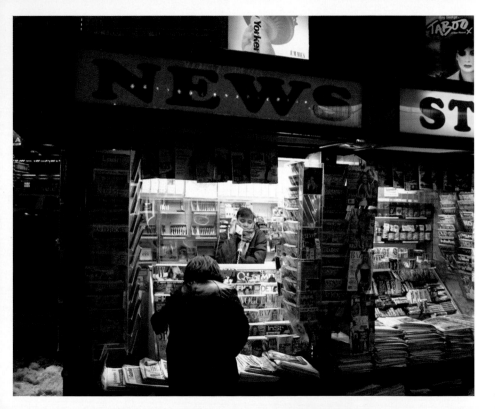

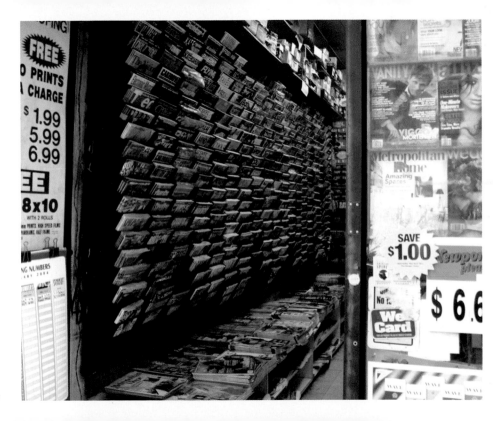

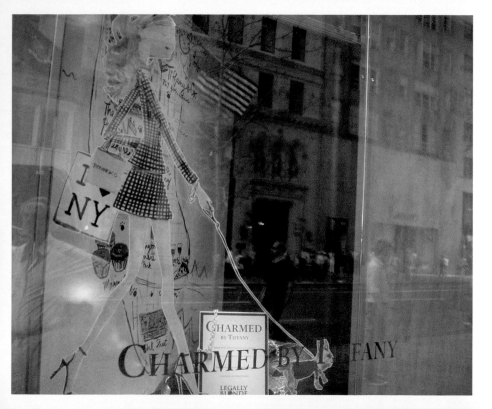

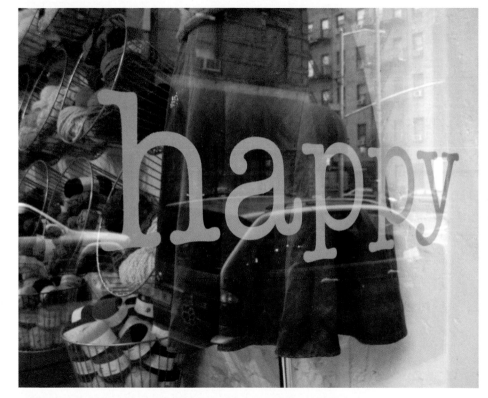

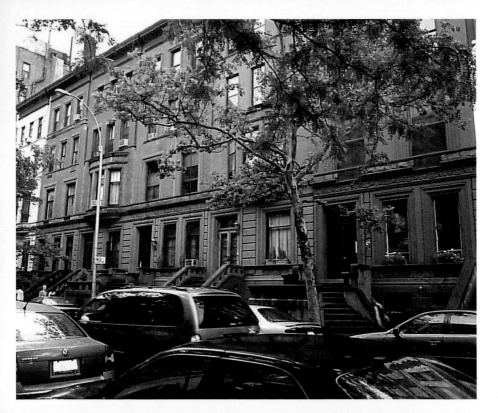

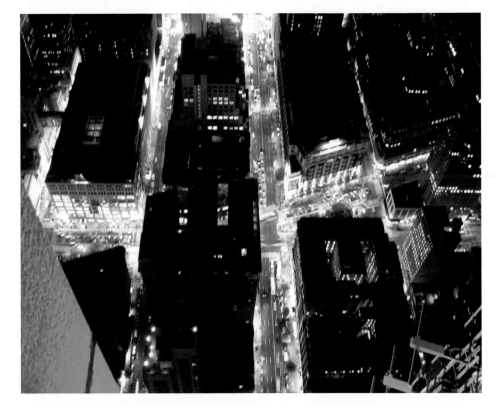

CRISTINA ROUCO-ALEJANDRO GIUSTI ✳ LIGHTS / 2004

411

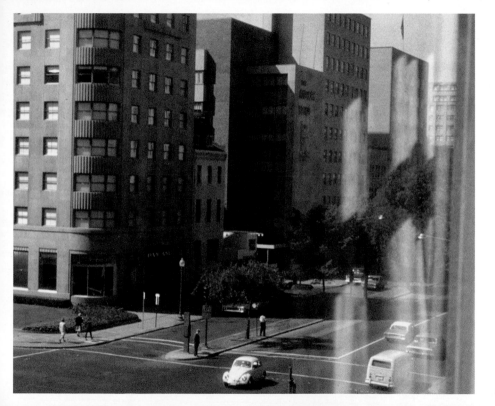

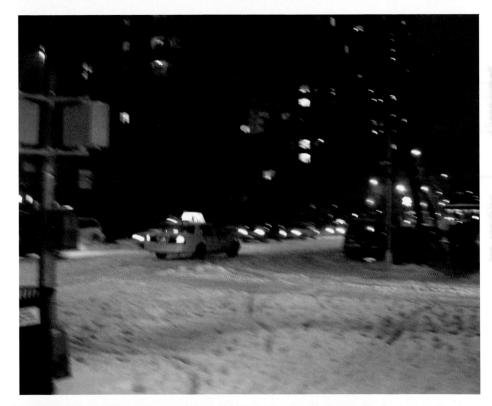

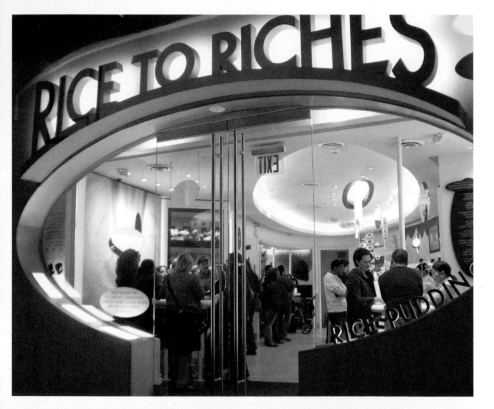

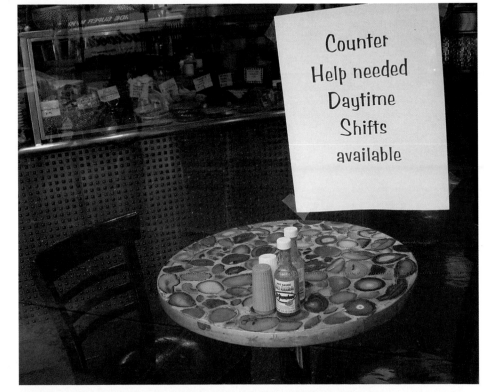

Counter
Help needed
Daytime
Shifts
available

GABRIELA KOGAN ✱ UPPER WEST SIDE / 2002

415

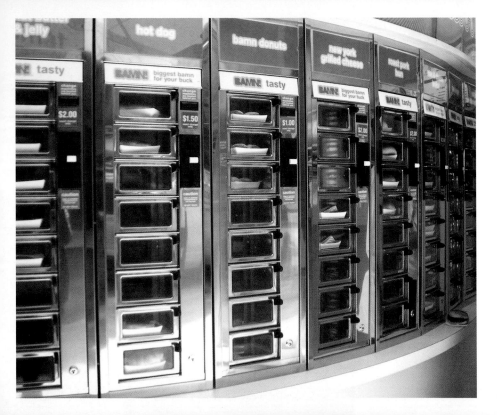

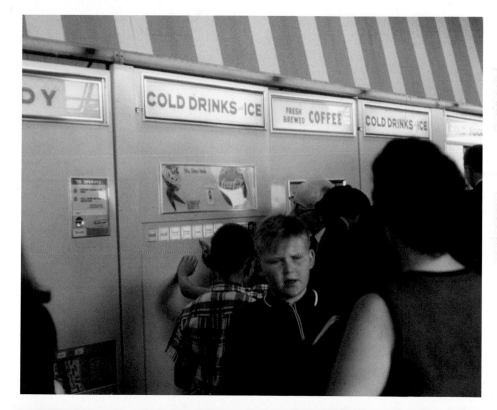

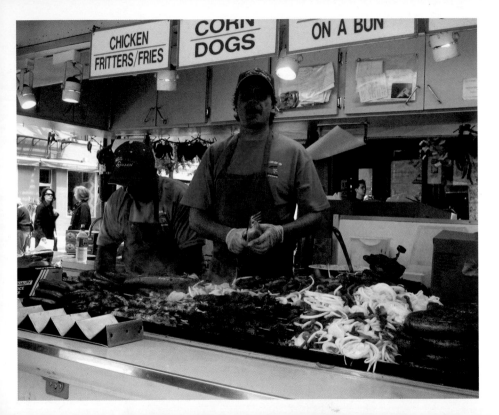

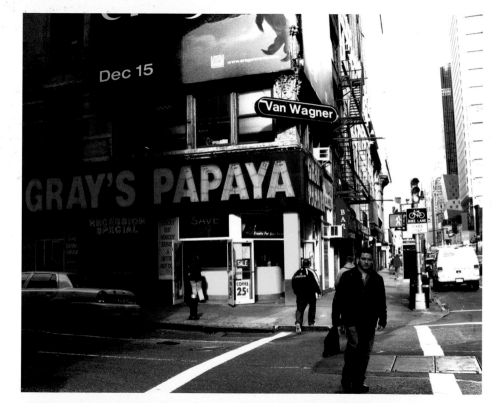

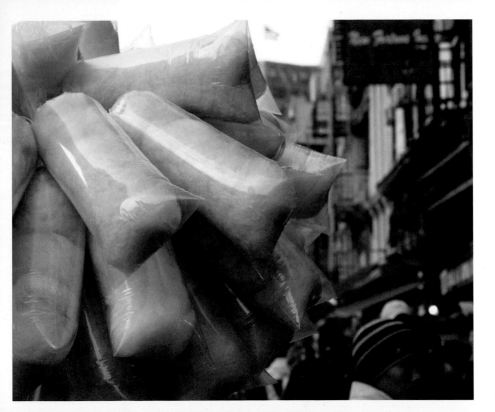

ERIC DUPUIS ✳ COTTON CANDY ON CANAL STREET / 2007

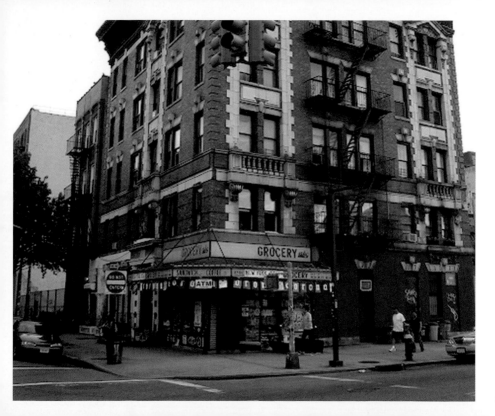

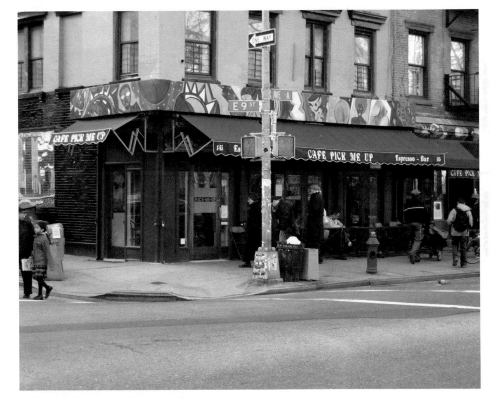

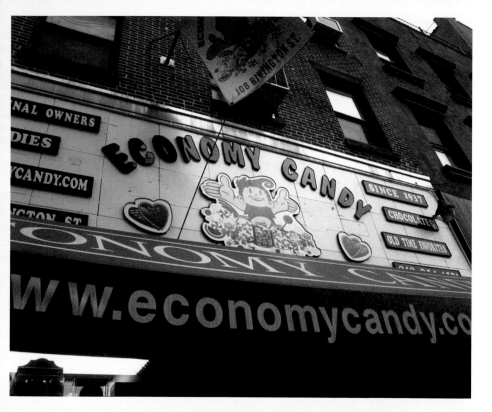

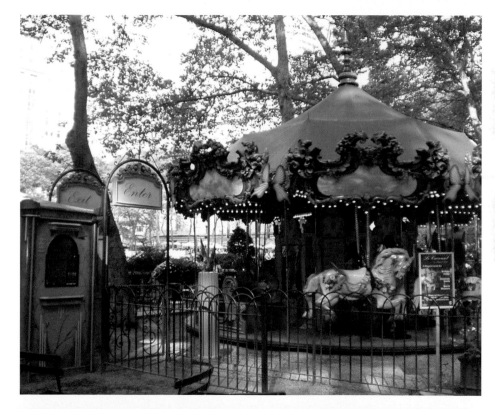

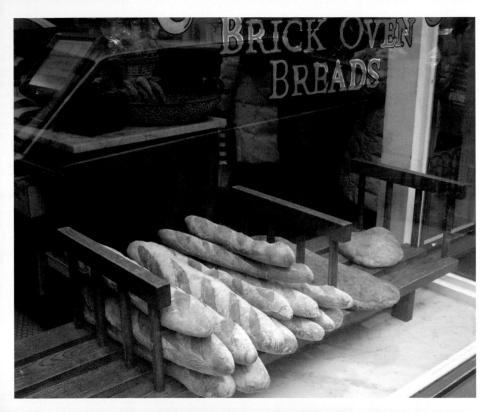

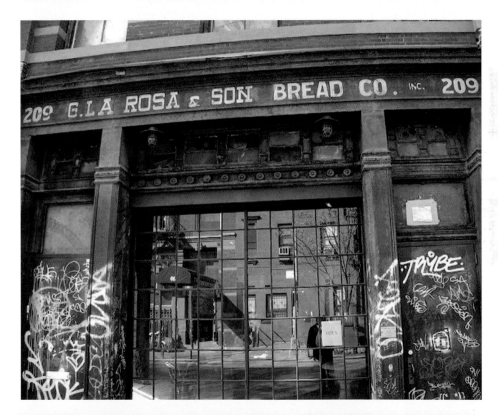

427

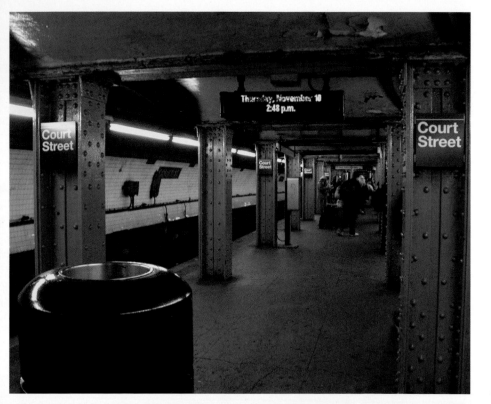

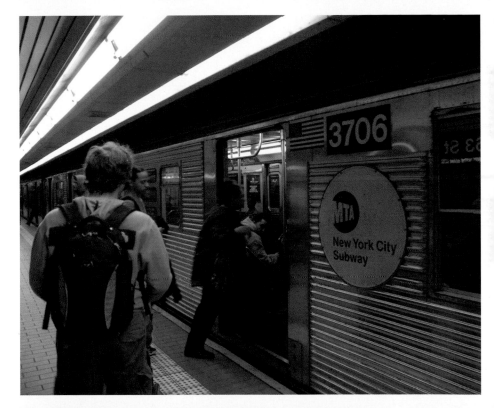

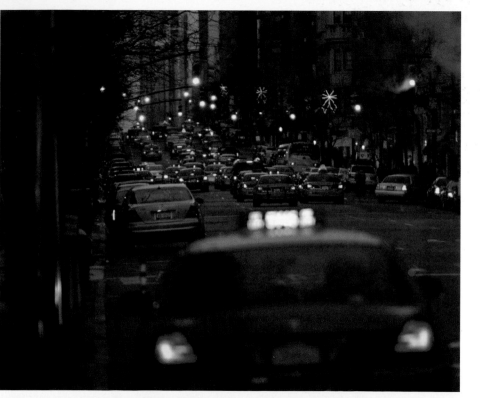

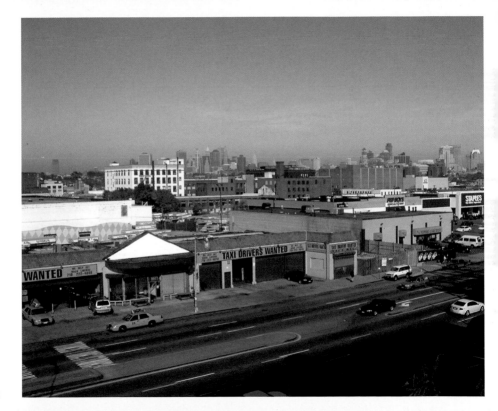

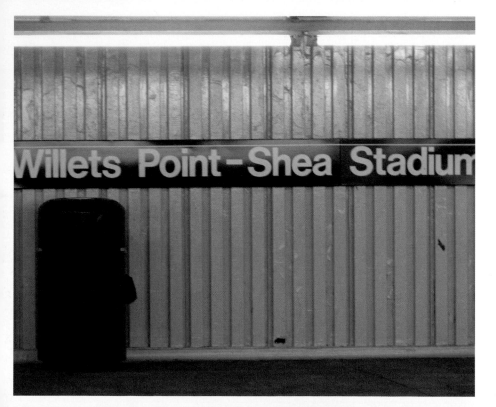

RANDY LEVINE ✳ THE TEAM, THE TIME / 2006

433

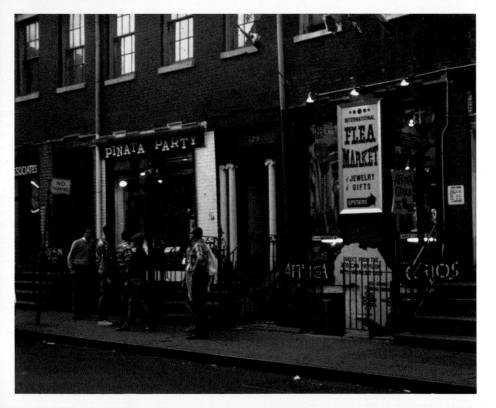

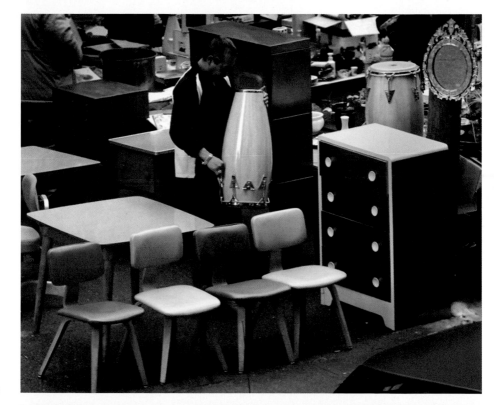

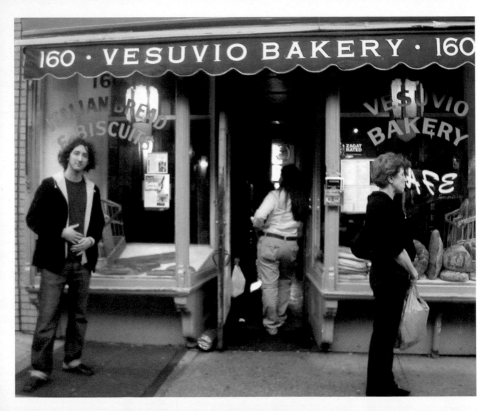

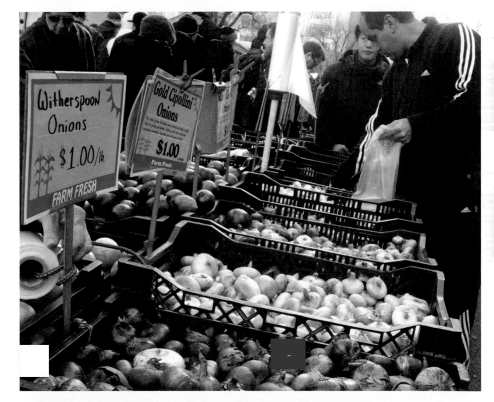

Witherspoon
Onions
$1.00/lb.

FARM FRESH

Gold Cipollini
Onions

$1.00

Farm Fresh

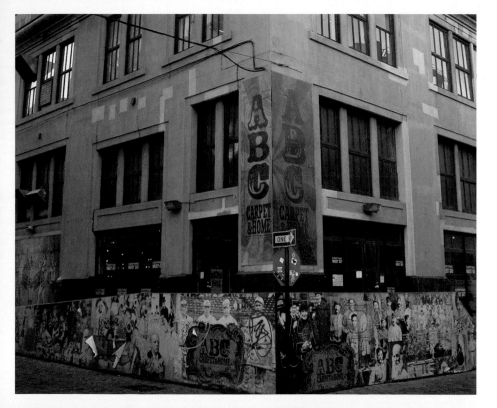

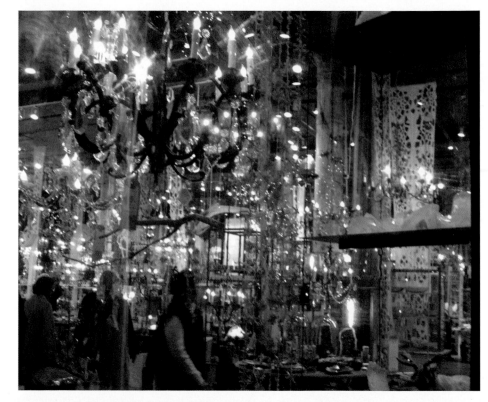

439

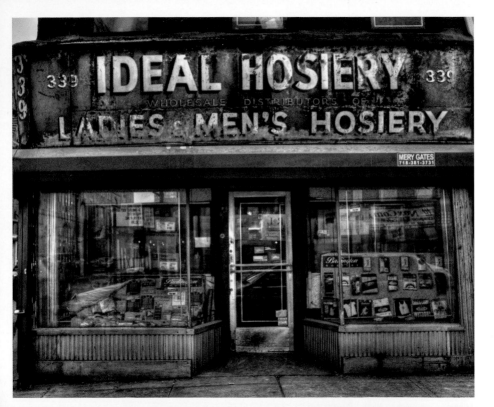

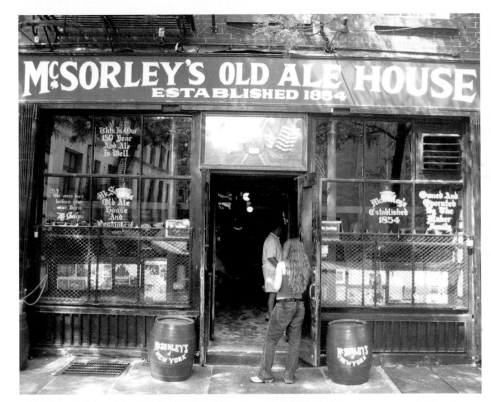

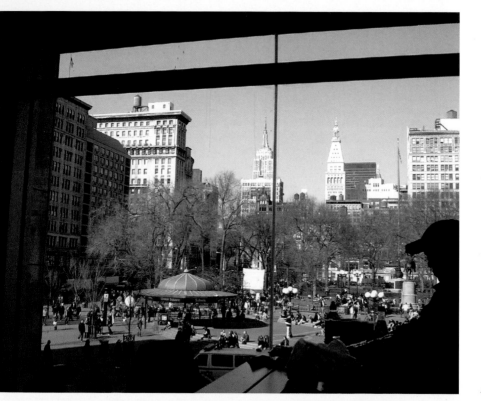

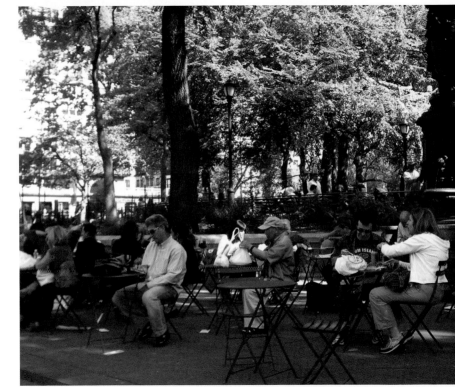

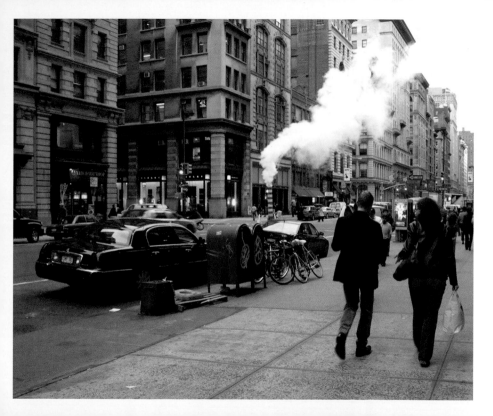

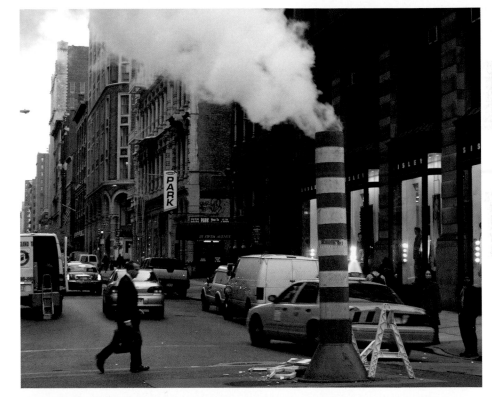

PABLO KOLODNY ✱ STREET / 2005

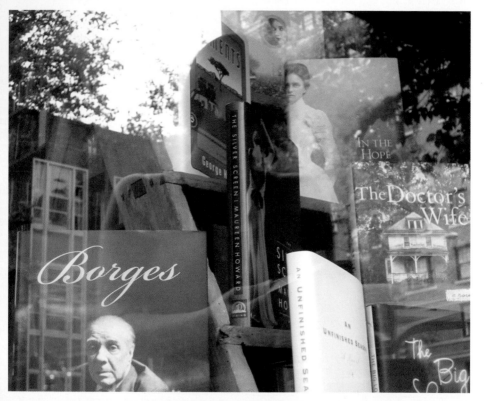

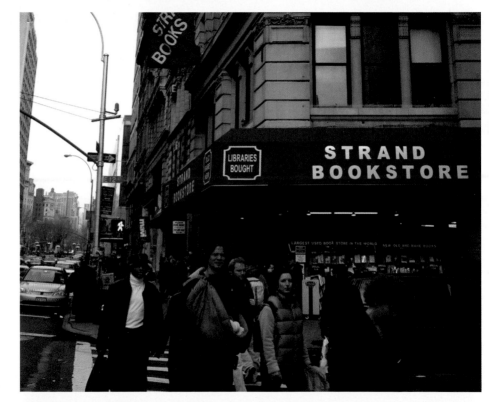

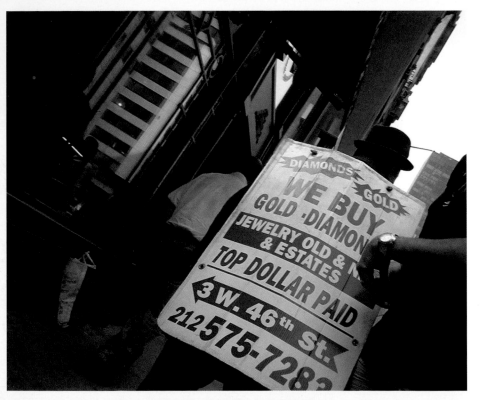

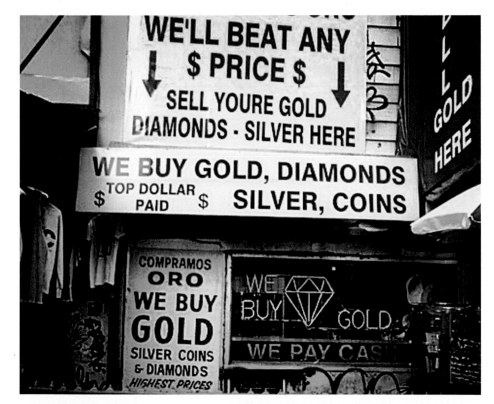

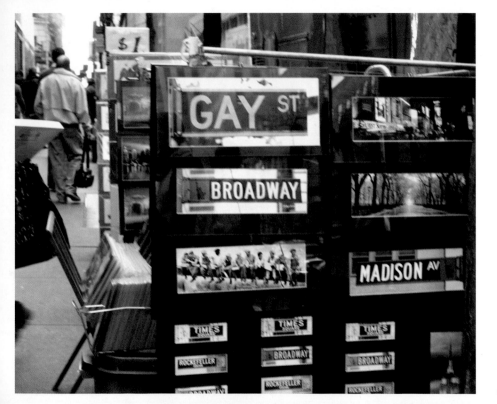

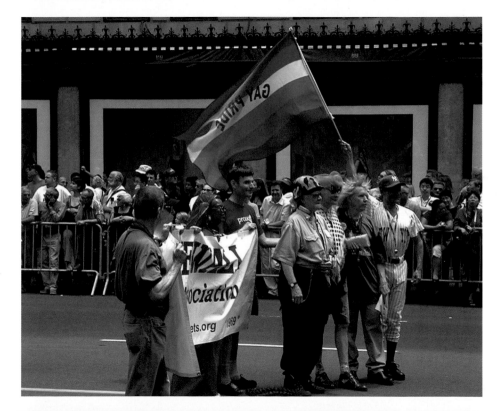

451

GABRIELA KOGAN ✳ DOLLS / 2002

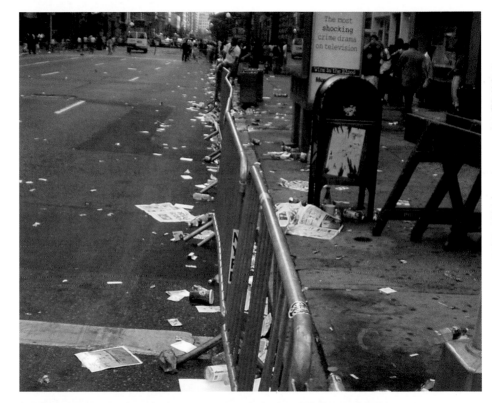

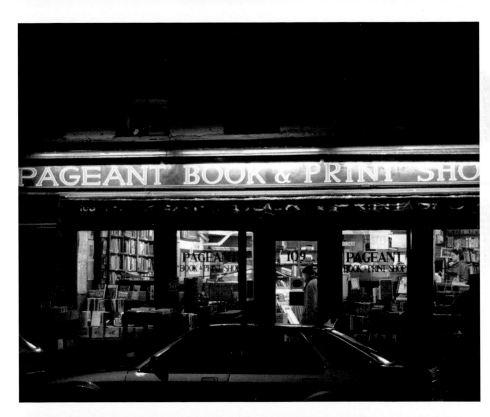

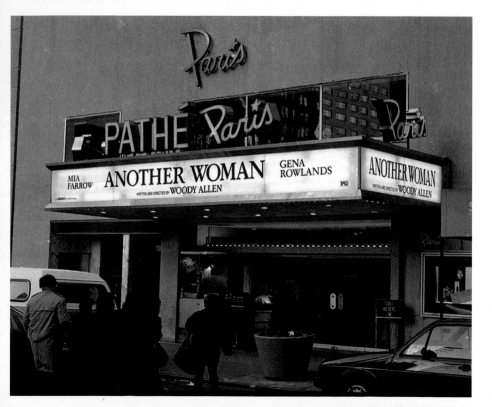

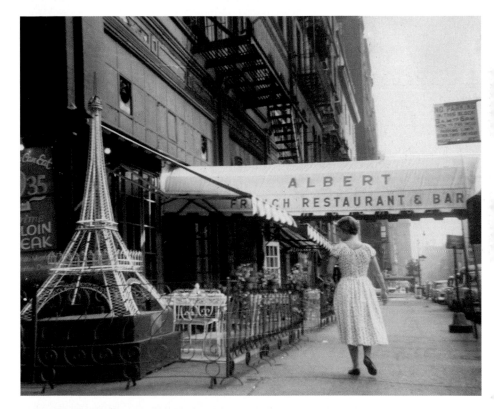

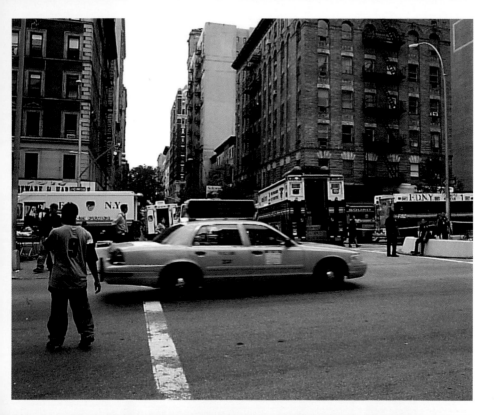

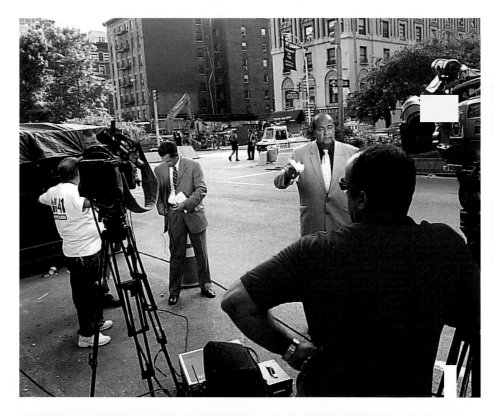

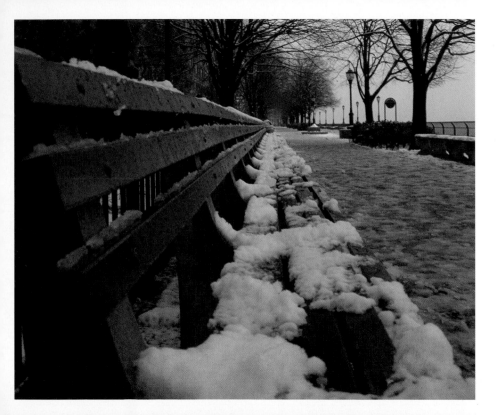

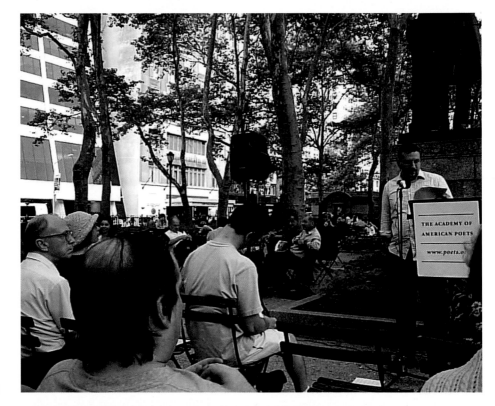

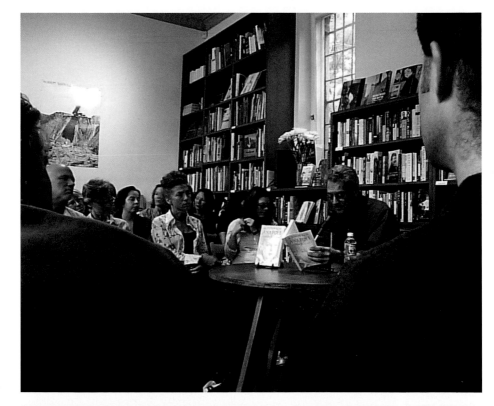

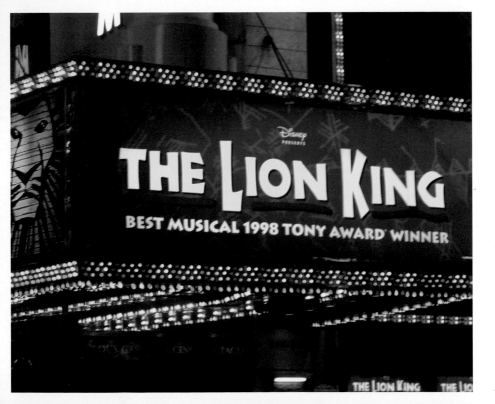

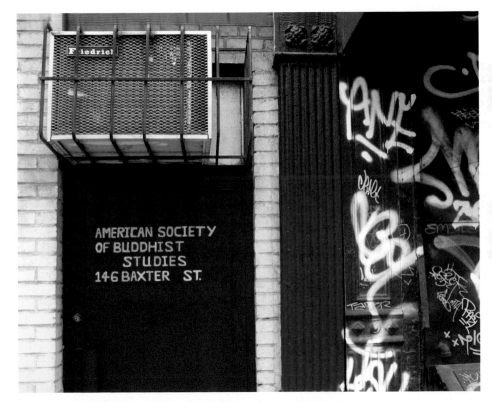

AMERICAN SOCIETY
OF BUDDHIST
STUDIES
146 BAXTER ST.

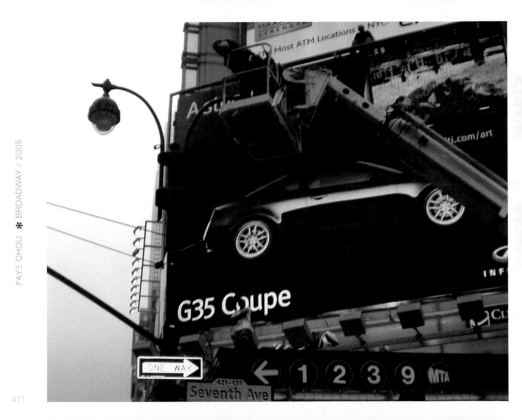

471

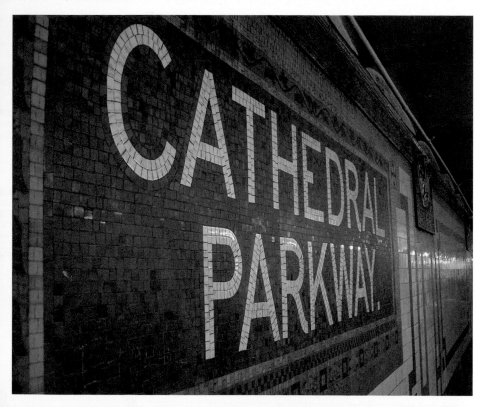

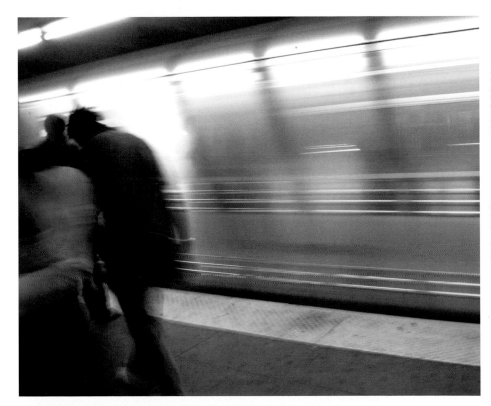

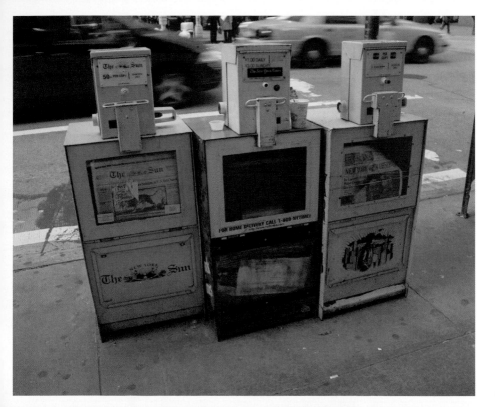

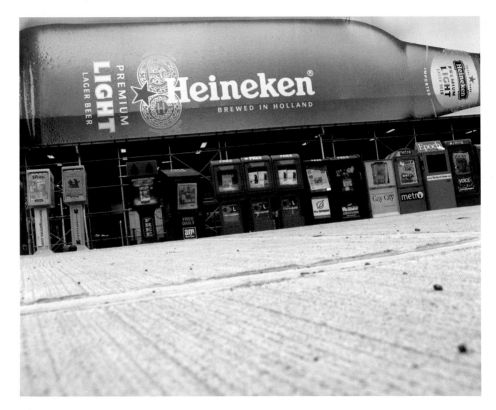

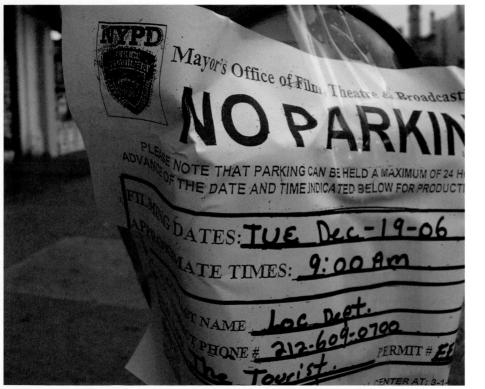

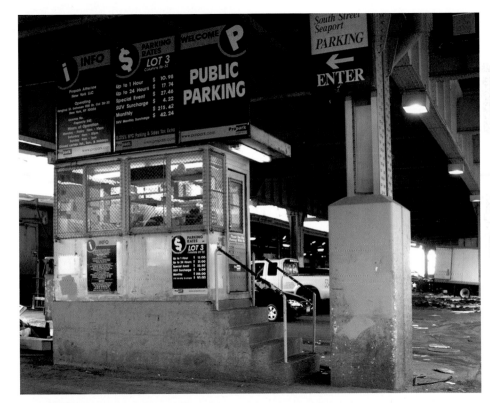

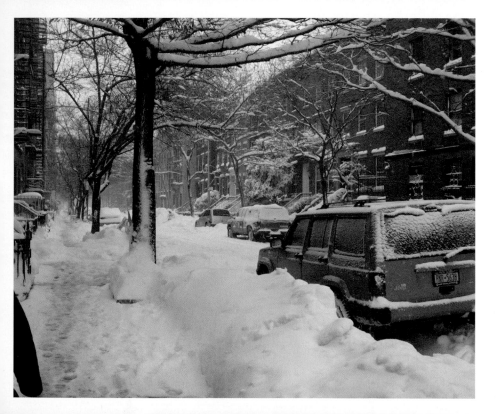

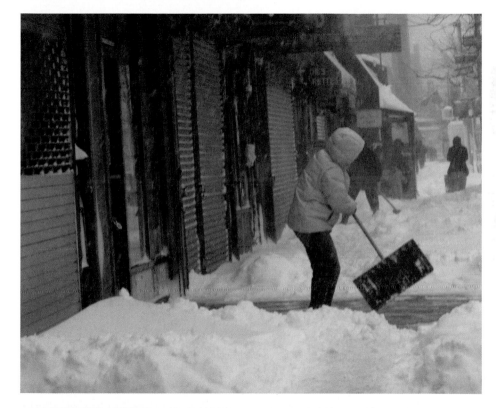

479

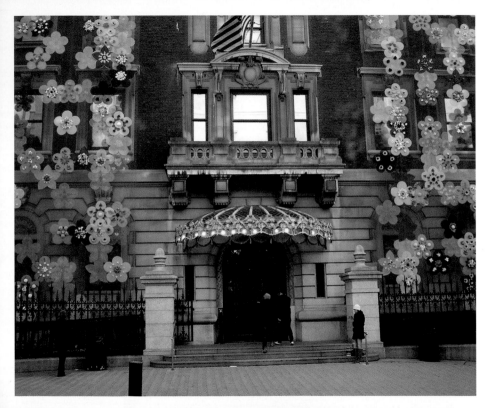

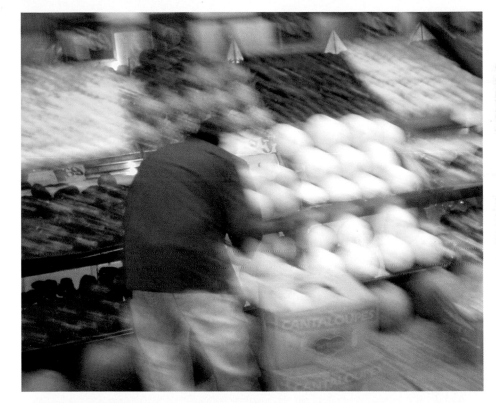

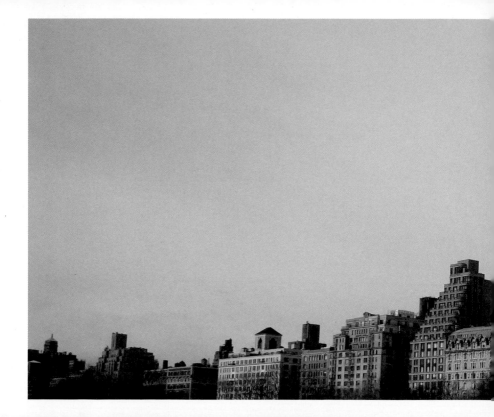

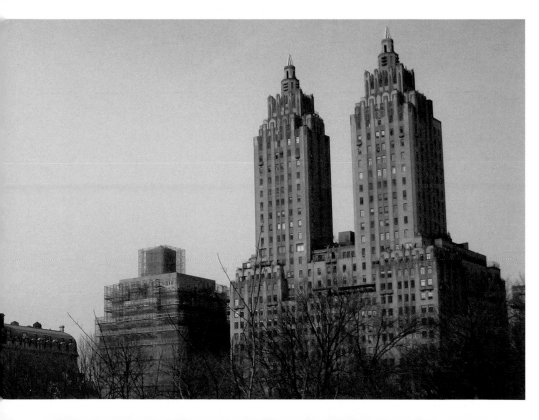

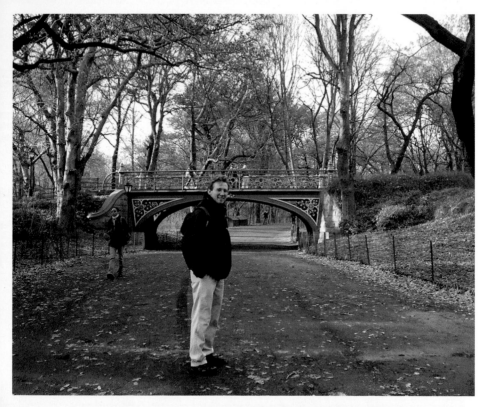

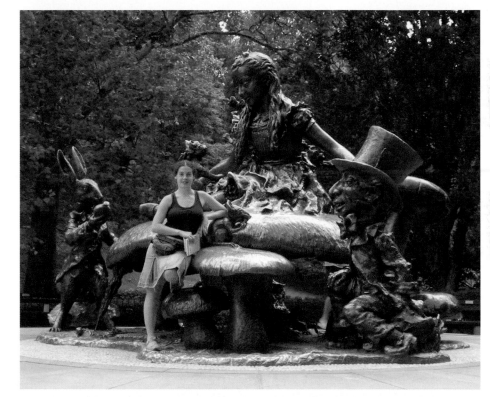

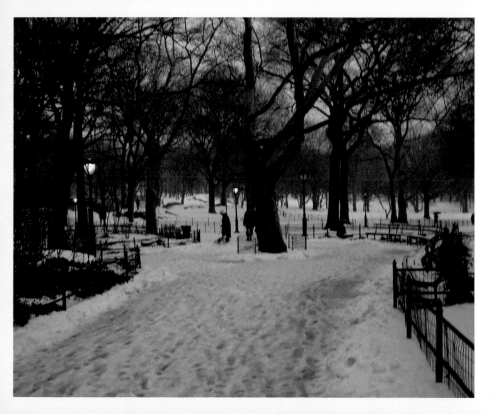

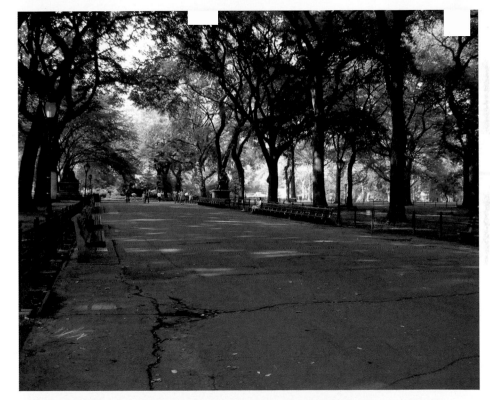

PABLO KOLODNY ✻ CENTRAL PARK / 2005

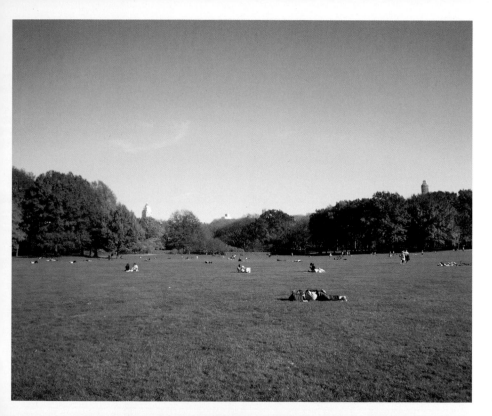

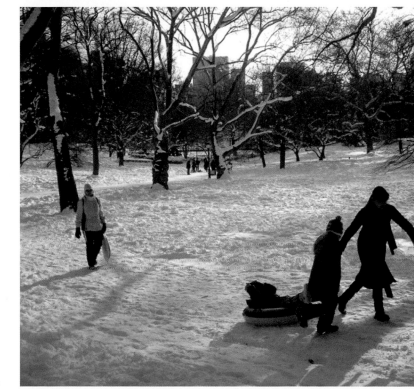

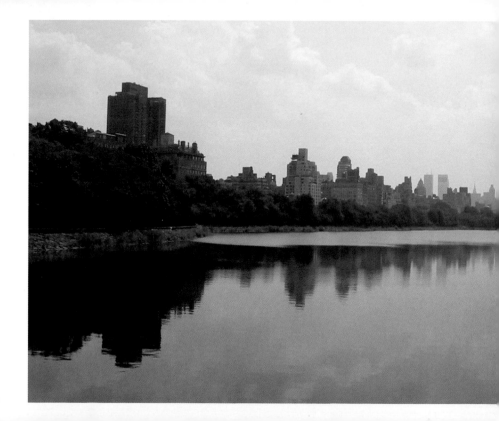

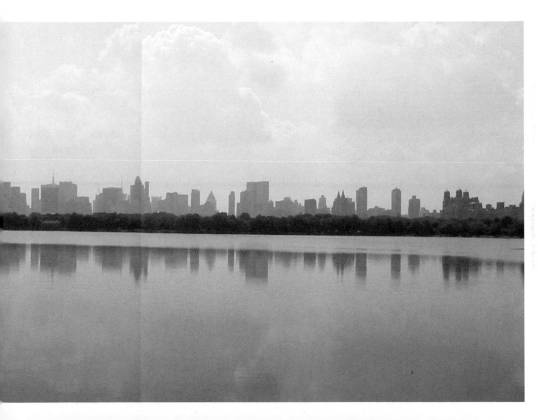

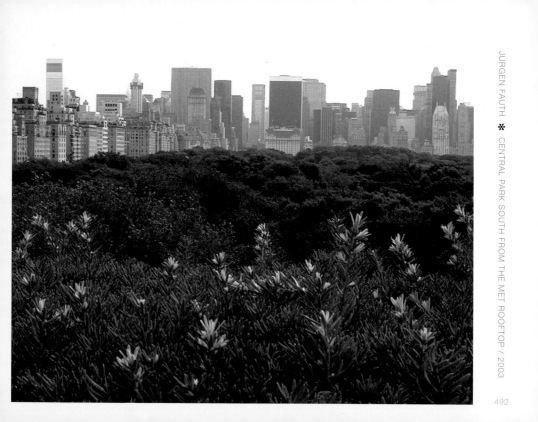

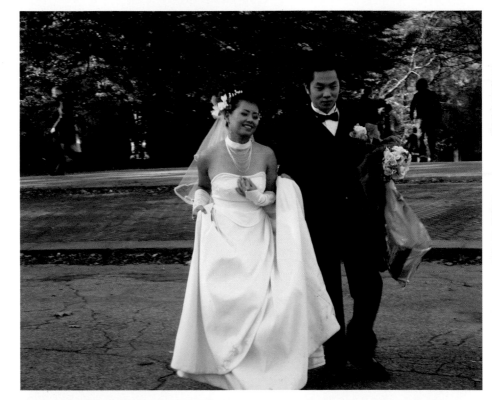

JONATHAN GORANSKY ✱ WEDDING / 2006

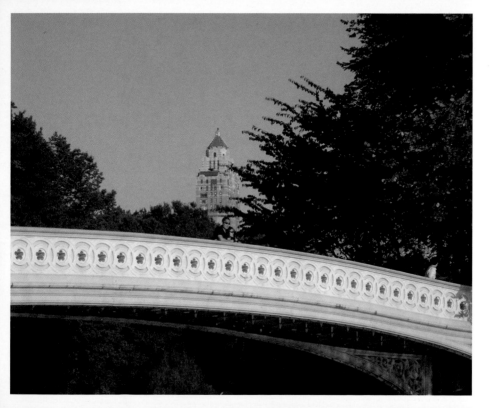

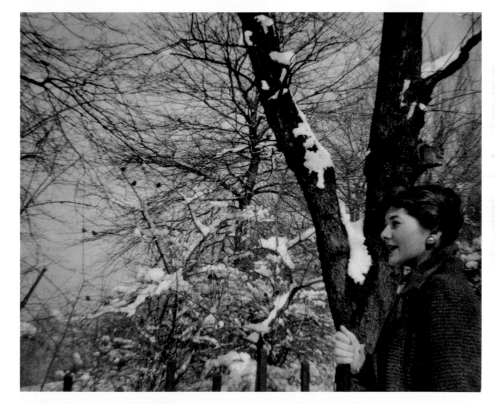

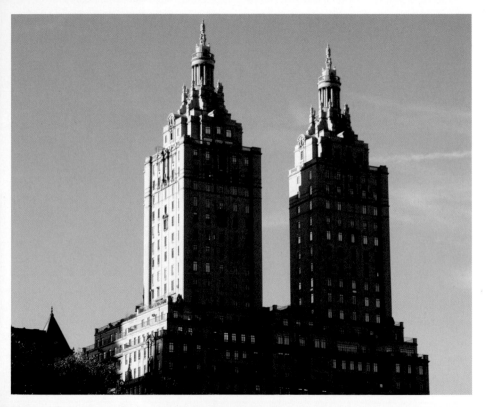

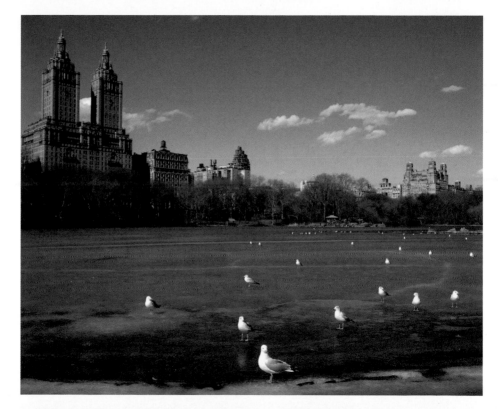

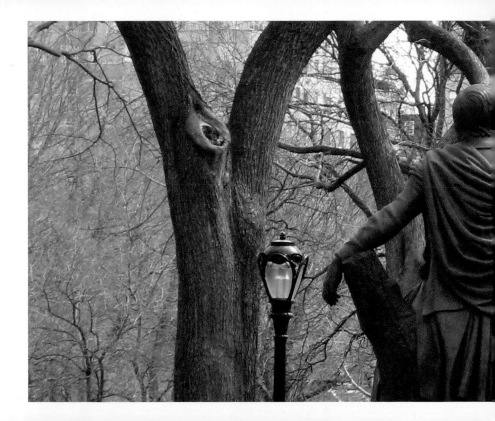

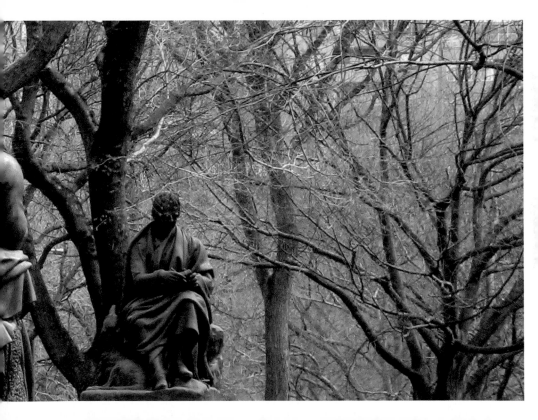

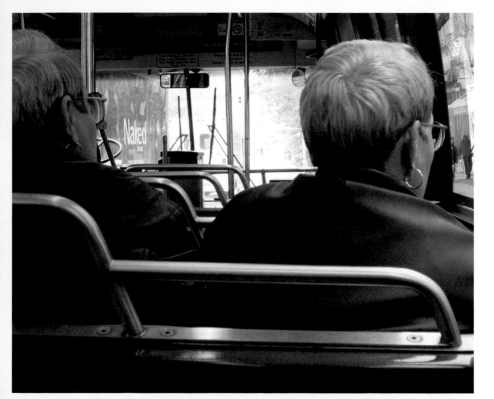

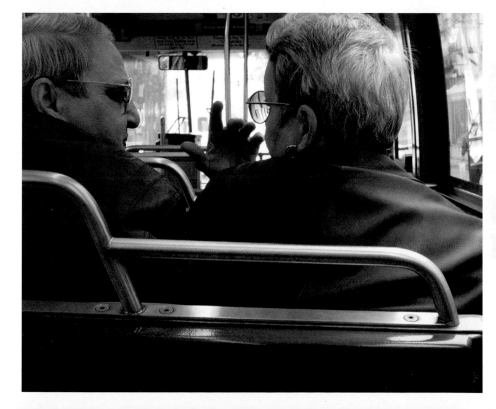

501

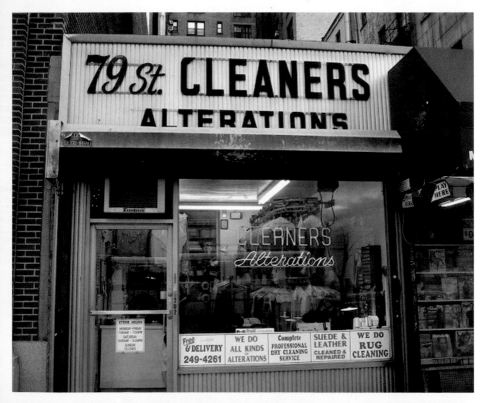

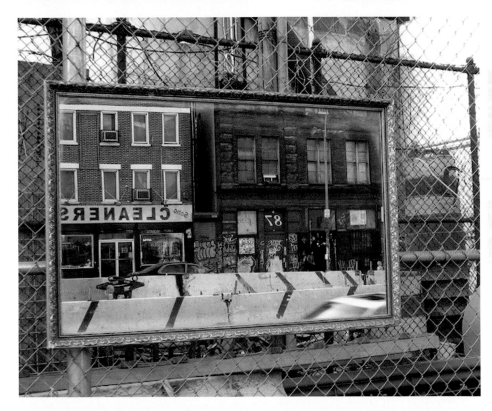

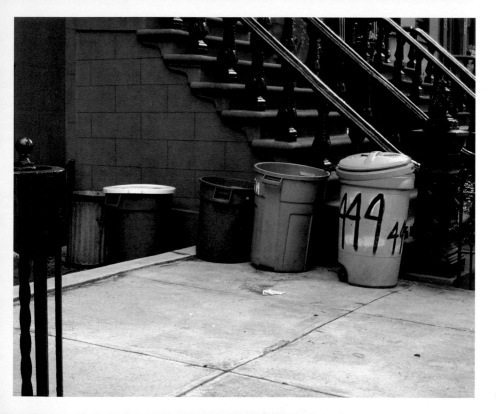

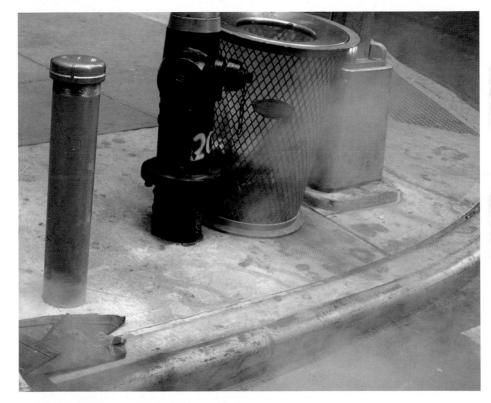

505

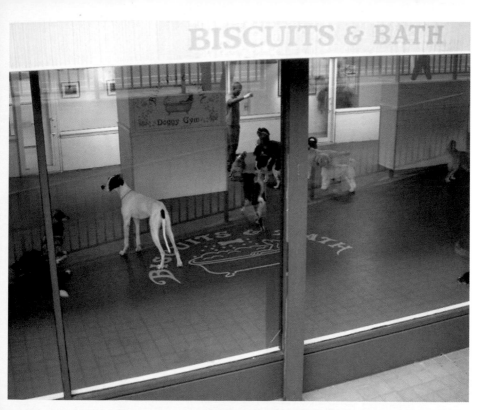

BISCUITS & BATH

509

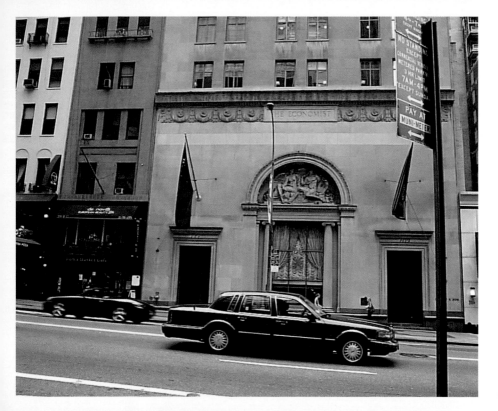

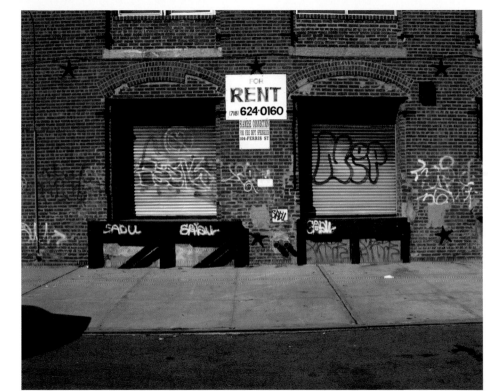

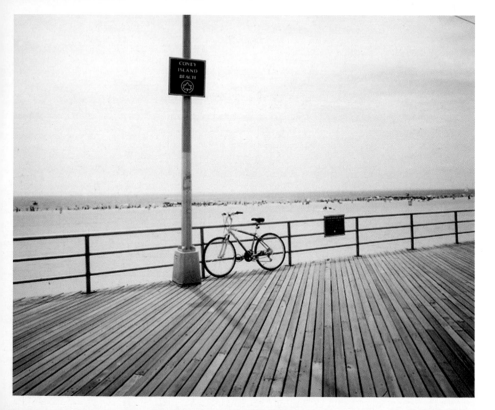

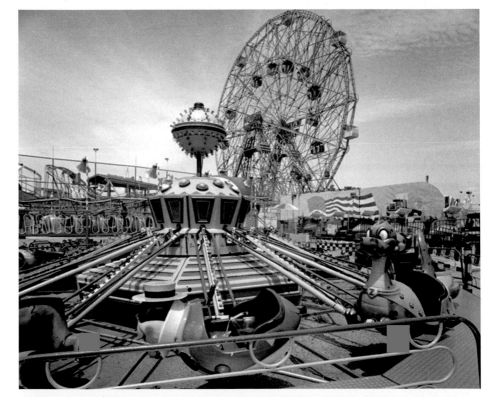

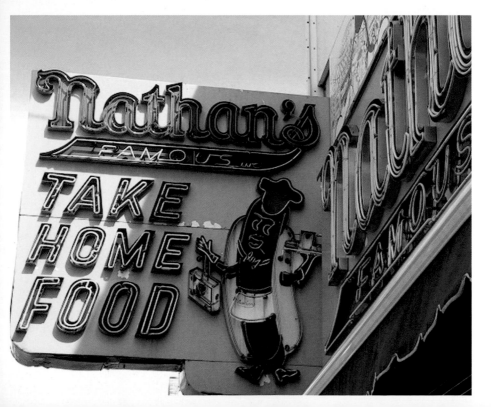

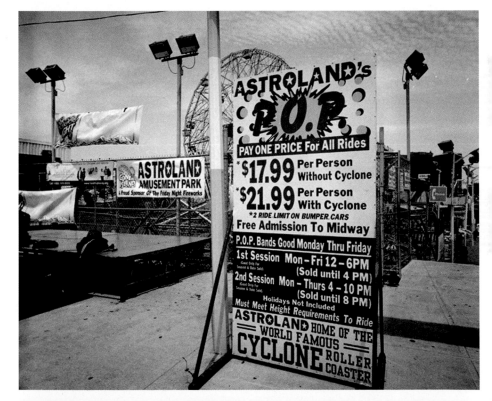

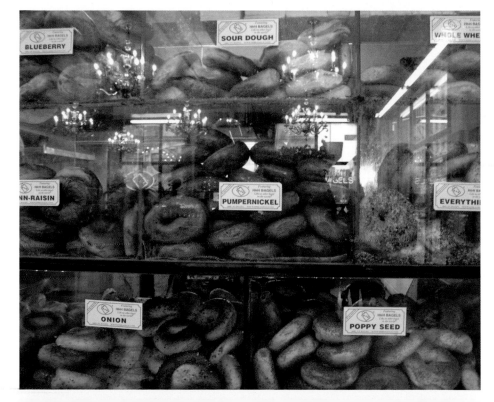

517

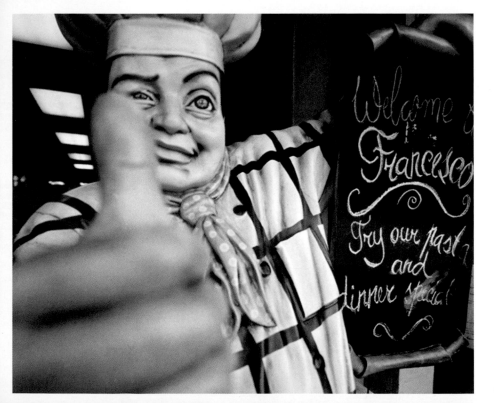

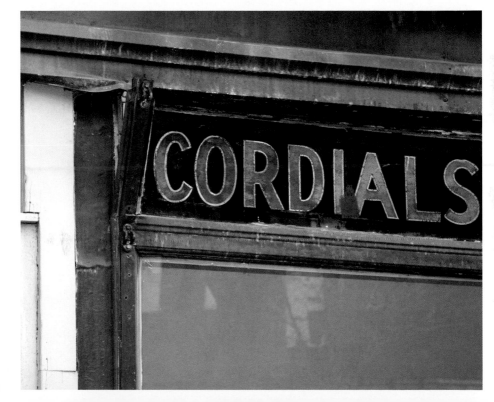

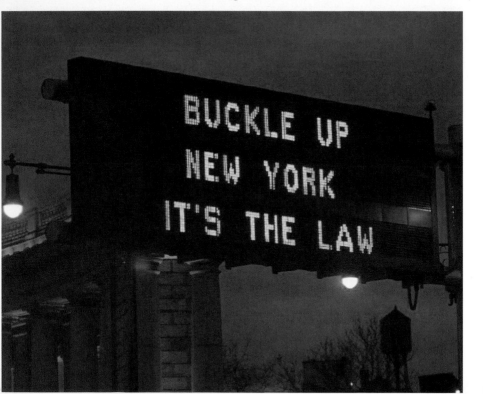

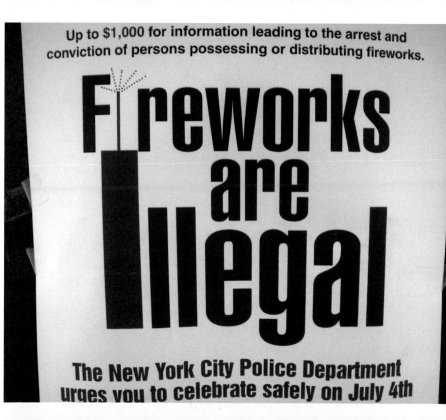

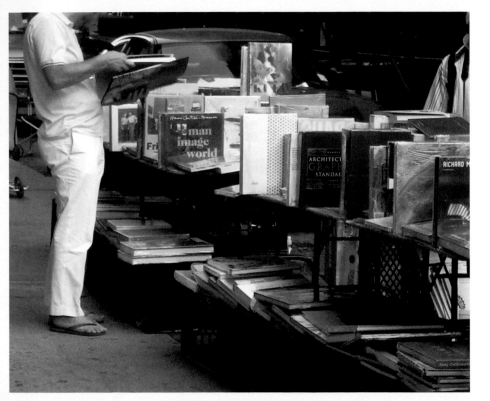

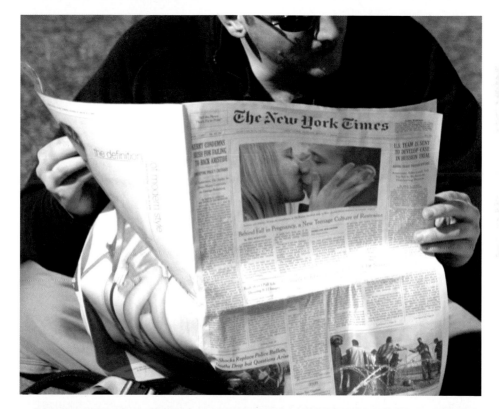

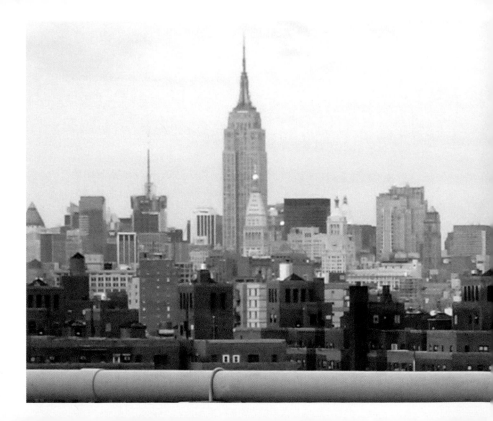

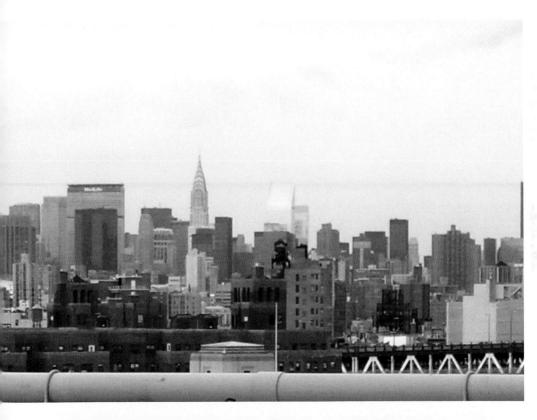

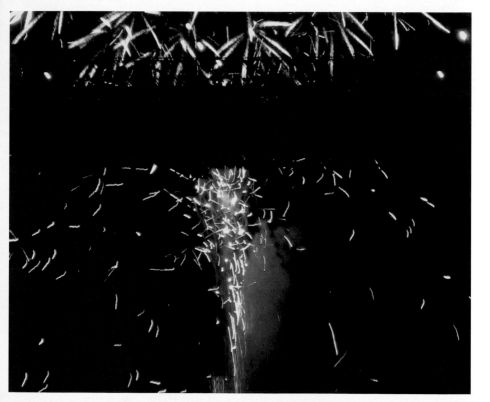

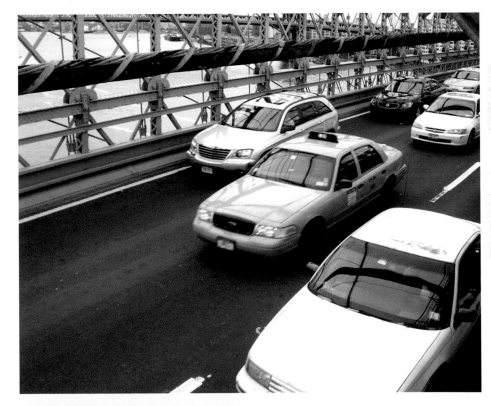

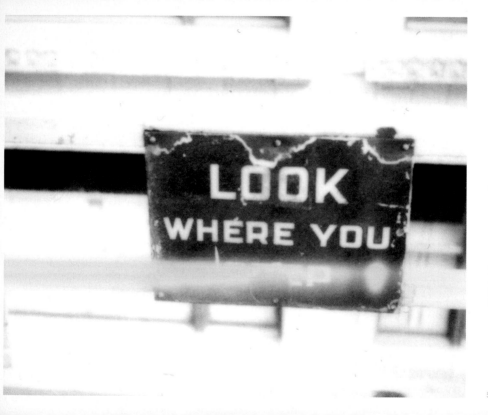

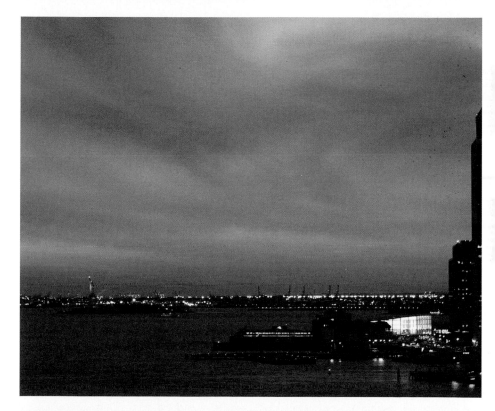

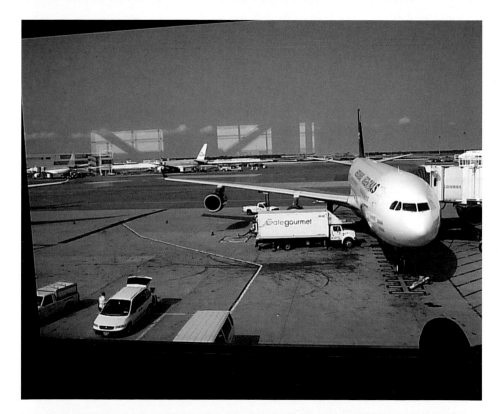

MARINA KOGAN ✳ I'LL BE BACK / 2005

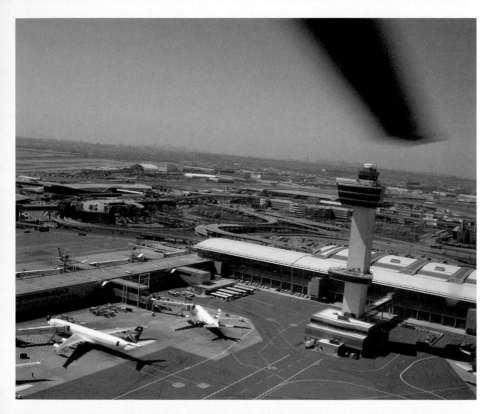

532

And the photographers are . . .

Adam Hertz

He lives in San Francisco, California, where he manages engineering at Technorati. Zabar's is just one reason that New York City is his favorite place in the world to visit. He has many family members and friends there. His wife, Joan Gelfand, hails from Queens and spent her youth frolicking in Manhattan.

Amanda Jahn

I always wanted to live in two places when I was little: London and New York. My devotion to *Sex and the City* only fueled that desire to be a Manolo Blahnik wearing socialite! Now a resident of London (and unable to get an American visa) I travel there as often as I can.

Andrea C. Jenkins

She currently lives in Portland, Oregon, and has been madly in love with New York City since 1993. There's no place else she'd rather be than wandering the streets of New York with a camera in hand.

Andrea Cantarelli

I am an entrepreneur in Perugia, Italy. If someone does not have a relationship with New York, it means he doesn't want to have a relationship with the world.

Andrés Slater

Among friends, I always presented myself as an artist, a poet, and a dreamer. Not far from that introduction, I am devoting my life to photography and based in Buenos Aires, Argentina.

During a period of four years, I had the opportunity to travel to New York City on several occasions, and I really do not know how to express in words my attraction to this city. It's that invisible and magnetic feeling

that all major cities have, a unique style hidden among gray buildings and loud noise. In many ways, New York City sets the beat to which the rest of the world dances.

Andrew Lachance
He is a wandering musician and photographer. New York is the vortex on which he stands.

Camila Miyazono López
I live in Buenos Aires, Argentina, and I am a photographer. I simply love New York City. I find it magical. I would like to live there for a while. I just keep images of travels as a tourist for now.

Chie Shimodaira
My pictures in this book were taken during my fourth visit to New York in March 2007. Since my first visit in 1997–98 for Christmas and New Year's holiday, the metropolitan city has been a special place for me for its beautiful, diverse, and lively culture and people.

While working at a company based in Tokyo, Japan, as a PR person, luckily I had a chance to work at its New York office and live in Chelsea for eight months from 2002 to 2003. During the stay, I discovered various faces of New York through making friends and exploring outside Manhattan—Brooklyn and Queens. The temporary New Yorker life was more than enough to make the city even more special.

Clay Williams
I live in Bedford-Stuyvesant, Brooklyn. New York is my home, and has been all my life. I use my photography as a way to become closer to the city. It helps me focus on its many facets. I love to shoot small details that we walk by every day: fire hydrants, manhole covers, graffiti, and strangers in the street.

Colin Swan

I was born in Munro, a small country town in Victoria, Australia. I live in Melbourne and work as a sound recordist in film and television and I play five string bluegrass banjo. I enjoy taking photographs of interesting people and places; I see a lot of them while traveling, either through my work or with my girlfriend. New York City is one of my favorite destinations. I love the atmosphere, the architecture, the people, the hustle and bustle, the art, and the music.

Cristina Rouco-Alejandro Giusti

New York is the firt place we share with our children. There are special places in New York that take a part of our lives. It always has something new, it's New [York]. It always has something that is us.

Daniel Modell

He is a graphic designer with a love for photography and the city he calls home, New York. He has lived there for ten years, but his New York City roots go back to his grandparents, all of Eastern European Jewish descent, who lived in Brooklyn for most of their lives. He studied graphic design at Syracuse University in upstate New York and lived in Boston, Massachusetts for one year before moving to a series of apartments in and around New York City. He is now more firmly planted in Manhattan, a stone's throw from Central Park where he can often be found walking and taking pictures with his wife, Roseanne, and two-year-old son, Asher.

David Baker

I went to New York in October 2007. It was somewhere I'd always wanted to go but never before had the opportunity. As a graphic designer, I'm always absorbing visuals, whether it be on a screen, in print, or my surroundings. In New York, I found it so hard to take it all in! It was everything I'd expected, and so much

more. From the hard lines of the towering skyscrapers to the traffic rushing by, everywhere I looked proved a fantastic photo opportunity. Shortly before my visit, I had purchased my first digital SLR camera. What a place New York was to break it in.

Dolores Calcagno

Only when I am in New York, I see the anguish of knowing that it exists relent. Sometimes, I wish I had never been there. On other occasions, I am grateful that I had the almost exclusive privilege to experience and enjoy this city. I can never get enough of it.

Eda Strauch

I have lived in Barcelona, Spain, for thirteen years, with my husband and my daughter. All the people who have ever been to New York and who can understand it find this city special. Wandering around its streets, gazing at its lights, hearing its noises, enhaling its perfumes, talking to its people, learning from its museums, having fun with its shows, marveling at its architecture, and enjoying its parks make you understand this city and, once you do, you get to love it. New York is multicultural—each little piece of the world is contained in it. It is an empire where the man is the king. Besides, I have another strong reason to return as often as possible: my son lives in New York, which makes it even more special!

Emily Mandelbaum

I am twenty-six years old. I grew up in a town outside of New York City and lived there until I went to university in California. Upon graduation, I returned to live in Manhattan where I currently work.

I often find myself exhausted from the city: it's a noisy, dirty, and stressful place to call home. It's difficult to be alone here, but it's quite easy to be lonely. At times, I wonder if I can spend a lifetime in a place like this.

Then, I remember that I live in a beautiful city, full of secret treasures and quiet charm. I can walk through different neighborhoods and find new worlds and universes, just one block away. New York City is an old place of legend and history. I have to work hard not to be lost here, and I long for those moments of tranquility, as fleeting as a memory. I try to keep a camera with me when I explore the city in hopes that I will capture a perfect moment of peace on film that will remind me why I live here.

Éric Dupuis

7 a.m. Coming out of the subway I'm blinded by the sun beaming in between two buildings and shining on the wet surface of the pavement. A whiff of pretzel smoke rushes down my throat as I get onto the already crowded sidewalk. Imposing buildings rise on either side, observing the city from their thousand windows. I start the day visiting galleries and museums. In one single day I can appreciate masterpieces of famous Impressionists as well as brand new contemporary creations just out of the artists' studios. I also search up and down the streets for unusual boutiques, or secondhand bookstores hoping to find some treasures. I wander on Canal Street, immersed in the ambient chaos, with its uninterrupted flow of people looking for a sidewalk bargain. New York is indeed an unlimited reservoir of impressions and sensations—a true source of inspiration. I live in Montréal, Canada, where I own a graphic design studio. Photography is my way of exploring the surprising world we live in.

Eric Felton

I'm a writer in my "day job" and a very active photographer during my off hours. I live in the Washington, DC, area, but New York has always been one of my favorite cities—so much color, light, and energy. I took my photograph in December 2001, which was my first visit to New York following 9/11.

Eugenia Álvarez

Our family is formed by Julian, Eugenia, our seven-month-old baby Lukas, and our nine-year-old cat Axl. We live in San Jose, California. As with many other people, we are linked to this spectacular city through its art, culture, museums, ethnic diversity, architecutre, and 24/7 lifestyle (that is 24 hours a day, 7 days a week).

Faye Chou

I'm from Taiwan. My first experience with New York City was in 2001—I visited there as a tourist. In August 2002, I came to New York again to study in the Interactive Telecommunications Program at Tisch School of the Arts, New York University. In 2005, I started working full-time in New York·while taking design classes at Parsons The New School for Design after work. In 2007, I started taking lessons in Argentine tango, salsa, along with other social dances, and also took illustration classes at the School of Visual Arts.

I soon realized that New York is an ideal place for not just art lovers but also for dance lovers. Here, I am able to approach sophisticated Latin dances with a sophisticated New Yorker's mind, learning from great dance teachers from Argentina, Spain, and around the United States. I just regret that I didn't start exploring dance sooner, then I would have made more friends and had a morc cnjoyable life in the past few years. I currently live in Manhattan.

Fumika Nagano

I'm a graduate student in English who live in Tokyo, Japan. I spent much time in New York while attending Rutgers University in New Jersey from 2005 to early 2007. I went to the city for books, music, art, and yes, to take photos of the city I adore.

Gabriela Kogan

I live in Buenos Aires, Argentina. I am an author and book editor. I have loved New York since my first trip in 1987. I am always returning. This city nourishes me, boosts me, and connects me to the rest of the world.

Gary Curtis

I'm from Sheffield, England. The photos are from my first visit to the city of New York—a place that has always been in my heart since 9/11 and a city that I have always wanted to visit as a child.

Gerald San José

He lives in New York City. He was born and raised in San Diego, California, got shipped overseas as a military brat to southern Spain, and spent a couple years in Berkeley, California before travelling extensively for work to not-so-exciting places. Tired of living in airport lounges and being obsessed with collecting frequent flyer miles, Gerald left his corporate job in the Bay Area for an even bigger one in New York City. He now maintains enterprise software web applications while eating and blogging his way through the New York City food scene.

Jodi McKee

I am originally from Indiana. I visited New York City several times during high school. After I graduated from college, I lived in Yokohama, Japan, for a year. Then, I returned to Indiana. It felt very "small" after living in a big city in Japan. I visited New York again several times and really wanted to move there; I was finally able to in January 2006. I love living in New York! I recently moved to Queens, and although I miss living in Manhattan, I feel very lucky to live and work in one of the best cities in the world. And the best part? Wandering around and photographing it all!

John Liu

I live in Melbourne, Australia. I'm an architect and part-time jazz musician. We—me, my wife, and my parents—had a great time in New York. It was my first time in New York and hopefully not the last time. It is probably the only city on earth that has everything that I love: diverse culture, art, architecture, and jazz. Finding public toilet is a pain, though, because they don't exist!

Jonathan Goransky

I am a theater producer in Buenos Aires, Argentina. For me, both work and pleasure are inspired in New York. I visit The Big Apple whenever I have the chance.

Joshua Gaynor

I moved back to New York City four years ago after living in California for four years—two years in San Diego and two years in Berkeley/San Francisco. I had lived in New York previously for two years while earning a Master's degree in education at New York University. I am currently a Class Dean at Columbia University. I couldn't stay away from New York for too long. I love the energy and beauty of the city that never sleeps. I love not owning a car and being able to walk almost everywhere.

Julian Bleecker

I was a longtime resident of New York City. I currently live in Los Angeles, California, but I still have my apartment in the city.

Julie Herrick

I was born and raised in Southern California. I love New York City. I went there once when I was sixteen years old, but I enjoyed it even more visiting again as an adult. My sister and I spent two days in November walking all over the city. I thought it was interesting that the ceiling of the Grand Central Terminal is painted with the constellations. I don't know if this is true or if it's urban legend, but I heard a story about the ceiling: apparently it got so dirty over the years and somehow people forgot about the beautiful piece of artwork that was underneath. One day they started to clean it and were surprised to find the masterpiece hidden beneath the grime. I'm a big fan of *Seinfeld*, so I was amused to run across the shop that inspired the "Soup Nazi" episode. They really have RULES posted on the door when you enter.

Jurgen Fauth

PhD, he is a writer and film critic from Wiesbaden, Germany. He moved to New York City in 2000 and loves to take photographs of his adopted home. Jürgen writes about films at worldfilm.about.com and blogs at jurgenfauth.com.

Kiira Turnbow

I'm a graphic designer living in Los Angeles, California, originally from Northern California. Whenever I go to New York, I always have my digital camera on hand. I love to photograph different parts of Manhattan; taxis, people, architecture, and fascinating places to visit. My design background has made me look for something unique in each frame. There is always something interesting to see in New York. As a designer, there is endless inspiration everywhere you look.

Leo Novik

I am originally from Chile and I have lived in New York for eight years. Many of my friends visit me in my Upper West Side apartment and I always urge them to show me photographs they took of the city. Through photographs I get to know different angles of human sensitivity.

Lupe Arenillas

I am a translator, an editor and, soon, a Doctor of Literature. New York is the only place that turned out to be better than I had imagined.

Mariano Colantoni

I was in New York in 2005 for business (and a few days of vacation). I work at the largest telecommunication company in Italy, in the International Department. We have an office in New York on Fifth Avenue. I will be in New York again soon.

Marina Freire

I adore New York, where I had the opportunity to live in 1992. I stayed in a house of artists located in the most ridiculously exquisite area, St. Mark's Place, in the East Village. It was an incredible experience, which explains my love for this amazing city.

Marina Kogan

I was born and live in Buenos Aires, Argentina. I am a writer. Ever since I first visited New York in 2005, I have only dreamed of going back and living there for at least one or two years. Meanwhile I have become addicted to television shows and films where New York is the protagonist.

Marlen de Vries

I am an architect and a German, French, and English translator. Being a native of Buenos Aires, Argentina, a window to the world opened for me in 1956, when I was twenty years old—I won an internship program granted by the United Nations at its headquarters in New York. At the time, I was in the third year at the School of Architecture. I felt this immediate passion for Manhattan, which persisted whenever I returned: in 1969, 1993, 2002, and 2007. It is always spectacularly different yet always the same.

Mauricio Szuster

I am a psychoanalyst and I have been traveling to New York since 1966, initially for professional purposes and later for love and empathy with the city. I used to visit it during the roaring sixties and many times after that because I felt attracted to the surprising life it offers.

Melody Ng

I arrived in New York City via Hong Kong and Sydney, Australia. The object of my photographs is to capture the every day. Frequently, it involves food—meals with friends or new foods I have tried. New York is a chance for me to experience a type of multiculturalism that is different from that in Australia.

Michael Casey

I'm the Technology Services Director for the Gwinnett County Public Library in Atlanta, Georgia. I grew up in eastern Pennsylvania and spent many weekends and vacations in New York City. I've always been interested in New York City, its history, and culture. I'm also a huge fan of Woody Allen.

Mike Dumlao

He is a New York-based artist and photographer. He started dabbling in photography as a hobby in 2002 and took a digital photography course at the Fashion Institute of Technology. His teacher encouraged him to pursue his hobby more seriously, acknowledging that he had the photographer's eye. Mike then joined Flickr, an online community of photographers and hasn't stopped since. His photography depicts his passion for capturing the moment in his unique compositions that interplay light, shadow, and point of view. He also specializes in street photography and portraiture.

Mirta Duer

I have a bachelor's degree in Clinical Psychology. I am a member of the Asociación Psicoanalítica de Buenos Aires (Psychoanalytical Association of Buenos Aires) and the International Psychoanalytical Association. New York's intensity and wide range of possibilities surprised me. In this city, there is always something new to discover; something is always changing.

Mo Riza

I walk the city. I walk alone . . . to clear my head, then fill it with the vibrant colors, noises, moments, and cornices. Then, when I get back to where I started, I shake my head furiously.

Mixing all those, with my noodles, for a fresh serving the next day.

Nicolas Mirguet

I was born in Paris, but I've always moved around in France. I've lived in the southwest (Bordeaux, for example) and the southeast (Marseille).

My relationship with New York City is quite special. At first, I was really attracted by this city because it is an icon in the world. The city is a legend from abroad and I really wanted to discover it, and not just from a tourist's point of view. Finally I went to New York for two months in the summer of 2006. Thus I had the time, first, to discover the city and to explore it, from the highlights to the anonymous streets. Then I became quite upset with the "shining" part of New York City, mostly Manhattan, and enjoyed its less famous parts like Brooklyn. What I dislike about Manhattan is the fact that people there are quite ill-addicted to New York—they are more like in a show, which is exactly the contrary in boroughs such as Brooklyn or Queens. People and places there are more anonymous, but still very true, according to my point of view. They are not living in New York to be in New York and they are, for me, the true New Yorkers, the one who created the history of the city.

Pablo Kolodny

I am a photographer and I live in Buenos Aires, Argentina. I try to go to New York whenever it is possible. Once a year is ideal, or twice, or more.

Patty Mann

Like anyone who drives in New York City, I spend a lot of time stuck in traffic. I like to make the most of this time by taking pictures. I have to admit that I sometimes choose the most congested route, rather than the quickest. I get more pictures that way.

Paul Fontana

I was born in Queens, New York in 1941. From the time I was a baby until I was sixteen years old, my family lived in Brooklyn in an area now called Cobble Hill. We moved away in 1957, but as an adult I've returned many times to expand my knowledge of my place of birth. I always discover something new.

Paul McDougal

My relationship with New York was pretty brief. I only spent a week there, but what an amazing city! It completely lives up to its reputation, and is perhaps the only city in the world that truly does.

Paula Mariasch

I'm from Buenos Aires, Argentina, and I visited New York in March 2001, when I was twenty-three years old. Of all things it already is, New York can also appear as a sum of snapshots, a mixture of the huge and the subtle. These images—a schoolgirl, a trash can—make up my memory of the city. As an architect and a photographer, I walked the streets in a state of wonder. It was just like in the movies.

Peggy Shanks

I'm from Canada. I'm very fortunate to live just a six-hour drive away from New York so I'm able to get down for a long weekend every other year or so.

Randy Levine

I'm twenty-nine years old, work in advertising, and have been living in New York City for about seven years. I grew up about 30 miles north of the city and love it for its beauty, convenience, and all it has to offer. There is always something new to discover around every corner.

Raphael Rodriguez

I have lived in the Bronx, New York for more than forty years. I have been taking pictures since I was twelve years old. I am currently working on some projects, where I help upcoming models with their profiles and portfolios. I also photograph New York–related events, including parades, demonstrations, and celebratory activities. Recently, I had some of my photographss published in a newspaper called *New York Press* and also in a local college paper. My reason for photographing my city is my love of New York, the infinite subjects, the structures of the buildings, the streets, and the dreams anyone can accomplish.

Robyn Lee

I currently live in New York for school, but my home is in New Jersey. Although many things about New York get on my nerves (dirty streets, unreliable subway, tall sunlight-blocking buildings, lower on the pedestrian-friendly and beauty scale than Paris), it gets the job done when it comes to providing its inhabitants with lots and lots of food, spanning more cuisines than I knew existed. As one of my passions is eating, this is very convenient—the only downside possibly being that it has led to a slight obsession with eating new things all the time and documenting the process. As long as New York City provides me with inexpensive food, in particular awesome cookies and great pizza, I'll be here to eat it.

Rosa Wolkowiski

I am an architect and artist from Buenos Aires, Argentina. For me New York City is the center of the universe. I can enjoy all cultures there.

Rosenmanios

I am learning photography. I like Luke Skywalker and cheese.

Shane Stroud

I am a thirty six year old corporate attorney and have been living in New York City for about five years. I moved to Manhattan from New Orleans in 2002. I love the energy and vibrancy of living in Manhattan; there is always something to see or do.

Teresa Teruzzi

My observations of New York develop in many different ways. I'm spellbound by its countless colors. I love walking in the streets discovering enchanted corners that immediately become part of me; I love being one of the uncountable dots making up the flow of people invading the city every day, on the surface and underground, looking out from the windows of the subway. Little things catch my eye, such as those urban pieces of life you can experience while walking down the street.

Every time you go round the corner, you are thrown into a new world, but I can still watch the city from above, scan its map.

It is probably more difficult to explain what New York means to me than to say what it surely isn't. It'll never be like a white piece of paper to me because it always oozes with unexpected inspiration, just like it does with the smoke coming out from manholes. It is like an installation of art (in any form of its expressions). It's like you can literally read it through a thousand words: signs, advertisements, graffiti art on the walls, and the myriad of words that have been written in order to describe the city. Taking shots of New York is like taking notes of this wonderful city, and any of its typical noises is enough to recall distant memories.

To me visiting New York is like listening to a song for the first time, realizing that—just like music—it gets straight to your heart.

Tiffany Jones

I love New York! I lived upstate in a college town for a year and a half and made several trips into the city to take photographs. I'm Canadian now living in London, United Kingdom, and just returned from another visit to New York in March 2008.

New York City is the place where I discovered my passion for street photography. I studied photojournalism and publishing in Canada, and now spend much of my time walking the streets looking for pictures that tell the stories of what I have seen, what excites me about people living in this world in this time and place, which is passing and tomorrow will only be a memory.

The pictures I recently took in New York are physically much more close and intimate with people. The buildings there will make you feel taller and more alive. The piles of trash on the corners help you see how the city works as a machine, as they disappear every morning. The people of New York are hard workers—you see this in their faces—but they are also neighbors and friends who easily smile and help those in need.

Todd Terwilliger

I was born in upstate New York, but my first memories were of my family moving to New York City. I lived in the city until I was fourteen years old. My family moved overseas and I began a twenty-year odyssey that ended when I moved back to New York last year. I currently live in the Clinton Hill neighborhood in Brooklyn.

Victoria Cattani

As a biology PhD student, my research is in Rochester, but my heart lies in New York. For the last two years I have been traveling back and forth between two cities to visit my boyfriend and to live the urban life that I miss so much. These pictures reflect the awe and fascination we both feel for this city.

Thank you very much to all of you
for opening your albums and hearts to share with us.
Gabriela

First published in the United States of America in 2009 by
Universe Publishing
A division of Rizzoli International Publications, Inc.
300 Park Avenue South
New York, NY 10010
www.rizzoliusa.com

This book was produced by
ORO editions
PO Box 150338
San Rafael, CA 94915
www.oroeditions.com

Edited and designed by Gabriela Kogan

ISBN: 978-0-7893-1856-5

Library of Congress Control Number: 2008934536

2009 2010 2011 2012 / 10 9 8 7 6 5 4 3 2 1

Printed in China by ORO Group Ltd.
Www.oroeditions.com

Jacket Images

Front left: Mike Dumlao
Front right: Peggy Shanks

Back:
Top: Faye Chou; Gabriela Kogan; Andrea C. Jenkins; Marina Freire
Middle: Pablo Kolodny; Clay Williams; Clay Williams; Jodi McKee
Bottom: Cristina Rouco-Alejandro Giusti; Cristina Rouco-Alejandro Giusti; Eric Felton; Pablo Kolodny

Case Images

Front:
Top: Daniel Modell; Joshua Gaynor; Cristina Rouco-Alejandro Giusti; Joshua Gaynor
Middle: Cristina Rouco-Alejandro Giusti; Jodi McKee; Pablo Kolodny; Cristina Rouco-Alejandro Giusti
Bottom: Jonathan Goransky; Chie Shimodaira; Jonathan Goransky; Pablo Kolodny

Back:
Top: Faye Chou; Jonathan Goransky; Cristina Rouco-Alejandro Giusti; David Baker
Middle: Camila Miyazono López; Mariano Colantoni; Jonathan Goransky; Faye Chou
Bottom: Marina Kogan; Pablo Kolodny; Faye Chou; Colin Swan

Endpapers: Cristina Rouco-Alejandro Giusti

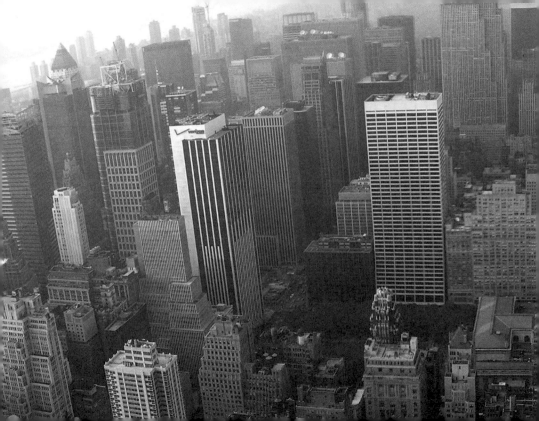